FIVE HUNDRED
YEARS OF THE ART OF
THE BOOK IN
IRELAND

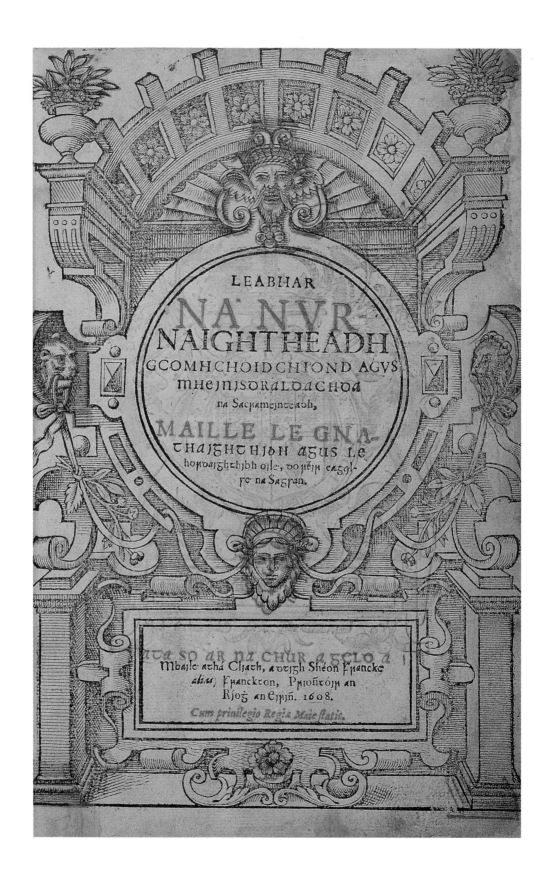

LEABHAR
NA NVR
NAIGHTHEADH
GCOMHCHOIDCHIOND AGVS
mheinisdraldachda
na Sacramainteadh,

MAILLE LE GNA
thaighththibh agus le
horduighththibh oile, do réir eagal-
re na Sagran.

ta so ar na chur a gclo a
Mbaile-athá Cliath, a dtigh Shéon Francke
alias) Francton, Príohtóir an
Ríog an Eirín. 1608.
Cum priuilegio Regiæ Maieſtatis.

JOSEPH McDONNELL

FIVE HUNDRED YEARS
OF THE ART OF THE BOOK
IN IRELAND

1500 TO THE PRESENT

National Gallery of Ireland
in association with
MERRELL HOLBERTON
PUBLISHERS LONDON
1997

FOR ANNE O. CROOKSHANK
FELLOW EMERITUS, TRINITY COLLEGE DUBLIN
ON HER SEVENTIETH BIRTHDAY

This book accompanies the exhibition
Five Hundred Years of the Art of the Book in Ireland: 1500 to the present
at the National Gallery of Ireland, Dublin
22 May – 27 July 1997

First published in 1997,
in association with Merrell Holberton Publishers Ltd,
by the National Gallery of Ireland
All rights reserved

ISBN 0 903162 98 9

Produced by Merrell Holberton Publishers
Willcox House, 42 Southwark Street,
London SE1 1UN
Designed and typeset in Dante and Mantinia by Dalrymple
(with acknowledgement for the design to the late Stephen Harvard)
Printed and bound in Italy

Jacket illustration:
All the Orations of Demosthenes, 1756, upper and lower covers, cat. 32
(Museum für Kunsthandwerk, Frankfurt-am-Main)

Frontispiece: *The Book of Common Prayer* in Irish, 1608, cat. 7
(National Library of Ireland, Dublin)

CONTENTS

VORD

UCTION

PLATES
I

OGUE

Century 115

h Century 121

Century 131

Century 160

Century 164

EDGEMENTS
71

GRAPHY
73

LENDERS
76

ERRATUM:
Cat. 14 (p. 126, para. 3), should read:
A unique example of a seventeenth-century
Irish Jesuit binding from the Noviciate at
Kilkenny. Medallions of the Crucifixion were
common on the bindings of liturgical books
and works of devotion in France during the
reign of Henri III (1574–89).

¶ Certaine notes for the more plaine explication and decent ministracion of thynges, conteyned in this booke.

IN the saiyng or syngyng of Mattens and Euensong, Baptizyng and Buriyng, the minister, in parishe Churches and Chapels annexed to the same, shall vse a Surplesse. And in all Cathedrall churches and Colledges, the archedeacons, Deanes, Prouostes maisters, Prebendaries and felowes, beyng Graduates, maie vse in the quier beside theyr Surplesses, suche hoodes as perteineth to their seuerall degrees, which thei haue taken in any vniuersitie within this realme. But in all other places, euery minister shall be at libertie to vse any Surplesse or no. It is also seemely that Graduates, when thei doe preache, should vse suche hoodes as perteineth to theyr seuerall degrees.

¶ And whensoeuer the Byshop shall celebrate the holy Communion in the Churche, or execute any other publike ministracion: he shall haue vpon hym, besyde his Rochette, a Surplesse or Aulbe, and a Cope or Vestment, and also his Pastorall staffe in his hand, or els borne or holden by his Chapeleyne.

¶ As touchyng kneelyng, crossyng, holdyng vp of handes, knockyng vpon the breast, and other gestures: they maie be vsed or left, as euery mans deuocion serueth, without blame.

¶ Also vpon Christmasdaie, Easter day, the Ascension day, whitsondaie, and the feast of the Trinitie, maie be vsed any part of holy scripture hereafter to be certainely limitted and appoincted, in the steade of the Lateny.

¶ If there be a sermon, or for other great cause, the Curate by his discrecion, maie leaue out the Latenie, Gloria in excelsis, the Crede, the Homely and the exhortacion to the Communion.

FINIS.

Imprinted by Humfrey Powell, Printer to the Kynges Maiestie, in his hyghnesse realme of Ireland, dwellyng in the citee of Dublin in the great toure by the Crane.

Cvm priuilegio ad imprimendum solum.

ANNO. DOMINI.

M. D. LI.

Colophon of The Book of Common Prayer, *the first book printed in Ireland, 1551 (see cat. 4)*

FOREWORD

THE PRESENT EXHIBITION has been assembled to promote a better appreciation of the Irish book, as distinct from Irish literature, which enjoys universal acclaim. The emphasis in this show is on the physical aspects of book production in Ireland, focussing on the achievement of printers, engravers, calligraphers and especially binders. Though most people are aware of the splendid achievements of the early Middle Ages, before the onset of printing, the art of the book in Ireland continued to flourish after 1500, with publishers and binders serving a busy and discerning market.

Up until the early nineteenth century (*ca.* 1820) all books were bound by hand, promoting the development of a range of skills which at times reached extraordinary levels of sophistication. In eighteenth-century Ireland in particular the skill of the bookbinder reached a standard of achievement which matched anything produced elsewhere in Europe. The Irish Parliamentary bindings, produced between *ca.* 1710 and 1800, enveloped the proceedings of the Irish Houses of Commons and of Lords in a spectacular display of elegance and invention unparalleled in the history of the craft. Tragically the one hundred and forty-nine volumes which had survived into this century were destroyed in 1922 when the Public Records Office, then located adjacent to the Four Courts, was gutted by fire during the Civil War. This exhibition seeks to establish a context for the Parliamentary bindings and the other crafts involved in book production, noting the continuation of these traditions right up to the present day, when these same skills are flourishing still.

The foundations for this exhibition were laid by Sir Edward Sullivan who, almost a hundred years ago, documented the Parliamentary bindings both in photographs and in rubbings. His legacy formed the basis of Maurice Craig's seminal publication *Irish Bookbindings 1600–1800*, which appeared in 1954. For many years Joseph McDonnell has dedicated much of his time to the study of the Irish book. This survey reflects the fruits of his researches, presenting his choice of material accompanied by his commentary on the volumes on display. The eighty-three books which he has selected for this exhibition have been generously made available by individuals, trusts and institutions, to all of whom we are deeply indebted for their support. In this respect we owe a particular debt to our sister institution, The National Library of Ireland, who have been exceptionally supportive of this undertaking, lending virtually one third of the material on view. The administration of this event has been the responsibility of Adrian Le Harivel, who has liaised with the author, lenders and publisher, ensuring that all the critical elements are in place. In managing his responsibilities Adrian received the support of Fion nuala Croke and Susan O'Connor. Photography for much of the catalogue was carried out by Roy Hewson. The installation of the exhibits was supervised by Maighread McParland. The supports and display units were prepared by Niamh McGuinne. The production of the catalogue, including the editing, was supervised by Dr Paul Holberton of Merrell Holberton Publishers.

The Gallery wishes to note its appreciation of the support provided by George Mealy & Sons who not only assisted the arrangement of certain loans but also provided financial support towards the costs of mounting this show.

RAYMOND KEAVENEY *Director, National Gallery of Ireland*

INTRODUCTION

Fine craftsmanship is all about you, but you might not notice it. Look more keenly at it and you will penetrate to the very shrine of art. You will make out intricacies, so delicate and subtle, so full of knots and links, with colours so fresh and vivid, that you might say that all this was the work of an angel, and not of man. For my part, the oftener I see the book, and the more carefully I study it, the more I am lost in ever fresh amazement, and I see more and more wonders in the book.

This is probably the finest eulogy ever written on the art of a decorated book and all the more remarkable in that it was written by a chronicler of the Norman conquest of Ireland by whom the native population and their culture were perceived as alien if not barbaric. When Gerald of Wales (Giraldus Cambrensis) wrote this description of the Book of Kildare (which must have been the equal of the Book of Kells) after a visit to Ireland in 1183,[1] the Gaelic scribal tradition and the making of books had already a venerable past stretching back at least five centuries. Although the greatest period had passed, Irish manuscripts were still being written and illuminated in a style which was derived from the eighth- and ninth-century exemplars while incorporating later Viking ornament, such as the splendid Cormac's Psalter in the British Library (late twelfth century).[2] The fame of Irish book-making is perhaps revealed in a telling incident, recounted in the records of the monastery of Bury St Edmunds when the artist Master Hugo was commissioned to illuminate the great Bible for the monastery in about 1135: "This Hervey, the sacrist, brother of Prior Talbot, commissioned a large Bible for his brother the Prior and had it beautifully illuminated by Master Hugo. As Hugo was unable to find any suitable calf hide in these parts, he bought some parchment in Ireland."[3]

By the middle of the twelfth century, the Continental script had been introduced to the country in the houses of the new orders such as the Benedictines and the Cistercians. They probably imported books from England and the Continent and had them copied in the same style. The influence of the new scholastic learning from Paris, in particular the *Glossatura* of Peter Lombard, has been noted in a manuscript dated 1138 from Armagh.[4] The arrival of the Anglo-Normans naturally speeded up this process with the foundation of religious houses in Dublin and beyond.

Two stamped-leather fragments of a French Romanesque bookbinding *ca.* 1200 were uncovered in the vicinity of Christ Church Cathedral, Dublin (formerly known as Holy Trinity), during excavations in the 1970s. The binding possibly came from the former medieval priory attached to the cathedral. This type of binding is associated with glossed books of the Bible and especially the Great Gloss of Peter Lombard on the Epistles of St Paul. It has been suggested that the stamped-leather volume was brought back to Ireland by John Comyn, the first Norman archbishop of Dublin (1181–1212), after a visit to France.[5] By that stage the writings of Peter Lombard were very popular in all parts of Europe. The Archbishop of Canterbury, Thomas Becket, had acquired glossed books of Peter Lombard probably in Paris as early as 1169–70.[6] Interestingly a copy of the fourth book of Peter Lombard's *Sentences* survives "in that debris of a medieval library known as the Black Book of Christ Church".[7]

During the following centuries many liturgical books were imported, mostly from England. The most important was the Psalter commissioned in 1397 for Simon of Derby, prior of Holy Trinity (Christ Church) Cathedral, by the so called Egerton Master and showing strong Italian Trecento

influence (Bodleian Library, Oxford, Rawlinson MS G. 185).[8] Irish liturgical manuscripts like the Monasterevin Ordinal, copied by an Irish ecclesiastic in 1501, show typical English and Continental features such as *bas-de-page drôleries*, though executed in a naïve manner [fig. 1].[9] As well as liturgical books, religious houses frequently possessed bound manuscripts of transcripts of deeds and charters relating to their often extensive properties. Among the rare survivals of such documents, following the destruction brought about by the Dissolution of the Monasteries, is the Cartulary of St Thomas's Abbey in Dublin, which was compiled by William Copinger in 1526 and still has its contemporary Dublin blind-stamped binding [cat. 3].

Remarkably, the Gaelic scribal tradition survived more or less intact right through the sixteenth century, despite the upheavals of the Elizabethan wars as well as the potential challenge from the printing press. In fact from the fifteenth to the nineteenth century, Irish texts were written in the same type of script as had been used since the seventh century and were often decorated in the same manner as their eleventh- and twelfth-century exemplars. Unlike the period before the arrival of the Anglo-Normans, when all scribal activity took place in monastic scriptoria, the later Gaelic scribes worked under the patronage of secular rulers, either native or Anglo-Irish. The scribes came from certain 'learned families' of poets, lawyers and annalists, largely in Munster and Connacht. Their status in Irish society was always high and they owned land and castles.[10]

By the early sixteenth century, Irish manuscripts began to display outside influences such as an interest in contemporary figure illustration. An example of such a trend is the copy in the Bodleian Library (Rawlinson MS B. 514) of a *Life of St Columcille* (or Columba), translated into Irish at the behest of the chieftain Manus O'Donnell at his castle in Lifford in Co. Donegal in about 1532.[11] The Bodleian Library volume shows a full page 'portrait' of the saint as a frontispiece [fig. 2], derived perhaps from Gothic tomb sculpture. About forty years later, the most lavishly decorated Gaelic manuscript of the century, the Book of the De Burgo (Burke) family was commissioned, probably for Sir Seán Burke who became head of the MacWilliam Burkes of North Connacht in 1571 and died in 1580. Sir Henry Sidney, the Lord Deputy, wrote of him: "I found MacWilliam very sensible; though wantinge the English tongue, yet understandinge the lattin; a lover of quiett and cyvilitie". The volume contains the history and genealogy of the family and is illustrated with eleven coloured drawings – four of the Passion of Christ, followed by a series of nine Burke 'portraits' [cat. 5]. The Passion scenes were very probably influenced by popular German coloured prints.[12]

The printing press did not arrive in Ireland until 1550, when Humfrey Powell, a London printer, was paid the sum of £20 by the Privy Council of England to set up a press in Dublin. *The Book of Common Prayer* came off the press in the following year and was used for the first time in Christ Church Cathedral on Easter Day 1551 [cat. 4].[13] As well as having the Liturgy in the vernacular, one of the pivotal points of the Reform movement was the availability of the Bible in English. According to the *Annals* of Dudley Loftus, the Archbishop of York in 1559 sent "unto the Deans of Christe Church and St. Patricks twoe large bibles to be read in those churches for the instruction of those who pleased to hear them read". Loftus also remarked that "it appeared by the accompts of John Dale bookseller for the stationers of London that within twoe yeares they wer sould in Dublin 7000 bibles".[14] Outside of Dublin and the Pale, only a tiny minority spoke English, and the authorities realised that the Protestant reform was a lost cause until the Prayer Book and at least some of the Scriptures were translated into the vernacular of the country at large. Despite the dedication of a small band of Irish scholars this was not achieved until the beginning of the next century.

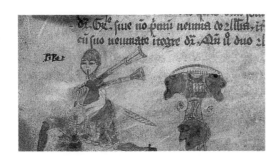

The earliest published reference to bookbinding in the late medieval period is in the Churchwarden Accounts (1484–1600) of St Werburgh's Church in Dublin. In 1484–85 Symon Walsh was paid four pence for binding two books. Other payments are recorded in the Accounts for the purchase of books – such as the acquisition of the Sarum Missal in 1503–04 – and for binding until the end of the sixteenth century.[15] Probably the earliest dated manuscript with a contemporary decorated binding is the *Cartulary* of St Thomas's Abbey, which was compiled by William Copinger in 1526 [cat. 3]. The construction and decoration follow the Netherlandish model which was introduced into England at the end of the fifteenth century. The decorated cover of the *Gormanston Register* [cat. 2] is even closer to the Netherlandish prototype and, although it covers a much earlier manuscript, the binding is probably nearly contemporary with the St Thomas's Abbey volume. In marked contrast to the international Netherlandish type of binding with its leather-covered wooden boards, found in Dublin and the Pale, is the binding of a *Life of St Columcille* (Columba) which was copied from the original manuscript, compiled under the direction of Manus O'Donnell, in his castle at Lifford in Co. Donegal in 1532. This copy, which was made for O'Donnell's brother-in-law, Niall Óg (Connallach) Ó Neill, is covered in dark-stained cattle-hide – without boards – and decorated in *repoussé* with different designs on each cover [cat. 1]. Both the system of construction and method of decoration are, at first glance, reminiscent of certain early Coptic bindings. The style of decoration, however, follows the well known late medieval Irish satchels such as that associated with the Breac Moedóig in the National Museum of Ireland. At the very end of the sixteenth century Sir Richard Shee of Kilkenny, an attorney and agent to the 10th Earl of Ormonde, had a three-volume cartulary relating to his family written up in a chancery hand. The manuscripts, bound and decorated with gold tooling, probably in London about 1600, are the earliest known examples of gold-tooled bindings commissioned by an Irishman [cat. 6].

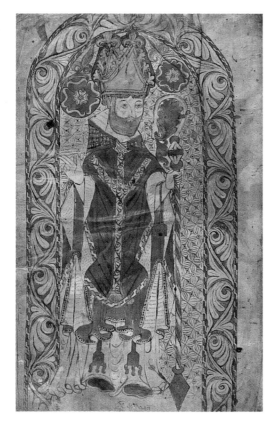

Since the printing of the first book in Irish – a Catechism – in 1571, over thirty years were to elapse before the New Testament in Irish eventually appeared in 1603 from the press of John Francke (or Franckton).[16] This was followed by *The Book of Common Prayer* in Irish in 1608, which has a very fine engraved titlepage with a Netherlandish strapwork cartouche in an architectural setting [cat. 7 and frontispiece]. Franckton as King's Printer had been given explicit control of the press at the beginning of

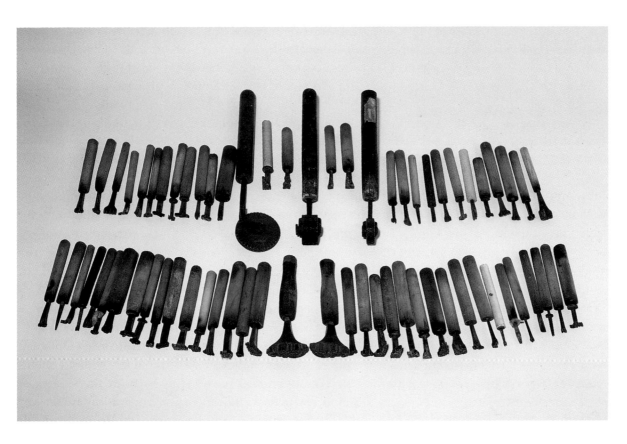

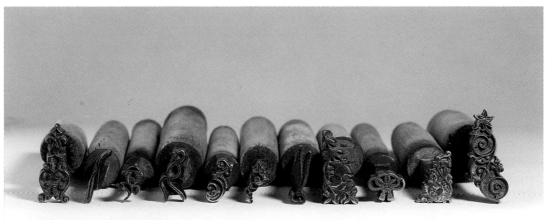

top: fig. 3
A set of bookbinding tools, English, late 19th century, Irish Georgian Society
(Gift of Paul Getty, KBE)

above: fig. 4
A selection of eleven punches from the set in fig. 5

the century which meant that all others were forbidden to print, bind, cover, publish or sell any books without his licence.[17] In 1618 three members of the London Stationers' Guild – Felix Kingston, Mathew Lownes and Bartholomew Downes – were appointed to the office of King's Printer for Ireland for the term of twenty-one years, giving them monopoly of all printing, binding and bookselling as in the case of John Franckton some years earlier.[18] Among the first works published by them was Richard Bolton's edition of *The Statutes of Ireland* (Dublin, Printed by the Society of Stationers, 1621; the colophon date is 1620) with an engraved architectural titlepage. A copy survives in a contemporary gold-tooled binding [fig. 5] which appears to be a Dublin product, as it shares an apparently identical floral tool on a gold-tooled binding of a manuscript done up for James Ussher before his consecration as bishop of Meath in 1621.[19] These two volumes are the earliest known Irish gold-tooled bindings. In 1633 the Society of Stationers issued a three-volume work, edited by Sir James Ware and often bound together: Edmund Spencer's *View of the State of Ireland*, Edmund Campion's *Historie of Ireland* and M. Hammer's *Chronicle of Ireland*. A finely bound copy of this work in brown goatskin and gold-tooled with centre-and-corner pieces is probably Dublin workmanship, as it shares an identical floral tool with two other gold-tooled Dublin books [fig. 6].[20]

By the 1630s the Counter Reformation movement had been very active with the building of new churches including the opening of a Continental-style Jesuit church and college in Dublin [cat. 13]. The rise of the Puritan party in the government forced the Jesuits to leave the capital and move to Kilkenny where they set up a house of studies with a printing press and bindery [cat. 14]. Nearby, the Cistercian Abbey of Holy Cross was undergoing a revival which was celebrated with an illuminated history of the abbey and its relic of the True Cross [cat. 12]. At the same time the writing and collecting of Gaelic

left: fig. 5
The Statutes of Ireland,
edited by Richard Bolton,
Dublin, 1621,
private collection

right: fig. 6
Edmund Spencer's View of
the State of Ireland,
Edmund Campion's
Historie of Ireland, *M.*
Hammer's Chronicle of
Ireland, *Dublin 1633,*
private collection

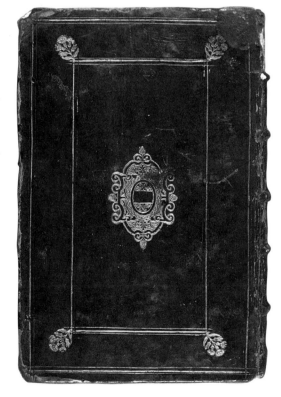

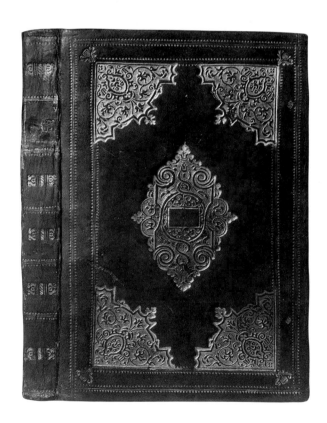

manuscripts was given a fresh impetus by the Franciscan friars – many of whom were educated on the Continent – who produced among other works the *Annals of the Four Masters*. Other notable Gaelic scholars included Dr Geoffrey Keating (*ca.* 1570–*ca.* 1650), who wrote a history of Ireland, *Foras Feasa ar Éirinn, ca.* 1633.

The forty-year period following the Restoration of Charles II to the throne in 1660 is regarded as the golden age of English bookbinding (though this renaissance had begun earlier under Cromwell), when the binders of Oxford, London and Cambridge were not content to follow the latest Parisian fashions but developed their own designs, such as the so called 'cottage-roof', introduced in about 1660.[21] This style was based on the architectural motif of the broken pediment with floral swags descending from the eaves; and was perhaps suggested by the frequent use of architectural titlepages in books at this period. Another motif derived from architecture was the 'drawer-handle tool', which became popular from the 1670s onward. In fact, it is an Ionic capital seen in profile, and was used in repeating patterns or 'all-over' designs. Another design which was of great consequence for the Irish Parliamentary binders of the early eighteenth century used an inner rectangle with onlaid centre-and-corner pieces of contrasting colours, producing an effect which owes a good deal to the designs of Persian carpets.

Our knowledge of the individual binders of the period is derived from a study of their tools, since we rarely know their names. Even when payment is recorded for work done, it is usually made to a middle man, who farms out the work, or to the head of a large establishment with a bookbinding department. Bookbinders' tools [figs. 3, 4] are engraved, not cast, since they are heated when used on the leather. Even when tool designs are closely copied, minute differences can be observed under scrutiny. Sets of tools can be established which show that the books on which they were used come from the same shop. In this way anonymous binders' work is identified and given names such as the 'Devotional Binder', one of the most important of the Restoration ateliers. The 'Devotional Binder' was so named by the late G.D. Hobson because most of his known bindings cover devotional literature ascribed to Dr Richard Allestree.[22] It has been assumed that this binder's shop was located in London between the years 1675 and 1685.[23] The tools of the Devotional Binder are distinctive, being larger and bolder in outline than those of his immediate contemporaries. A previously unpublished binding with the tools of the Devotional Binder covers a genealogical manuscript of the Duke of Ormonde (1610–1688), written by Richard Connell of Kilkenny in about 1675. The handsome folio volume is bound in black goatskin and tooled in gold to a panel design [cat. 15]. Recent research shows that a number of books with Dublin imprints are bound with the tools of the Devotional Binder.[24] The earliest is an octavo volume of *Sermons* by the ex-Jesuit Andrew Sall (Dublin 1674), bound in 'mauve-violet' goatskin and gold-tooled to a panel design [fig. 7]. Two copies of Richard Lawrence's *The Interest of Ireland* (Dublin, Printed by Jos. Ray, for Jo. North … and Will. Norman Bookseller, 1682), in identical panel-style bindings, are again bound with the tools of the Devotional Binder, possibly for presentation [cat. 17]. William Norman, the last named bookseller on the titlepage of this book, styled himself book-binder to the Duke of Ormond in 1683.[25] It is suggested that the Devotional Binder, who bound at least one manuscript for the Duke of Ormonde [cat. 15] and whose tools are found on a number of bound volumes with Dublin imprints, including presentation copies [cat. 16], worked in Dublin for a time, probably for William Norman.[26]

The general standard of printing in Ireland and in England during the seventeenth century was not good compared to the Continental presses, such as that of Plantin in Antwerp or the Royal press in

Paris. However, the situation improved in Dublin when George Grierson set up his printing office at the Sign of the Two Bibles in Essex Street in 1703. The series of classics which were issued from his press between 1721 and 1728 earned him the title 'the Irish Elzevier'. These were edited by his wife Constantia, who was described as "one of the most learned scholars of her age" and "mistress of Hebrew, Greek, Latin and French". The Griersons' finest achievement was a three-volume edition of the works of Tacitus, published in 1730. Of this work the bibliographer Harwood wrote: "This is the celebrated edition of Tacitus which Mrs. Grierson published. I have read it twice through, and it is one of the best edited books ever delivered to the world." Constantia Grierson died in 1733 at the age of twenty-seven.[27]

The next important stage in the development of printing in Ireland was the opening of the printing house at Trinity College in 1734. The printing house, designed by the German architect Richard Castle, was built in 1734 as a gift from Bishop John Stearne of Clogher. The inaugural edition from the press was *The Seven Select Dialogues of Plato* (1738). This was the first complete book in Greek to be printed in Ireland. Thirty large paper copies were specially bound for presentation, ten in blue goatskin and twenty in red. The ten blue copies were more elaborately bound at a cost of ten shillings each [cat. 26]. They were bound by Joseph Leathley's Binder. Leathley was College Bookseller and also supplied stationery ware, including bookbinding. These *Plato's Dialogues* in their special bindings, especially on the presentation copies, not only represent the token of pride in the new press and institutional courtesy towards establishment figures but are one of the finest pieces of work to be patronized both by the University, via the Printing Press, and by the College Bookseller, via his binder.[28]

fig. 7
Andrew Sall,
Sermons, *Dublin*
1674, bound by
Devotional Binder,
rubbing, courtesy of
Dr Maurice Craig

The success of the *Plato's Dialogues* was followed after a gap of seven years by a series of the classics printed by Samuel Powell and edited by John Hawkey. The five volumes of Hawkey Classics which appeared off the press from 1745 to 1747 were the most complete piece of book production for the entire century. As Jean Pierre Droz noted in his *Literary Journal* (Dublin 1745): "Mr. Hawkey is going on with his beautiful Edition of Latin Classics, undertaken by the Approbation of, and promoted by Encouragement from, our University, and printed in the College. Virgil is already come out, and fully answers the Expectation of the Public. Horace is now in the Press. – A few Setts are printed on royal Paper for the Curious, and will exceed any thing of the kind published in this Kingdom. Each subscription for common setts is a British half Crown." When the Terence came out it was acclaimed by Droz: "Terence by Mr. Hawkey came out lately, the Sets on Royal Paper equal whatever of the Kind hath been attempted in any part of Europe." This verdict was later echoed by the bibliographer Harwood, who

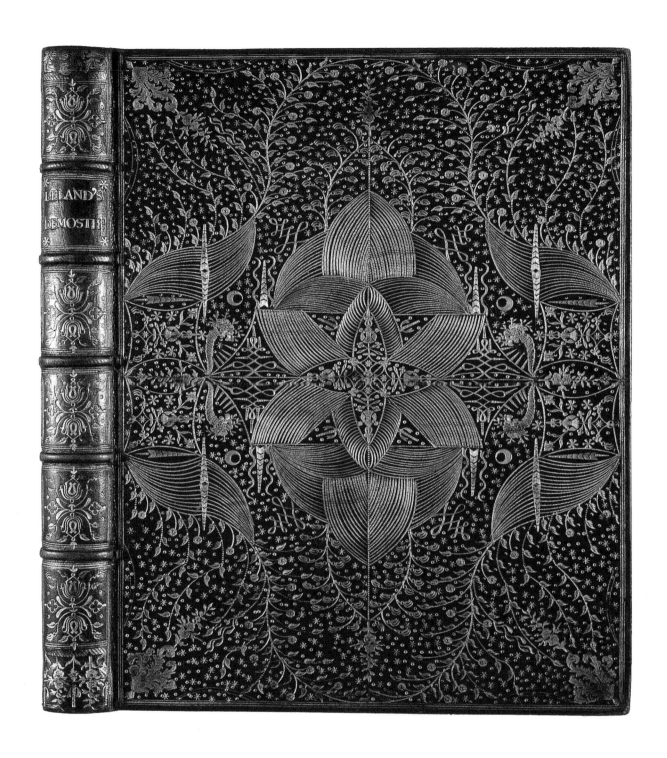

fig. 8
Thomas Leland's All the Orations of Demosthenes,
Dublin 1756, bound by Edward Beatty (Parliamentary Binder B)
private collection

pronounced the *Comedies* of Terence "a very beautiful and correct edition". The dedication copy to Philip Dormer Stanhope, 4th Earl of Chesterfield and Lord Lieutenant of Ireland, survives in a sumptuous binding [cat. 27]. A number of sets of the Hawkey Classics were also bound by Parliamentary Binder A, showing his mastery of the smaller scale as well as the large folio format [cat. 30]. In 1753 the Board of Trinity College allowed two members of staff, Thomas Leland and John Stokes, to print further editions of the Classics. The *Phillipics* of Demosthenes came out in 1754, and this was followed by the *Orations*, translated by Thomas Leland and published in 1756.[29] Two known copies were bound by Edward Beatty (Parliamentary Binder B), possibly for presentation, in his celebrated featherwork style, thus underscoring the importance of Trinity College as a patron of the art of the book in the eighteenth century [fig. 8 and cat. 31].[30]

In 1692 an event occurred which would lead to one of the greatest acts of patronage in the history of bookbinding. Robert Thornton, a Dublin bookseller, was granted a patent from the Crown as the first holder of the office of King's Stationer in Ireland.[31] This new office was to provide Parliament and government departments with stationery wares, which included bookbinding. From this date began the regular practice of binding up the transactions, or the fair-copy manuscript *Journals* of the Houses of Parliament after every session, which only ended with the Act of Union in 1800. When Sir Edward Sullivan (1852–1928) rediscovered the *Journals* about a hundred years ago in the Public Record Office of Ireland, 149 had survived with only six missing.[32] With the exception of a few of the earliest volumes of the Commons' *Journals*, on which calf or vellum was used, they were all bound in the finest goatskin, generally red in colour, and measuring on average about 21½″ by 14½″ (546 × 368 mm). Of these bindings Sir Edward remarked: "... considering the large number of volumes, and the magnificent and bewildering variety of their artistic designs, it may truly be said of them that there is no such set of bound books to be found in any part of the world."[33] And a later authority, G.D. Hobson,[34] described them as "probably the most majestic series of bindings in the world". Tragically the Parliamentary Journals with their incomparable bindings perished in the destruction of the Public Record Office in June 1922. Maurice Craig has written that "it was probably the greatest single artistic loss that Ireland has ever suffered, at least in modern times".[35] By great good fortune Sir Edward had a selection of the bindings photographed, and also took a very full set of rubbings, which are now in the National Library of Ireland.

The earliest surviving reference for binding work for Parliament is that listed in the accounts submitted by Joseph Ray, the Deputy King's Stationer, to the House of Commons in June 1705: for "Binding the New Journal" (that is, Commons' *Journal* for the year 1703), but no price is indicated.[36] A volume dedicated to the 2nd Duke of Ormonde was bound in the same shop and conveys the style of those early Parliamentary bindings [cat. 19]. The next bill submitted by Ray in 1707 is more specific and includes, *inter alia*: "Oct. 29. For Ruling the Journal & Binding it Gilt, marbled & Lettered £3. 10. 0." (that is, Commons' *Journal* for 1704–05).[37] The volume, like the previous example, was bound in calf with black marbling effects and tooled in gold to a panel design. The binding of the Commons' *Journal* for the year 1707 was in striking contrast to the previous volumes, as it was bound in red goatskin and richly tooled in gold to a triple-panel design with an inner rectangle ornamented with seven onlays of contrasting colours – the overall effect resembling a Persian carpet. It appears that a new finisher (the person who decorated the covers) was brought into an existing shop as some of the tools were previously used on covers of the earlier *Journals*.[38] The binding of the Commons' *Journal* for the next session (1709) was entrusted to a less accomplished finisher. His tools, including two with large

strapwork designs, are also found on a 1714 Dublin Bible, bound in the cottage-roof style [cat. 20].

By 1723 Samuel Fairbrother was the King's Stationer and it was during his tenure, which lasted till 1749, that the outstanding craftsman known as Parliamentary Binder A produced some of the most beautiful bindings the world has ever seen.[39] An early example of his work (*ca.* 1725–30) is the binding from Longleat [cat. 21], which illustrates his delicacy of touch. Over the next twenty years he was to create a series of over thirty-five folio volumes, each different from one another, except in a case where the *Journal* of some particular year runs into two volumes – which happens a few times only. Year after year the tooling became more and more luxuriant, and in the case of the Commons' *Journal* for 1747 the effect "is almost dazzling in its magnificence".[40] The richness is achieved partly by the extraordinary profusion of dots and daisy-like flower-heads which powder the surface of the bindings, and by the contrasting colour onlays, all of which was carried out with the utmost precision. Abraham Bradley succeeded Samuel Fairbrother as the King's Stationer in 1749 and the last work by Parliamentary Binder A was the binding of the Commons' *Journal* for the same year.[41] It must have seemed a daunting task for a new binder to follow the brilliance and outstanding achievement of Parliamentary Binder A. Edward Beatty (Parliamentary Binder B) met the challenge by creating, over the next ten years, a sequence of masterpieces which is unparalleled in the history of bookbinding.[42] His revolutionary style is characterized by such daring innovations as gold-tooling on splash-marbled and white paper onlays and, most dramatic of all, 'featherwork' decoration – the term employed by Maurice Craig to describe the arrangement of tooled graduated curved lines (both *au pointillé* and solid) or gouges, mostly in fan-shaped or radial patterns [fig. 8 and cats. 31, 32]. "Nothing resembling this was to be seen in European binding until the work of Paul Bonet in France in the 20th century, and when M. Bonet was shown a photograph of a featherwork binding he could not believe it had been done in Ireland two centuries earlier."[43]

The daring innovations of Edward Beatty naturally had some imitators but no equals. George Faulkner's Binder (formerly known as the Rawdon Binder) was active mainly in the 1750s and 1760s and worked for the collector Lord Rawdon for whom he bound some illuminated manuscripts [cat. 33].[44] As well as the twin institutional patronage of Parliament and College, binders were kept busy supplying the demand for finely bound bibles and prayer books. Another category which often required a fine binding was the presentation copy of a new book. Such, for example, was the case when Sylvester O'Halloran, the Limerick doctor who was trained in Leyden and Paris, wanted to present his latest publication on *Gangrene* ([Limerick] 1765) to the Lord Lieutenant, the Earl of Hertford. He obviously knew that his book was more likely to attract attention covered in crimson turkey leather and lavishly tooled in

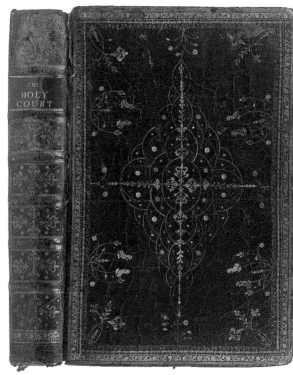

fig. 9
Nicholas Caussin,
The Holy Court,
Cork 1767, Cork binding, The Library Company of Philadelphia

gold than presented in wrappers with a Limerick imprint [cat. 36]. The great number of top finishers in Dublin around the middle of the century has been a source of wonder to bookbinding historians.[45] It seems that a taste for lavish binding was fairly widespread, like the taste for richly stuccoed interiors for which Dublin is justly famous.[46] Fine binding was not only confined to Dublin in the eighteenth century. Recently discovered examples from Belfast and Cork testify to the high levels of skill and originality outside the capital. A Cork binding is on Nicholas Caussin's *Holy Court* (Cork, Eugene Swiney, 1767), an ambitious publication by a Roman Catholic printer during the Penal Era [fig. 9].[47]

Almost since the beginning of the eighteenth century engravers were in demand for illustrating books, ranging from the classics to such major publications as George Faulkner's *Universal History* or Chambers's *Cyclopoedia*. Most of the work done in the first half of the century, with a few notable exceptions, was not of a very high standard, since the engravers were probably required by publishers and booksellers to copy foreign work [cat. 55(c)]. A noticeable improvement is seen in the later part of the century, for example in the publications of Peter Wilson where the first Dublin Rococo titlepage appears in his edition of *The Spectator* [cat. 55(a)]. James Esdall's etchings, which appear in several publications, are quite outstanding. The finest Rococo titlepages, however, were not found in printed books but in the manuscript estate maps of John Rocque and his associate Bernard Scalé [cats. 58, 59].

Outside of Dublin and the Pale, it should be remembered, the majority of the population spoke only Irish, and as there were hardly any printed books in that language Gaelic scribes were kept busy copying literary and historical works and also practical compilations on law and medicine. Even in

Dublin Irish scholars were copying manuscripts and building up collections, such as the scribe and collector John Carpenter, afterwards Roman Catholic Archbishop of Dublin [cat. 61]. Gaelic manuscripts were also being copied for such aristocratic collectors as the Earl and Countess of Moira.[48] Charlotte Brooke's *Reliques of Irish Poetry* (Dublin, George Bonham, 1789) was the first purely literary work containing printing in the Irish character which was ever published in Dublin. This fashionable interest in the Irish language and antiquarianism was no doubt a spin-off from the great success of MacPherson's *Ossian*.

After 1800 and the Act of Union, the Irish Parliament was no more. Patronage had shifted to London and the Irish book trade had suffered as a consequence, especially the bookbinders. A further blow came with the introduction in the 1820s of bookbinders' cloth and the mechanization of binding processes. Nevertheless, a first-rate firm such as that of George Mullen of Nassau Street, Dublin [cats. 65, 66], was finding work in the country house libraries, catering for a new type of client – the landowner who was also a bibliophile – such as the Marquess of Sligo and Christopher Dillon Bellew of Galway. Meanwhile other binders such as Gerald Bellew catered for a broader clientele and he is best known for his Celtic Revival-style

bindings [cat. 67]. A notable feature of the nineteenth century is the growth of provincial book-binders.[49]

The fame of Charlotte Brook's *Reliques of Irish Poetry* stimulated the interest in Gaelic literature. Under the direction of the Irish scholar and translator Thaddeus Connellan new Irish types were being cut for such institutions as the British and Foreign Bible Society [fig. 10]. The most distinguished Irish typeface of the nineteenth century was used by the Dublin University Press for the Irish Archaeological Society publications begun in 1841. The seven-volume *Annals of the Four Masters*, edited and translated by John O'Donovan, was the most prestigious publication of the century and was printed at the University Press by Michael Henry Gill between the years 1848 and 1851.[50]

The revival of bookbinding in England at the end of the nineteenth century was due to the pioneering efforts of T. J. Cobden-Sanderson, a practising barrister, who was inspired by the work of William Morris. In Ireland another barrister, Sir Edward Sullivan, 2nd Baronet, decided to learn the craft of bookbinding and became actively involved in the Arts and Crafts Exhibition held in Dublin in 1895, which showed examples of his work [cat. 70] and also that of Cobden-Sanderson.[51] Further exhibitions were held at the beginning of the twentieth century which fostered the work of other binders including Eleanor Kelly [cat. 71].

One of the most significant publications at the beginning of the twentieth century was the five-volume *Georgian Society Records* (1908–12). Otherwise it is the private presses, such as the Dun Emer Press and the Cuala Press, which are of greatest interest. The Dun Emer Press was established by Elizabeth Corbet Yeats in 1903 with W.B. Yeats's *In the Seven Woods* as its inaugural production. Five years later the Cuala Press was founded with the publication of *Poetry and Ireland* by W.B. Yeats and Lionel Johnson. The Cuala Press also produced illustrated editions, the finest example being *A Lament for Art O'Leary* with illustrations by Jack B. Yeats [cat. 73]. More recently the Dolmen Press has produced some notable publications, including *The Táin*, with illustrations by Louis le Brocquy [cat. 74].

1. F. Henry, *The Book of Kells*, London 1974, p. 165; J. O'Meara, 'Giraldus Cambrensis, in Topographia Hibernia', *Proceedings of the Royal Irish Academy*, LII, section C, no. 4, 1949, pp. 113–78.

2. British Library, Add. MS 36,929; F. Henry and G.L. Marsh-Micheli, 'A Century of Irish Illumination (1070–1170)', *Proceedings of the Royal Irish Academy*, LXII, section C, 1962, pp. 161–64; F. Henry, *Irish Art in the Romanesque Period 1020–1170 A.D.*, London 1970, pp. 72–73; M. McNamara, 'Psalter Text and Psalter Study in the Early Irish Church (A.D. 600–1200)', *Proceedings of the Royal Irish Academy*, LXXIII, section C, no. 7, 1973, pp. 250–51; R. Stalley, *The Cistercian Monasteries of Ireland*, London and New Haven 1987, pp. 217–18.

3. C.M. Kauffman, *Romanesque Manuscripts 1066–1190*, London 1975, p. 89.

4. Henry 1970, p. 4.

5. J. McDonnell, 'Romanesque Bookbinding Fragments', in *Miscellanea 1*, ed. Patrick F. Wallace (Medieval Dublin Excavations 1962–81, series B, II, 1988, fasciculus 1–5), Dublin (Royal Irish Academy) 1988, pp. 27–31.

6. C. de Hamel, *A History of Illuminated Manuscripts*, Oxford 1986, p. 116.

7. H.W. Lawlor, 'A Calendar of the Liber Niger and Liber Albus of Christ Church, Dublin', *Proceedings of the Royal Irish Academy*, XXVII, section C, 1908–09, p. 4.

8. Otto Pächt, 'A Giottesque Episode in English Mediaeval Art', *Journal of the Warburg and Courtauld Institutes*, VI, 1943, p. 51f.

9. Otto Pächt and J.J.G. Alexander, *Illuminated Manuscripts in the Bodleian Library*, Oxford 1973, III, no. 1286, pl. cxvii; F. Henry and G. Marsh-Micheli, 'Manuscripts and Illuminations, 1169–1603', in *A New History of Ireland*, ed. Art Cosgrove, Oxford 1987, pp. 789, 806, pl. 27a–d; Stalley 1987, p. 219, fig. 260.

10. Henry and Marsh-Micheli 1987, p. 790f.

11. Pächt and Alexander 1973, no. 1287, pl. cxviii; Henry and Marsh-Micheli 1987, pp. 807–09.

12. Henry and Marsh-Micheli 1987, pp. 809–15.

13. R. MacCarthy, *Ancient and Modern: A Short History of the Church of Ireland*, Dublin 1995, p. 32.

14. 'The Annals of Dudley Loftus (Marsh's Library MS 211)', *Analecta Hibernica*, X, 1941, pp. 235–36.

15. J.I. Robinson, 'Churchwardens' Accounts 1484–1600, St. Werburg's Church', *Journal of the Royal Society of Antiquaries of Ireland*, XLIV, 1914, pp. 138–39: "Item payed for II white lether skynnes to hell [cover] ye bokes VId. Item paied to Symon Walsh tuward the hellyng of II bokes IIIId".

16. D. Clarke and P.J. Madden, 'Printing in Ireland', *An Leabharlann* (Journal of the Library Association of Ireland), XII, no. 4, December 1954, p. 116.

17. M. Pollard, *Dublin's Trade in Books 1550–1800*, Oxford 1989, pp. 2–3.

18. C. Blagden, *The Stationers' Company, A History: 1403–1959*, London 1960, chap. 6.

19. Bernard Meehan, 'The Manuscript Collection of James Ussher', in *Treasures of the Library, Trinity College Dublin*, ed. Peter Fox, Dublin 1986, fig. 72.

20. The binding of *The Historie of Ireland*, 1633 (STC 25067a) was illustrated in Charles W. Traylen's Catalogue 27, 1953, no. 222, and passed later in the J.R. Abbey Collection (sold, Sotheby's, 21 June 1967, lot 224); it was subsequently sold at Christie's (11 June 1980, lot 469) and is now in an Irish private collection. A floral tool at the corners of the inner rectangle of the cover is the same as that found on two identically bound copies of James Barry's *The Case of Tenures upon the Commission of Defective titles* (Dublin, Society of Stationers, 1637): (A) Trinity College Dublin, I. ee. 18 (B) National Library of Ireland, Ir. Dubl. 1637, Dix. L.B.

21. H.M. Nixon, *English Restoration Bookbindings*, London 1974, p. 27.

22. G.D. Hobson, *Bindings in Cambridge Libraries*, Cambridge 1929, pl. LXII; Nixon 1974, pp. 38–39, pls. 84–87.

23. H.M. Nixon, *Broxbourne Library: Styles and Designs of Bookbindings*, London 1956, p. 157.

24. See cat. 15 for the complete list.

25. *Ibid.*

26. *Ibid.*

27. Laetetia Pilkington, *Memoirs*, 2 vols., Dublin 1748, *passim*; DNB; Clarke and Madden 1954, p. 123.

28. J. McDonnell and P. Healy, *Gold-tooled Bookbindings Commissioned by Trinity College Dublin in the Eighteenth Century*, Leixlip 1987, pp. 47–48.

29. *Ibid.*, pp. 31–32.

30. J. McDonnell, 'Parliamentary Binder B identified', *Bulletin of the Irish Georgian Society*, XXXV, 1992–93, pp. 52–56.

31. Sir Edward Sullivan, *Decorative Bookbinding in Ireland* (Opuscula, no. LXVII, Ye Sette of Odde Volumes), London (privately printed) 1914, pp. 28–29.

32. Sir Edward Sullivan, 'Ornamental Bookbinding in Ireland in the Eighteenth Century', *The Studio*, XXXIII, 1904, p. 56.

33. *Ibid.*

34. G.D. Hobson, *English Bindings, 1490–1940, in the Library of J.R. Abbey*, London 1940, p. 114.

35. Maurice Craig, 'The Irish Parliamentary Bindings', *The Book Collector*, II, no. 1, spring 1953, p. 24.

36. National Library of Ireland MS 8389 (unpaginated).

37. *Ibid.*

38. I cannot substantiate these findings here, but hope to do so in a future publication.

39. Maurice Craig, *Irish Bookbindings 1600–1800*, London 1954, pls. 1–3 (I differ with Dr Craig on the extent of the œuvre of Parliamentary Binder A).

40. Hobson 1940, p. 118; Craig 1954, frontispiece.

41. *Ibid.*, pl. 3.

42. McDonnell 1992–93, pp. 52–56.

43. Maurice Craig, *Irish Bookbindings* (The Irish Heritage Series 6), Dublin 1976, unpaginated.

44. Maurice Craig, 'Irish Bookbinding', *Apollo*, October 1966, p. 324, figs. 3 and 4; J. McDonnell, 'The Coote Armorial Bindings', *Bulletin of the Irish Georgian Society*, XXXVII, 1995, pp. 6–7, notes 27–30.

45. Craig 1954, p. 5.

46. J. McDonnell, *Irish Eighteenth-Century Stuccowork and its European Sources*, Dublin 1991, *passim*.

47. Hugh Fenning OP, 'The Catholic Press in Munster in the Eighteenth Century', in *Books beyond the Pale: Aspects of the Provincial Book Trade in Ireland before 1850*, ed. Gerald Long, Dublin 1996, pp. 21–22. Other Cork bindings from the same shop as the Nicholas Caussin volume include: (1) MS maps of the estate of Henry Cole Bowen in the County Tipperary, 1760 (reversed calf, tooled in blind), National Library, MS 2043; (2) *The Modern Monitor, or Flyn's Speculations*, Cork (William Flyn) 1771, red goatskin with wide gilt border roll, lettered on the upper cover: *Countess of Shannon, The Gilbert Library, Pearse Street, Dublin* (Craig 1954, p. 34, no. 129). Another Cork binding similar to the Nicholas Caussin volume but apparently from a different shop is the copy of Gray's *Poems*, Cork (William Flyn) 1768, Bodleian Library, Broxbourne 43,24 (I am grateful to Paul Morgan for a rubbing of this volume; it is listed in Craig 1954, p. 32, no. 103).

48. McDonnell and Healy 1987, pp. 214–17.

49. Charles Ramsden, *Bookbinders of the United Kingdom (outside London) 1780–1840*, London 1954, pp. 224–50.

50. Clarke and Madden 1954, p. 127.

51. McDonnell and Healy 1987, pp. xiii–xvii.

COLOUR PLATES

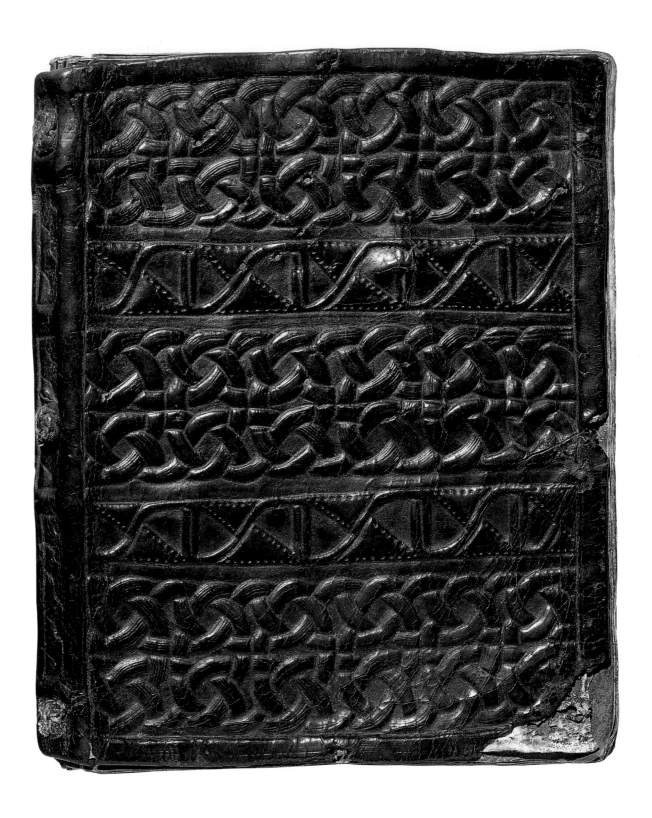

Cat. 1 Decorated Binding from Ulster, early 16th century, *Life of St Columcille*, upper cover

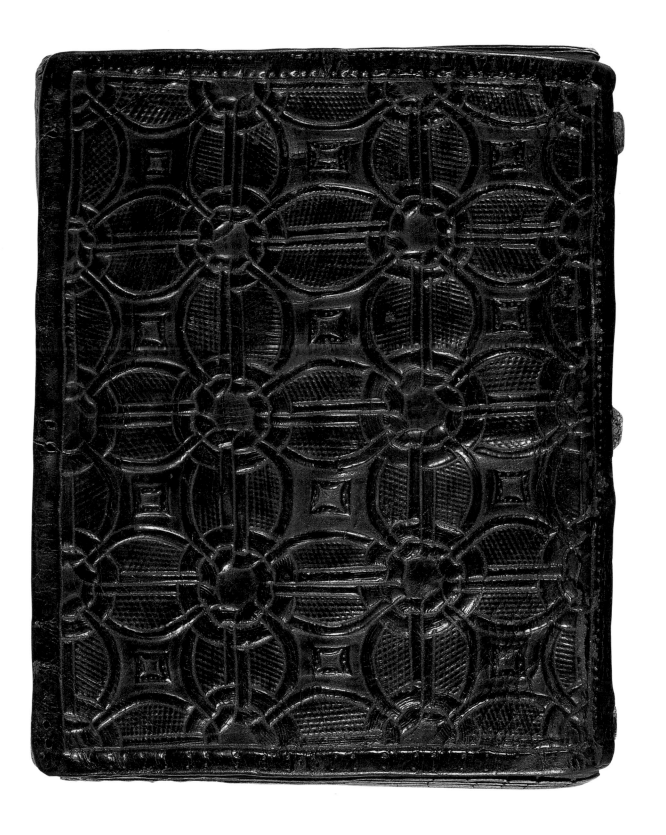

Cat. 1 Decorated Binding from Ulster, early 16th century, *Life of St Columcille,* lower cover

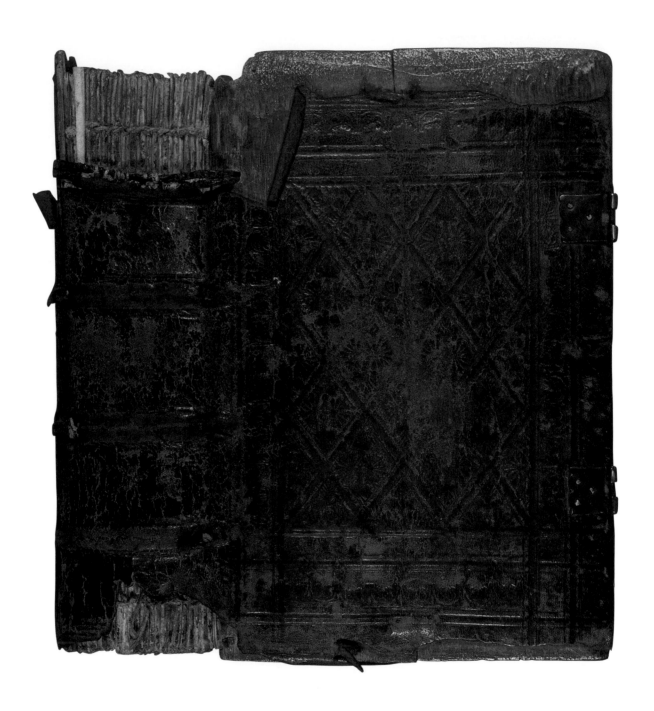

Cat. 2 Blind-stamped (?)Dublin Binding, early 16th century, *The Gormanston Register*, upper cover

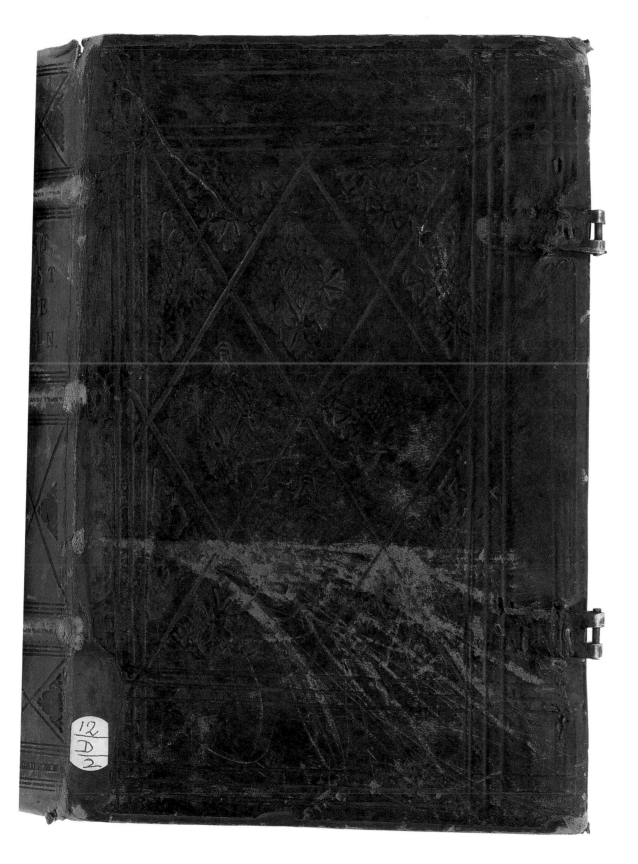

Cat. 3 Blind-stamped Dublin Binding, *ca.* 1526, *Cartulary of St Thomas's Abbey, Dublin*, upper cover

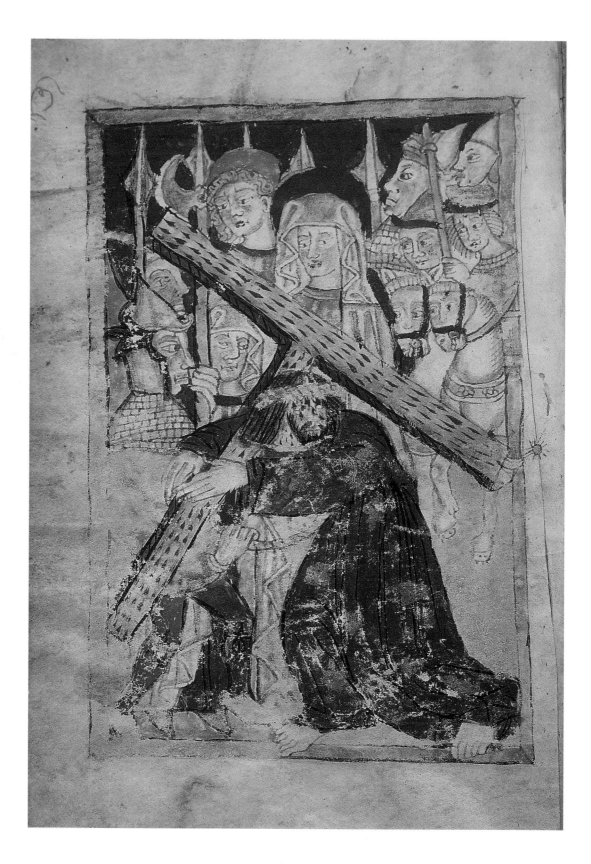

Cat. 5 Illuminated Manuscript Book from Connacht, *ca.* 1578, *The Book of the Burkes,*
f. 18v, *Christ carrying the Cross*

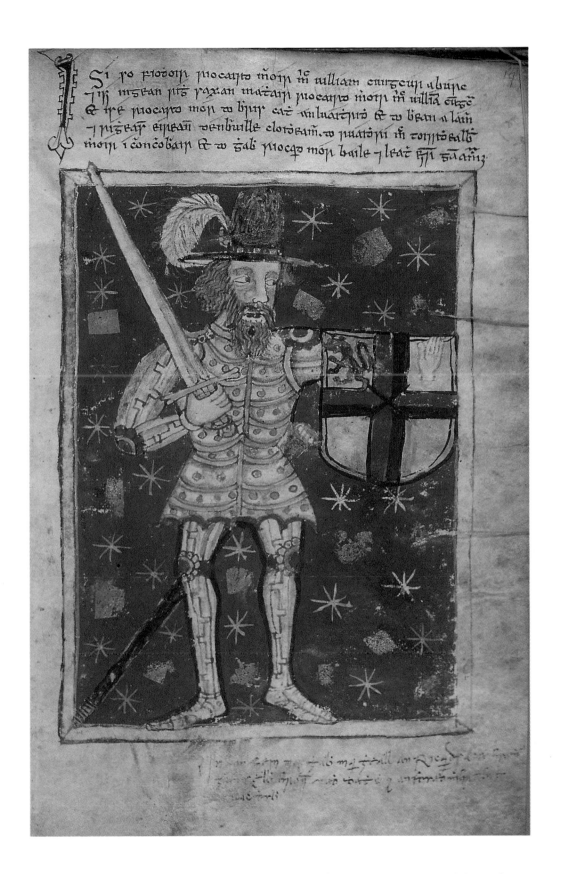

Cat. 5 Illuminated Manuscript Book from Connacht, *ca.* 1578, *The Book of the Burkes,* f. 19r, *Richard Mór Burke* (died 1243)

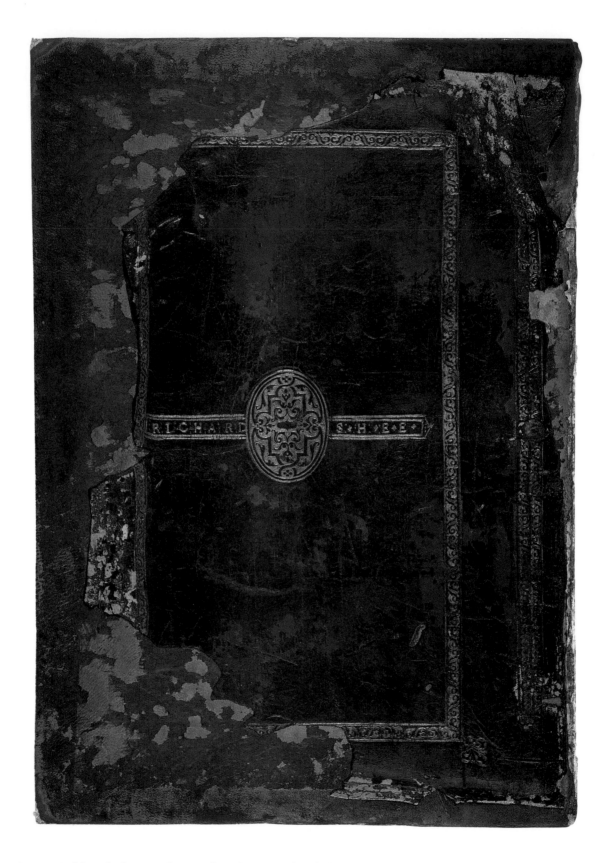

Cat. 6 Gold-tooled (?)London Binding for Sir Richard Shee, *ca.* 1600, *Richard Shee Cartulary*, lower cover

Cat. 7 *The Book of Common Prayer* in Irish, *Leabhar na Nur-Naightheadh Gcomhchoidchiond*, 1608,
upper cover

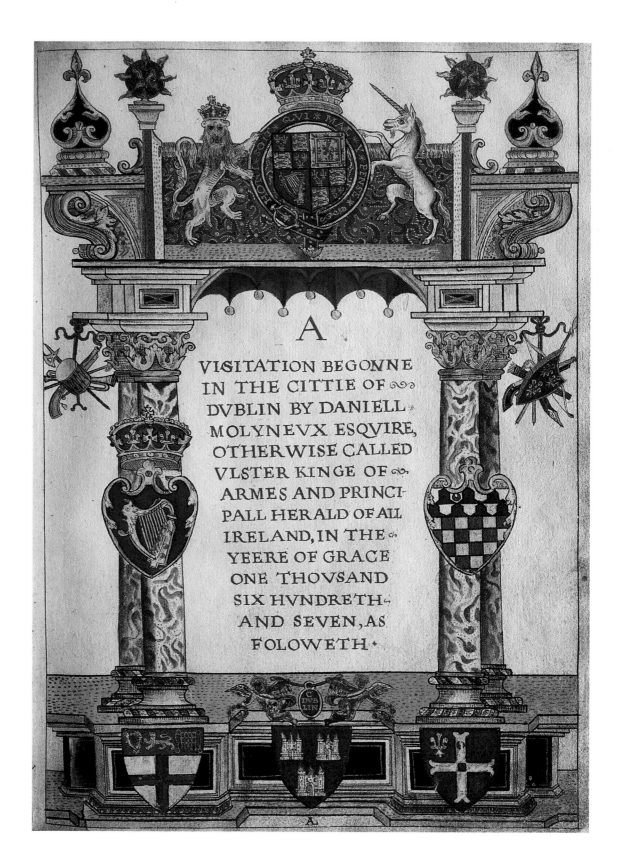

Cat. 8 Daniel Molyneux, Ulster King of Arms, *A Visitation Begonne in the Cittie of Dublin*, MS, 1607, frontispiece

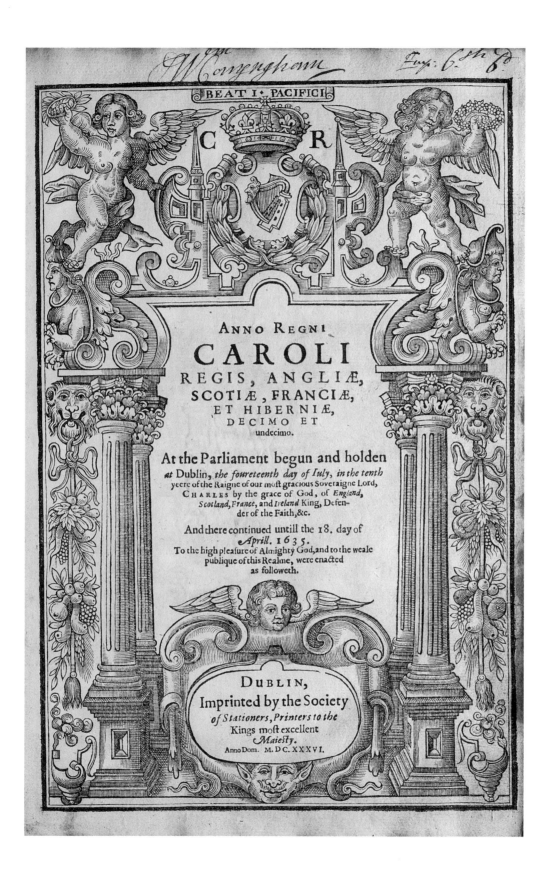

Cat. 9 *Statutes of Charles I*, 1635, architectural titlepage

Cat. 10 Irish or English *Pointillé* Binding, 1639–40, *A New Year's gift for Sir William Wentworth*,
upper cover

Cat. 11 *Blathmac's Poems*, 17th-century transcription

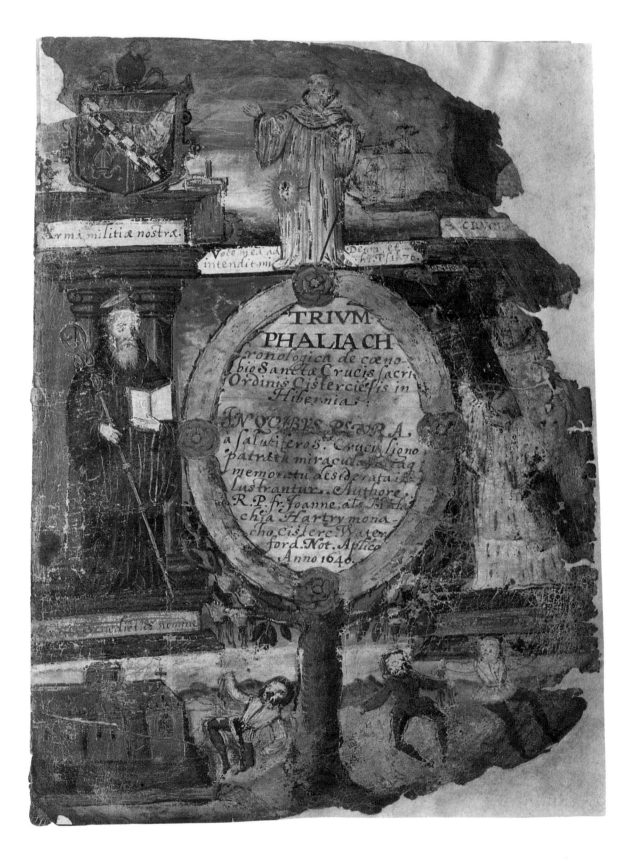

Cat. 12 Illuminated MS Book from Holy Cross Abbey, Co. Tipperary, 1640, Fr Hartry, *Triumphalia*, titlepage

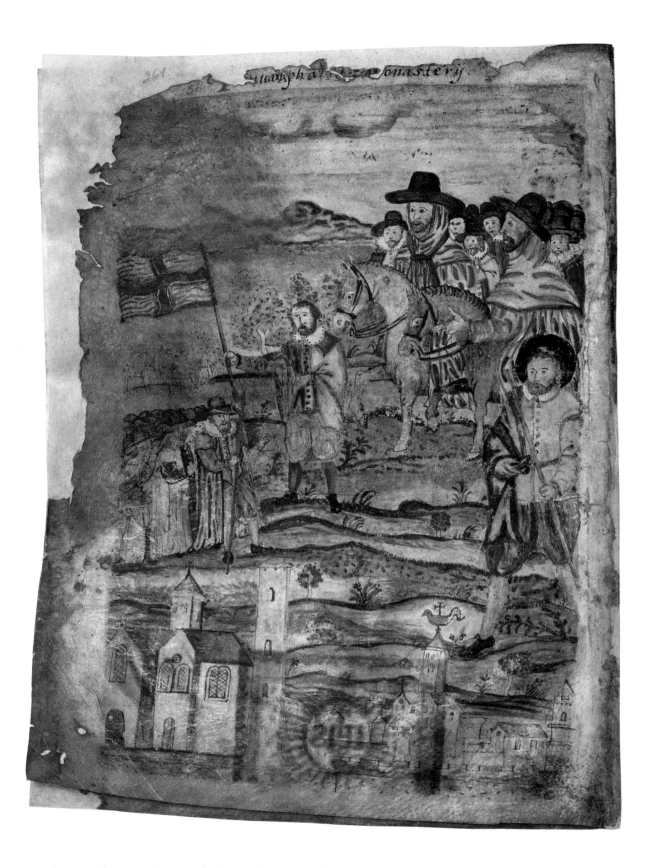

Cat. 12 Illuminated MS Book from Holy Cross Abbey, Co. Tipperary, 1640, Fr Hartry, *Triumphalia,*
The Relic carried in procession

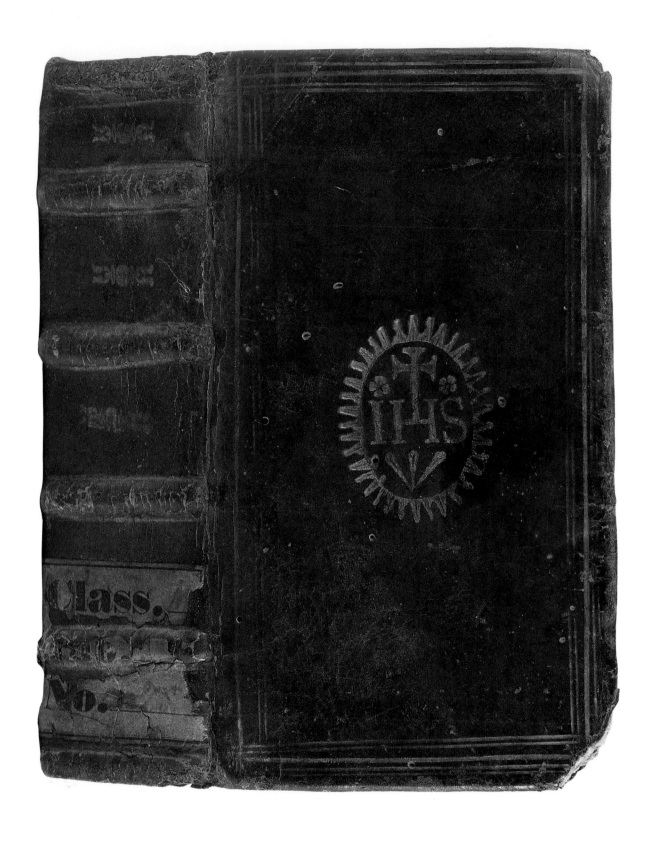

Cat. 13 Jesuit (?)Dublin Binding, early 17th century,
Enchiridion seu manuale quotidianorum exercitiorum spiritualium, upper cover

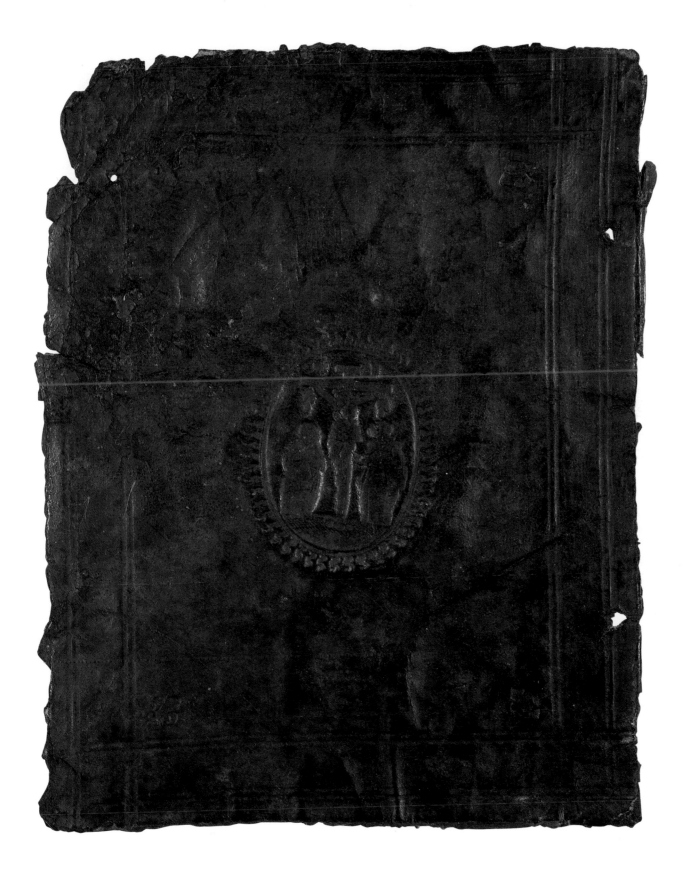

Cat. 14 Jesuit Kilkenny Binding, 1649, upper cover

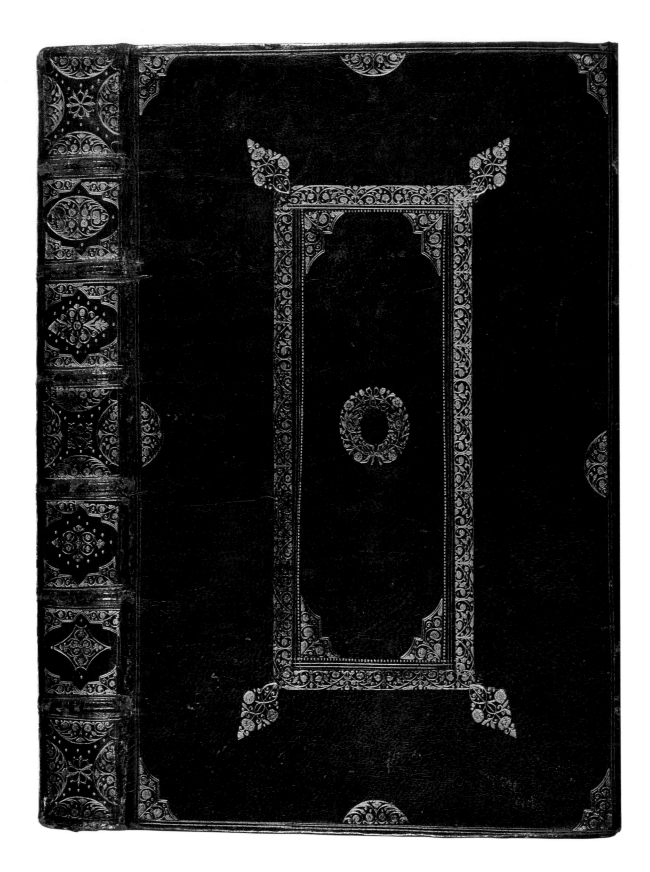

Cat. 15 Bound by the Devotional Binder, *ca.* 1675,
The Genealogy and descent of the Most Illustrious Prince his Grace James Duke of Ormonde, upper cover

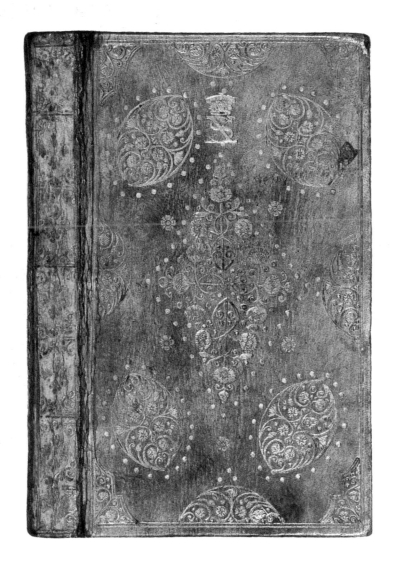

Cat. 16 Bound by the Devotional Binder, *ca.* 1675, *Meditationes*, upper cover

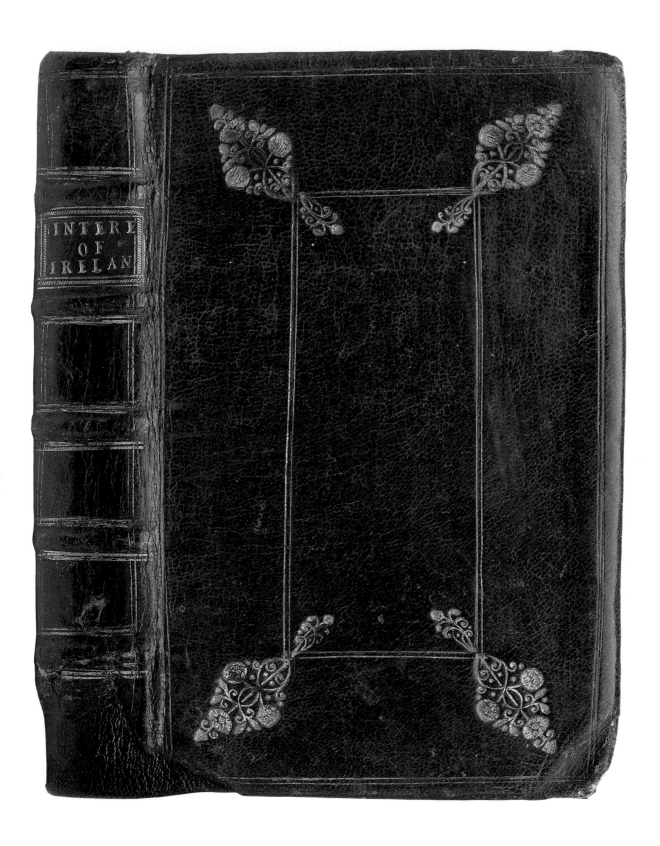

Cat. 17 Bound by the Devotional Binder, *ca.* 1682,
The Interest of Ireland in its Trade and Wealth Stated, upper cover and fore-edge

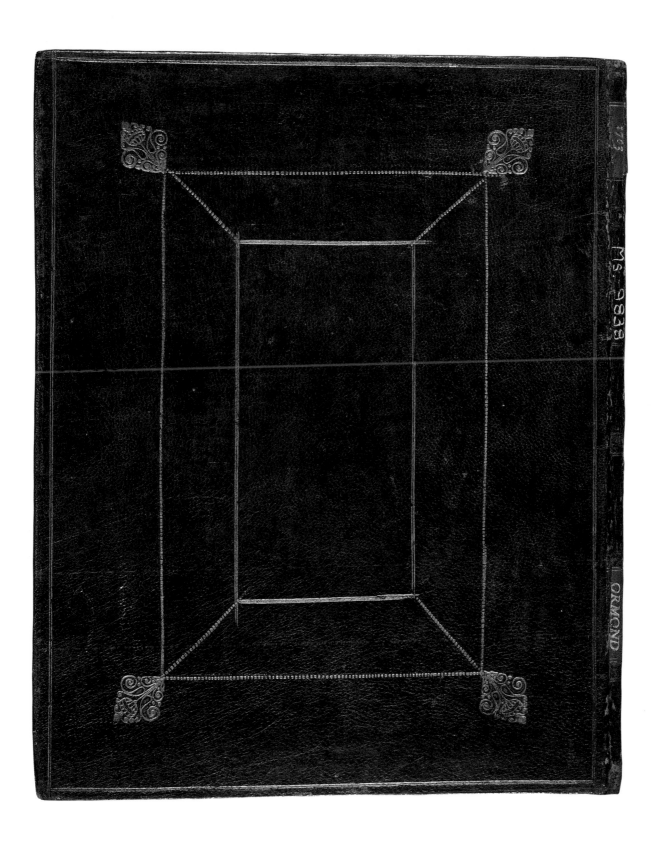

Cat. 18 Bound by David Servant, *ca.* 1703, *Carmen Triumphate*, lower cover

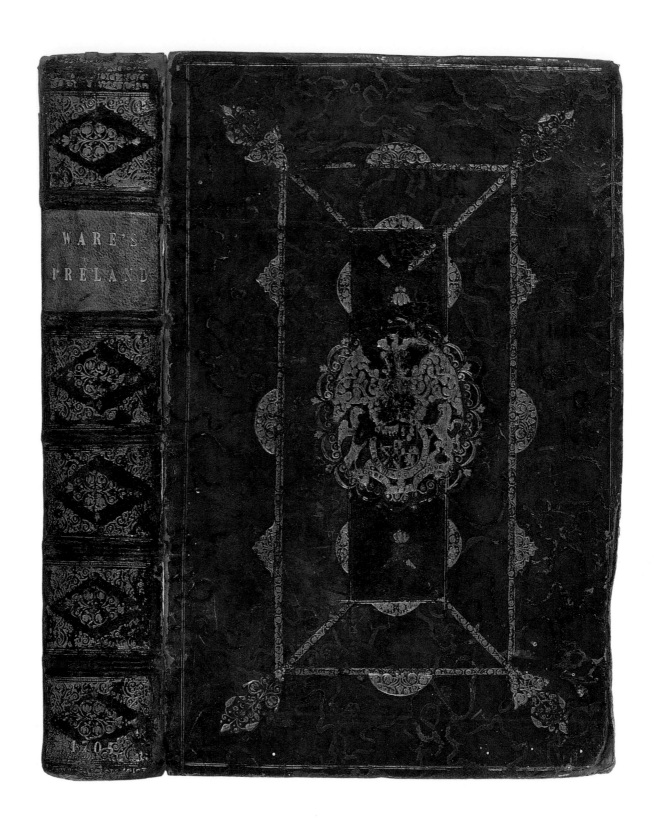

Cat. 19 Bound by the First Parliamentary Binder, *ca.* 1705,
The Antiquities and History of Ireland, upper cover

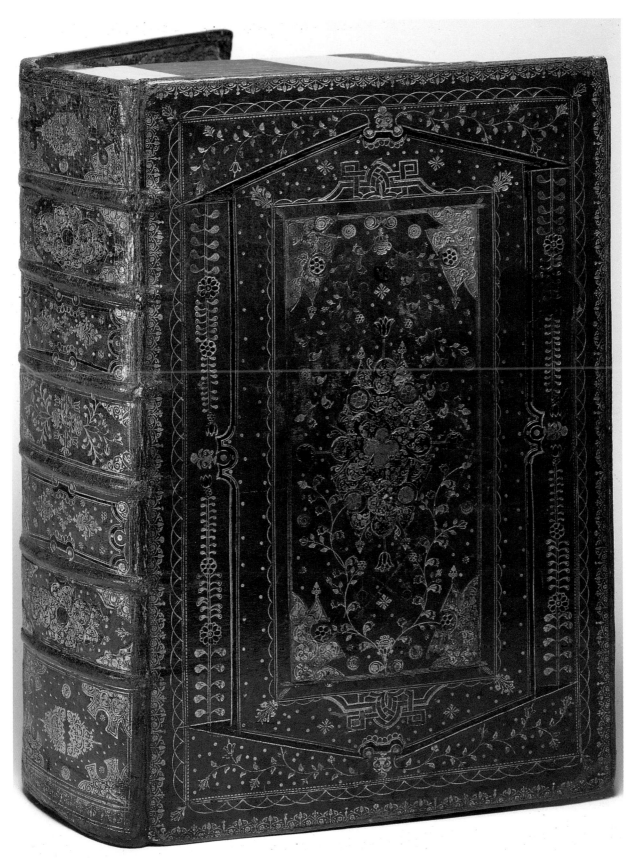

Cat. 20 Bound by the Second Parliamentary Binder, 1714,
The Holy Bible and *The Book of Common Prayer*, upper cover

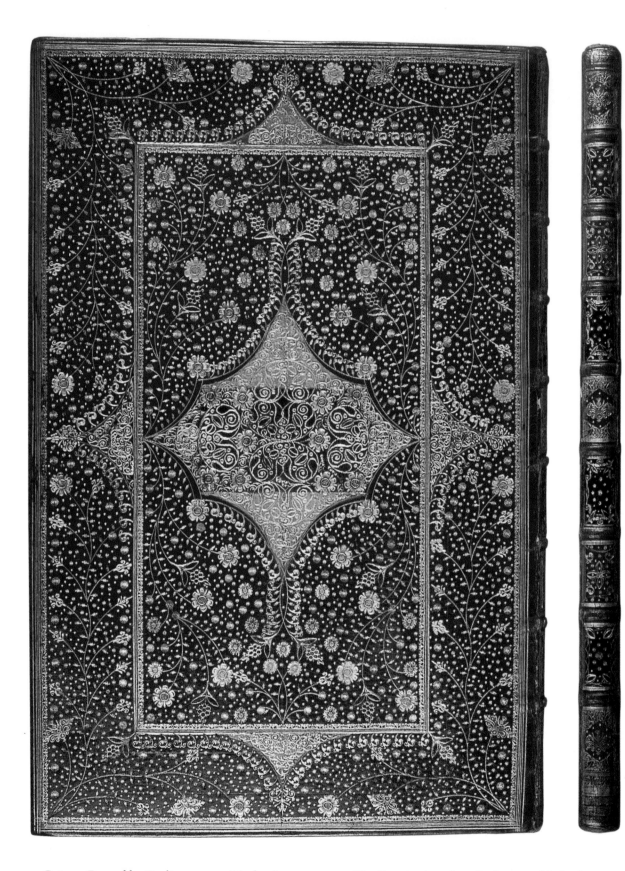

Cat. 21 Bound by Parliamentary Binder A, *ca. 1725–30, The Constitution of ye. Exchequer of Ireland 1693*, lower cover and spine

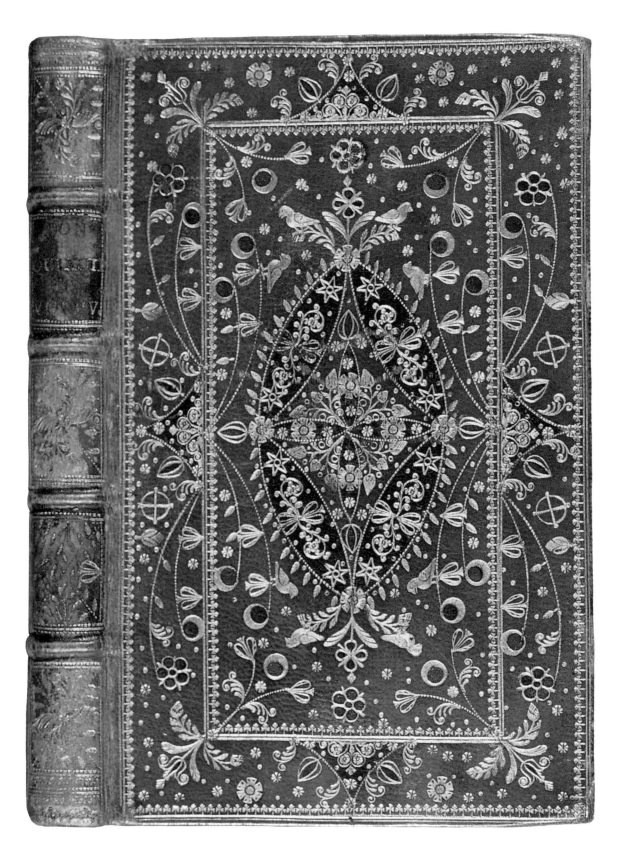

Cat. 22 Bound by Parliamentary Binder A, *ca.* 1733, Cervantes, *Don Quixote*, upper cover
(larger than actual size)

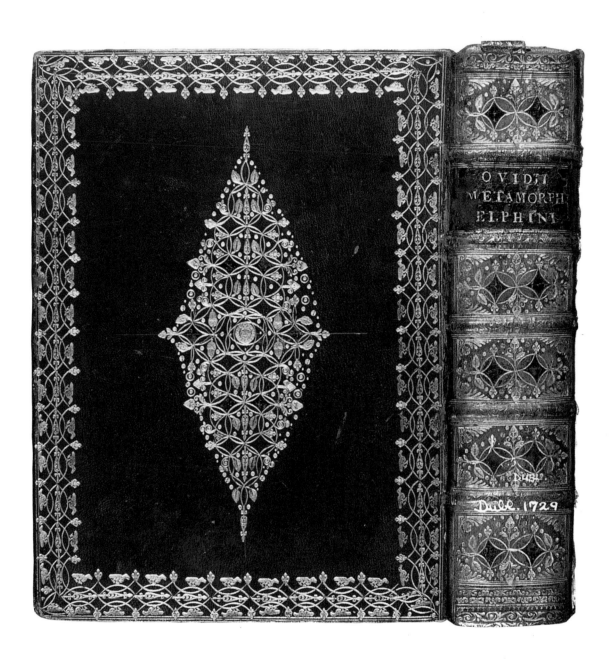

Cat. 23 Bound by the Worth Binder, *ca.* 1729,
P. Ovidius Naso, *Metamorphoseon … ad usum serenissimi Delphini,* lower cover

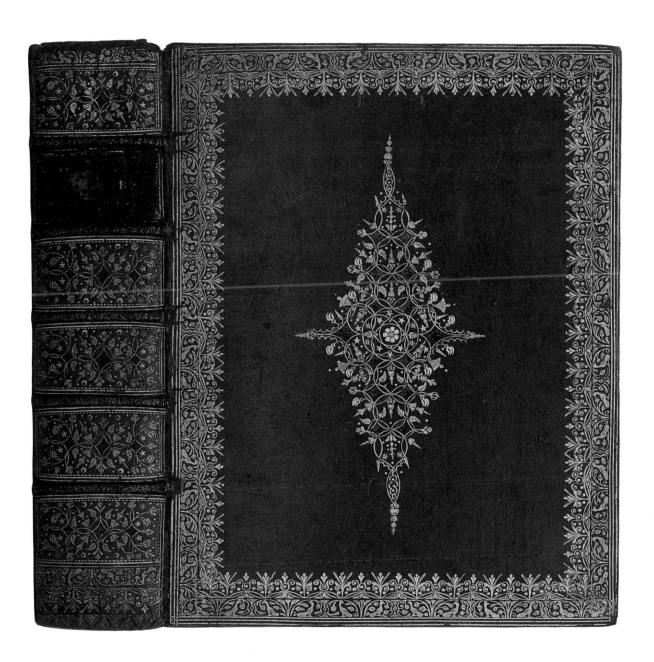

Cat. 24 Bound by Joseph Leathley's Binder, 1730s, Ovid, *Metamorphoses*, upper cover

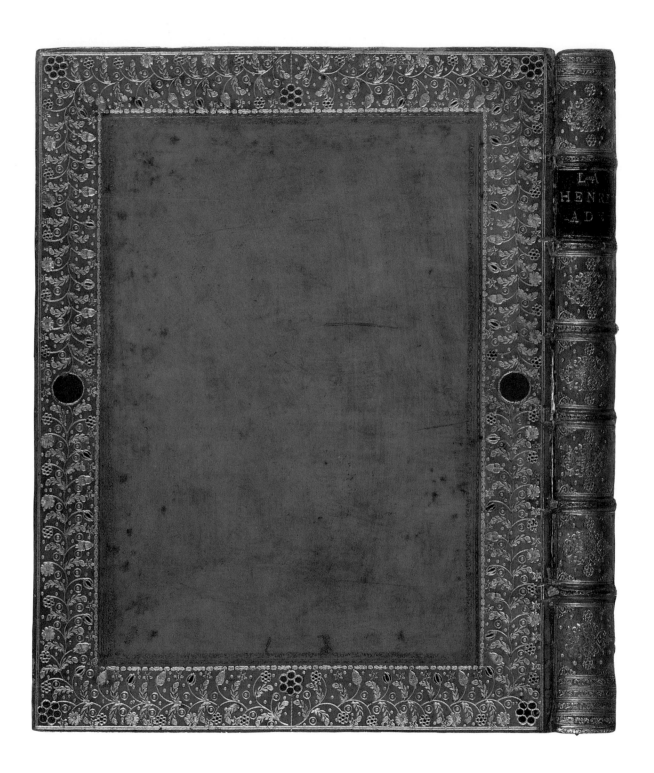

Cat. 25 Bound by the Worth Binder, *ca.* 1728, *La Henriade*, lower cover

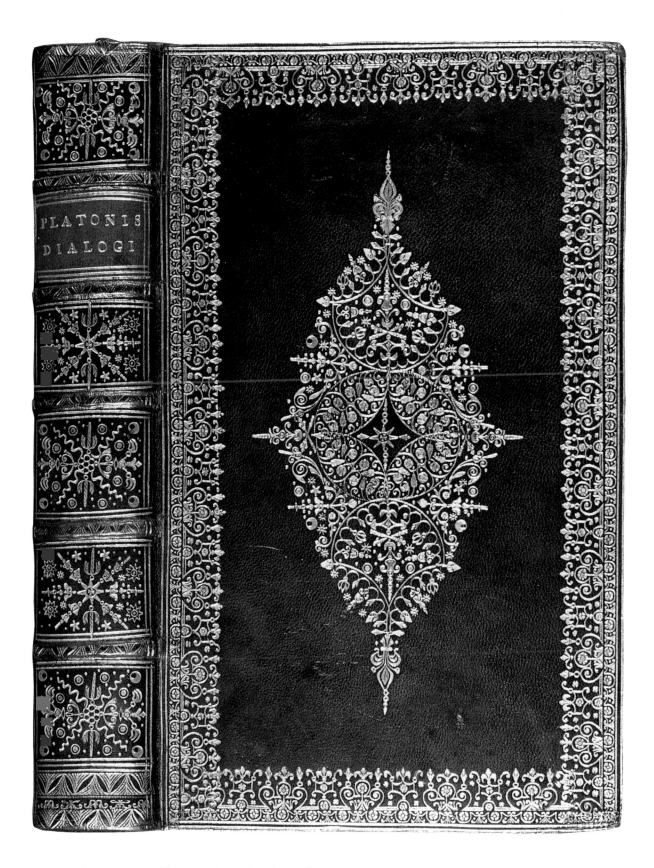

Cat. 26 Bound by Joseph Leathley's Binder, 1738, *The Seven Select Dialogues*, upper cover

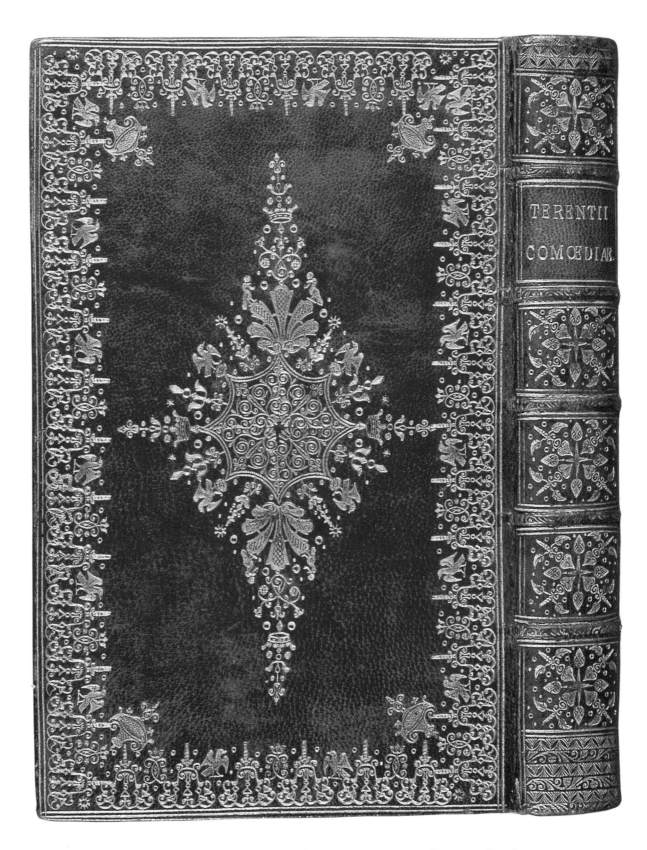

Cat. 27 Bound by Joseph Leathley's Binder, 1745, P. Terentius Afer, *Comoediae*, lower cover

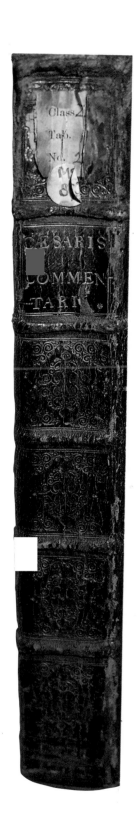
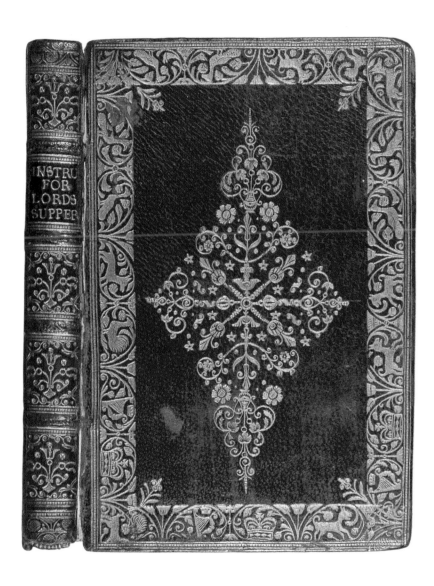

Cat. 28 Bound by the Watson Binder, 1730, *C. Julii Caesaris Commentaria*, spine

Cat. 29 Bound by the Exshaw Bindery, *ca.* 1749, *Instructions for the Lord's Supper*, upper cover

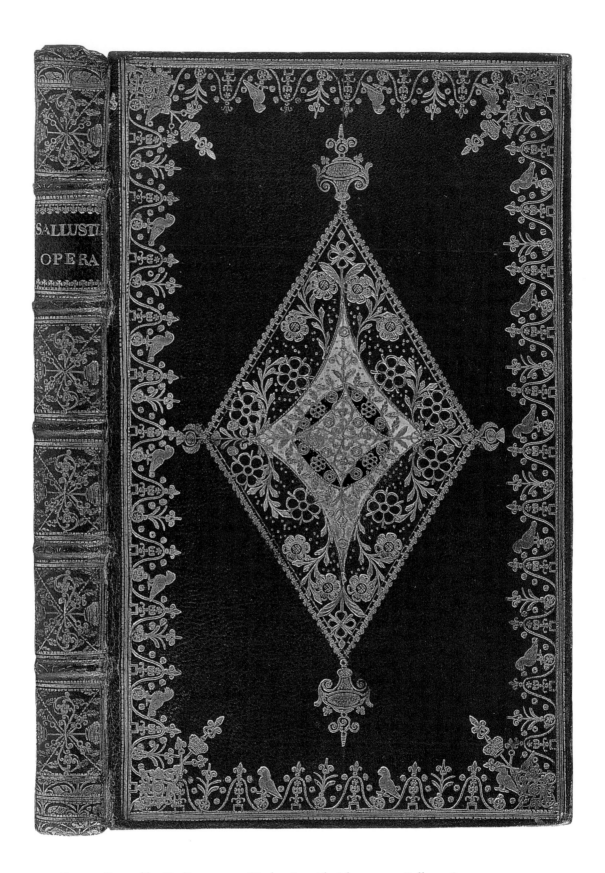

Cat. 30 Bound by Parliamentary Binder A, mid-18th century, Sallust, *Opera*, upper cover

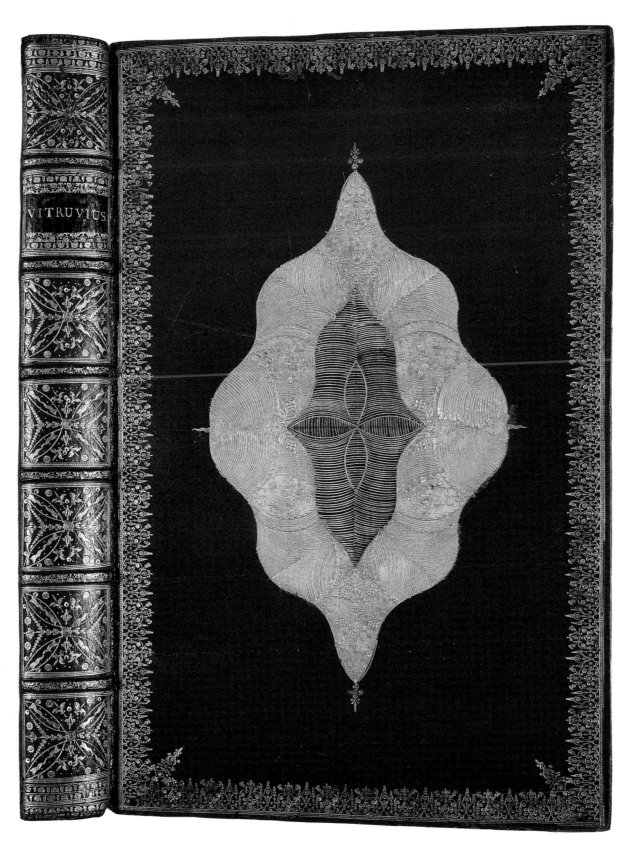

Cat. 31 Bound by Edward Beatty (Parliamentary Binder B), *ca.* 1755, Vitruvius, upper cover

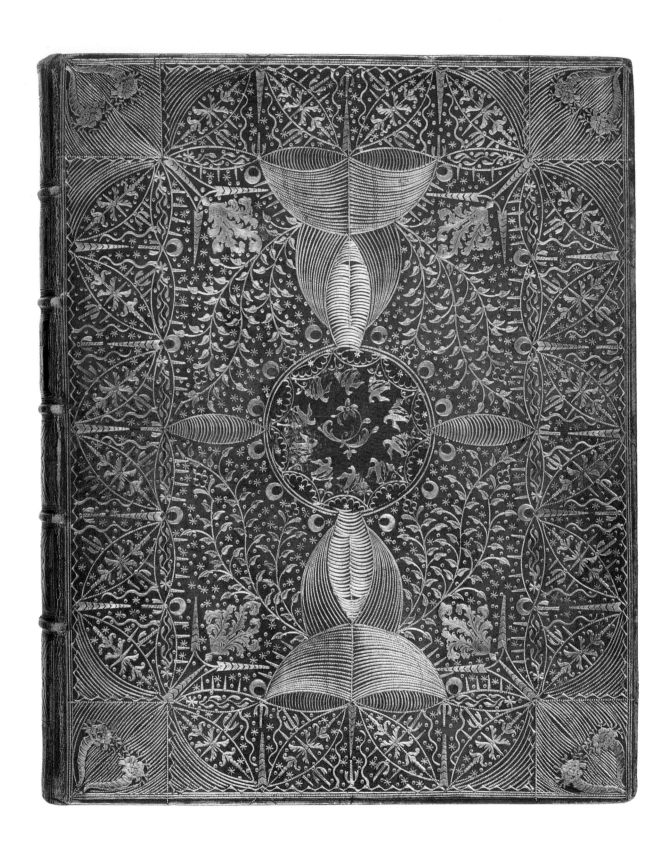

Cat. 32 Bound by Edward Beatty (Parliamentary Binder B), *ca.* 1756,
All the Orations of Demosthenes, upper cover

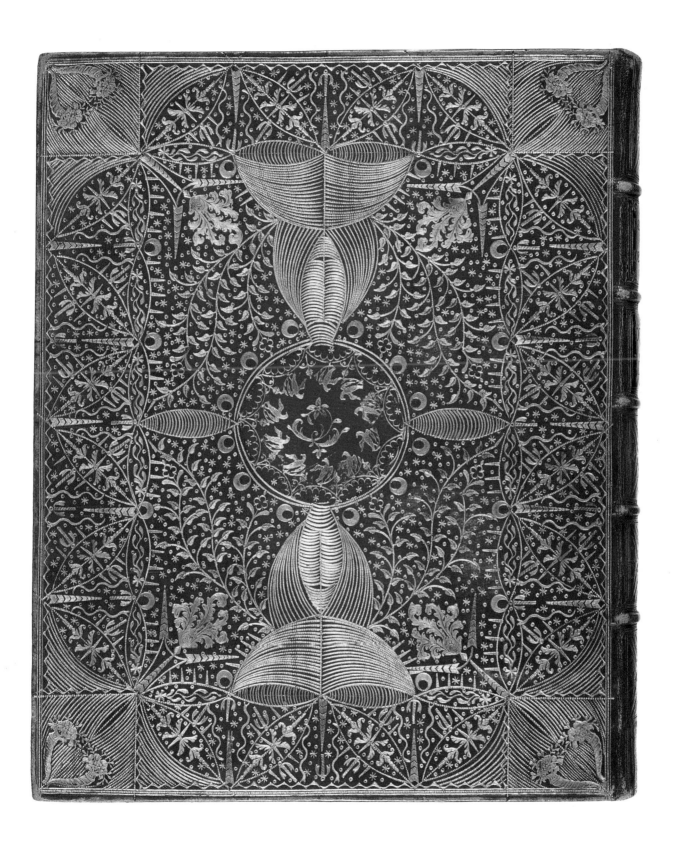

Cat. 32 Bound by Edward Beatty (Parliamentary Binder B), *ca.* 1756,
All the Orations of Demosthenes, lower cover

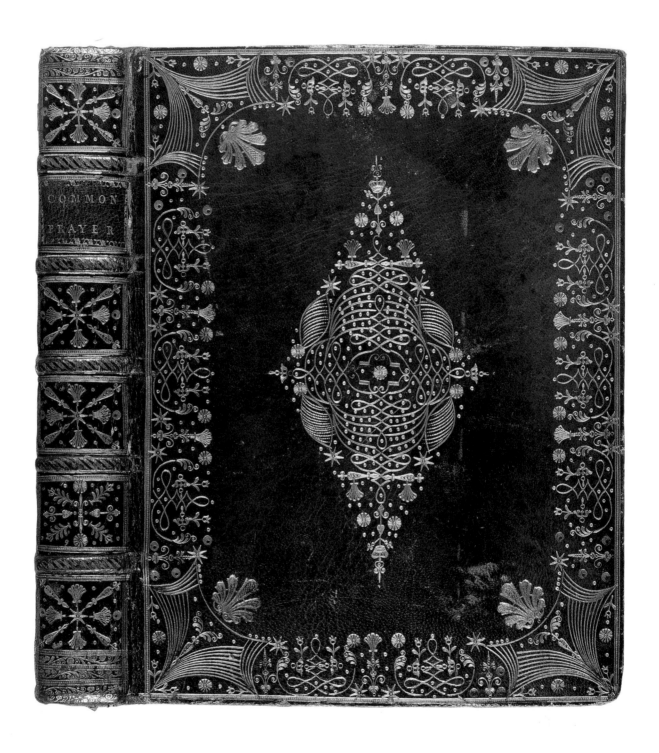

Cat. 33 Bound by George Faulkner's Binder (formerly known as the Rawdon Binder), mid-18th century,
The Book of Common Prayer, upper cover

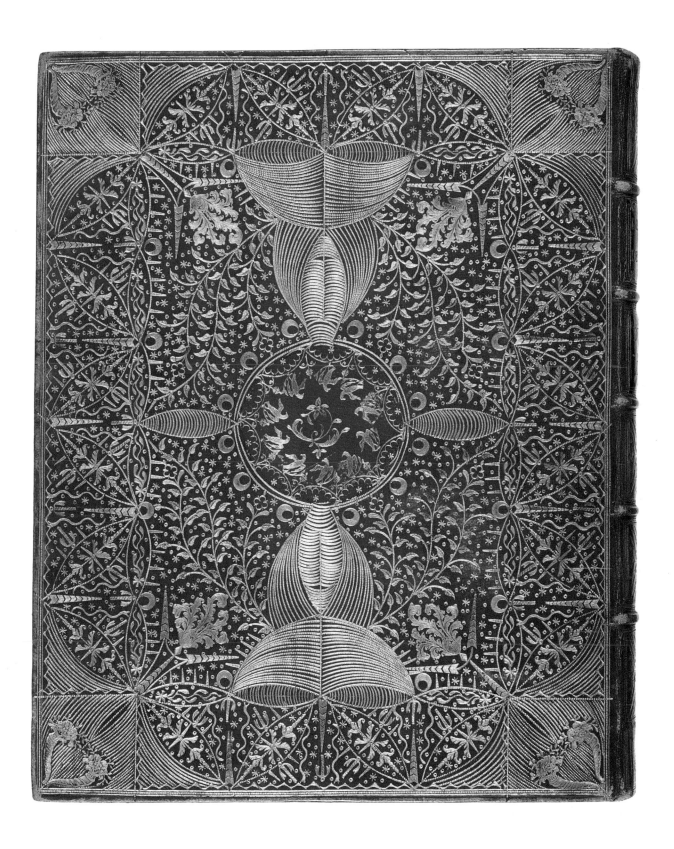

Cat. 32 Bound by Edward Beatty (Parliamentary Binder B), *ca.* 1756,
All the Orations of Demosthenes, lower cover

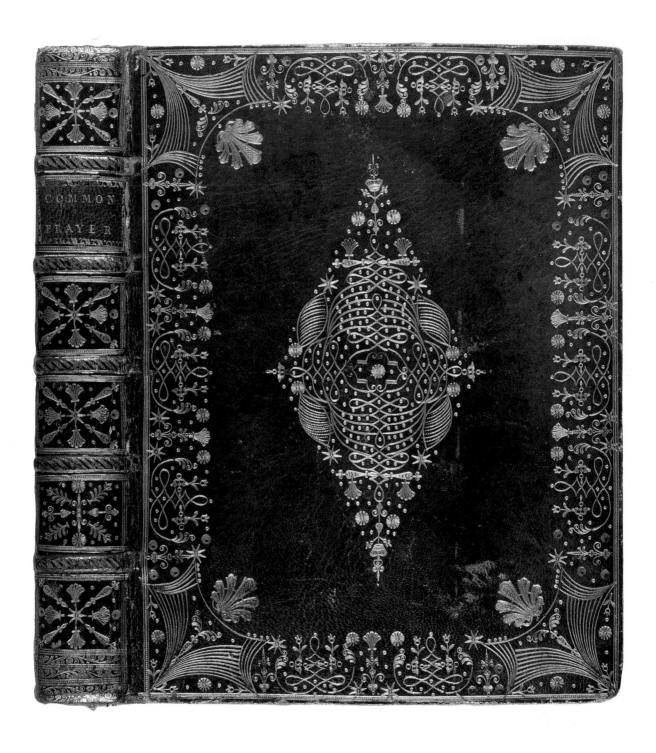

Cat. 33 Bound by George Faulkner's Binder (formerly known as the Rawdon Binder), mid-18th century,
The Book of Common Prayer, upper cover

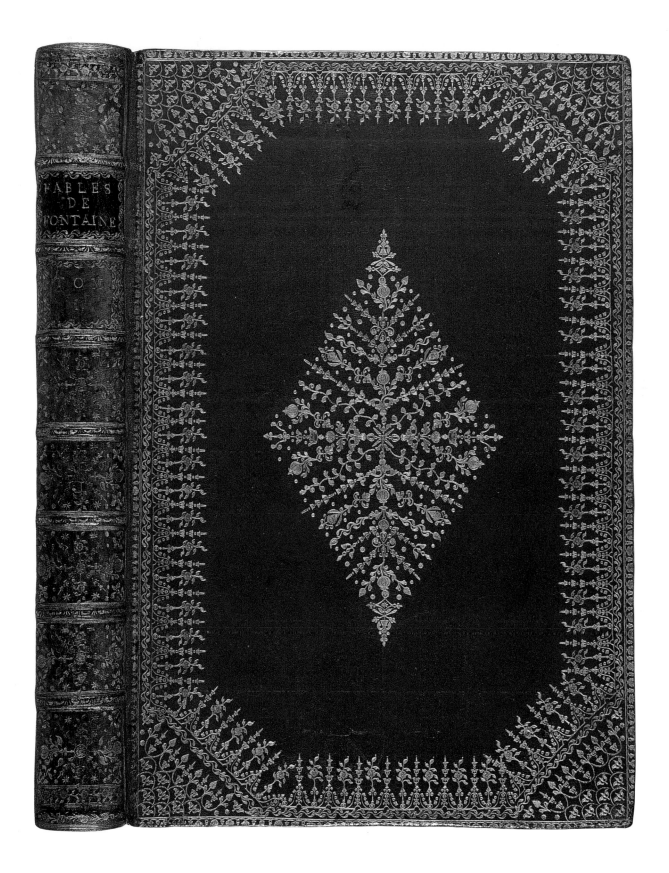

Cat. 34 Bound by the Coote Binder, 1760s, *Fables Choisies mises en vers par J. de la fontaine*, upper cover

Cat. 35 Bound by Boulter Grierson's Binder, 1765,
The Statutes at large passed in the Parliaments held in Ireland: from 1310 … to 1761, upper cover

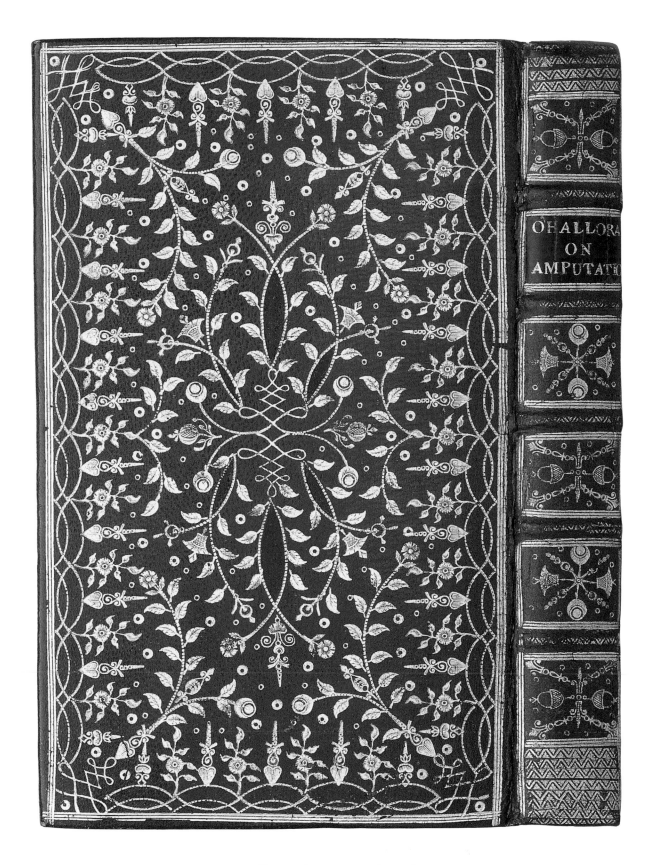

Cat. 36 Bound by Boulter Grierson's Binder, *ca.* 1765,
A Complete Treatise on Gangrene and Sphacelus; with a new method of Amputation, lower cover

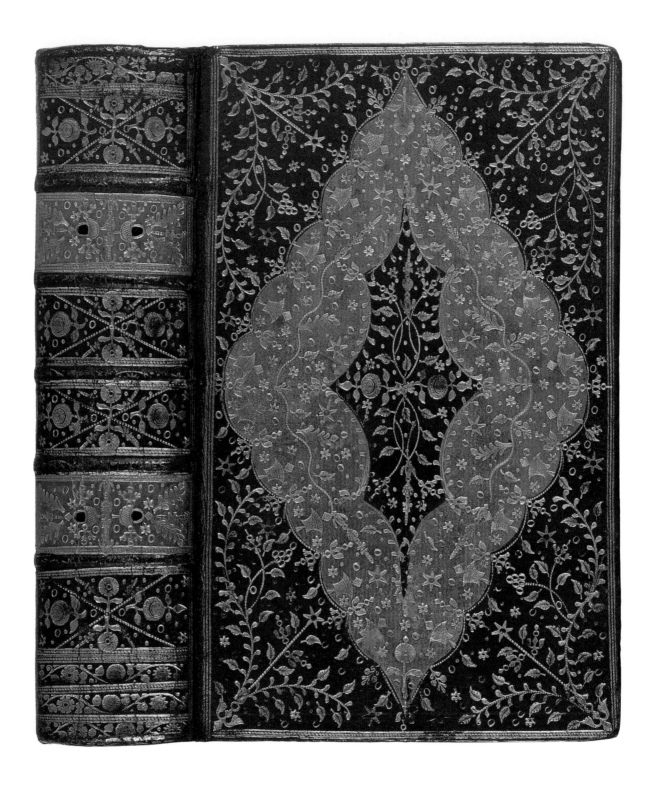

Cat. 37 Bound by the Bible and Prayer Book Binder, mid-18th century, *The Book of Common Prayer*,
upper cover

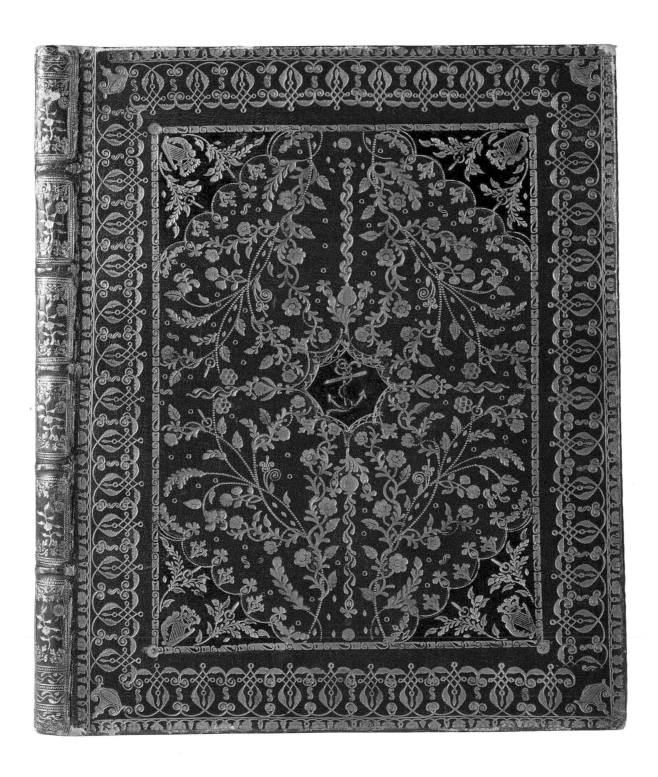

Cat. 38 Bound by Josiah Sheppard, *ca.* 1770,
A Sermon preached on the opening of Chapel of the Magdalen Asylum for Female Penitents, upper cover

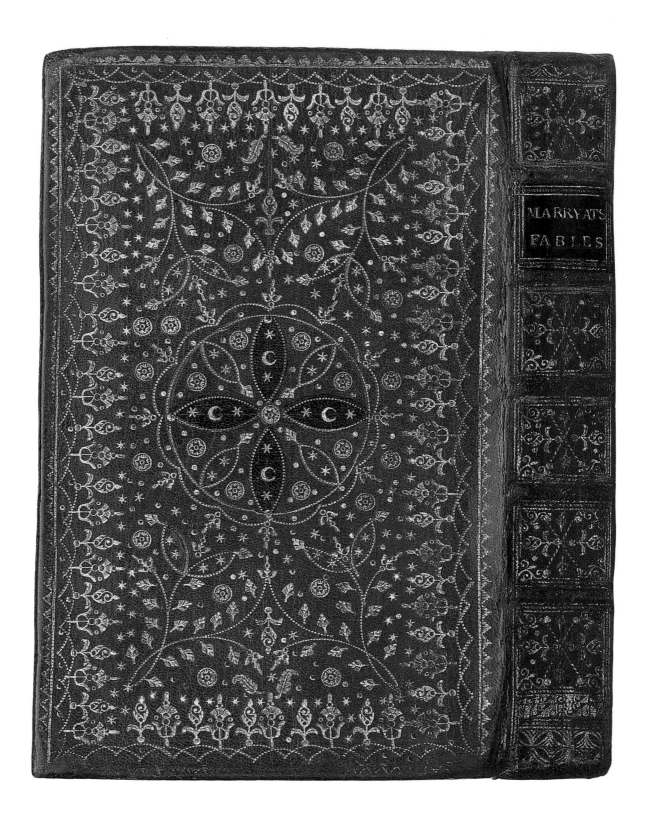

Cat. 39 (?)Belfast Binding, *ca.* 1771, *Sentimental Fables, design'd chiefly for the use of Ladies,* lower cover

Cat. 40 Bound by the Whitestone Bindery, *ca.* 1779, *The Syntax of the French Tongue*, upper cover

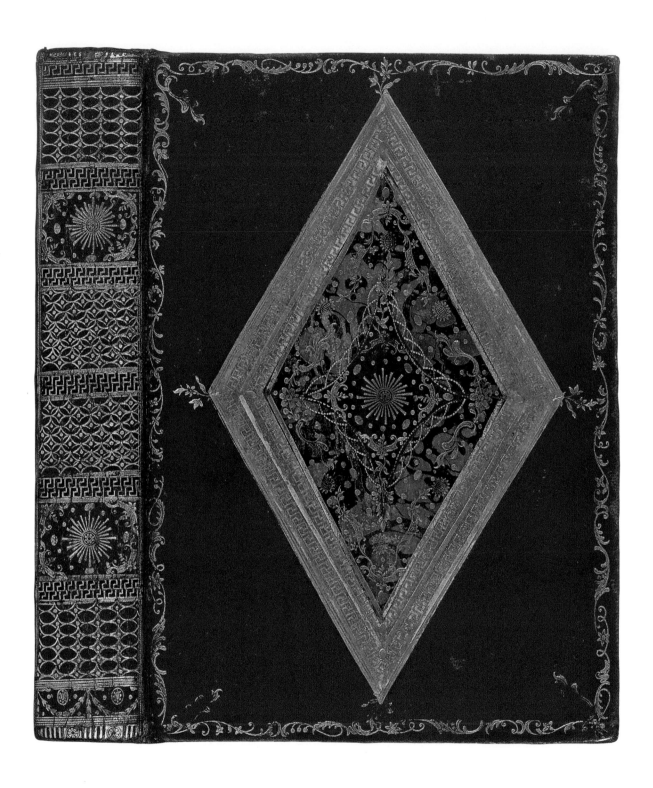

Cat. 41 Bound by the William Wilson Bindery, *ca.* 1779, *Historische Bilder Bibel*, upper cover

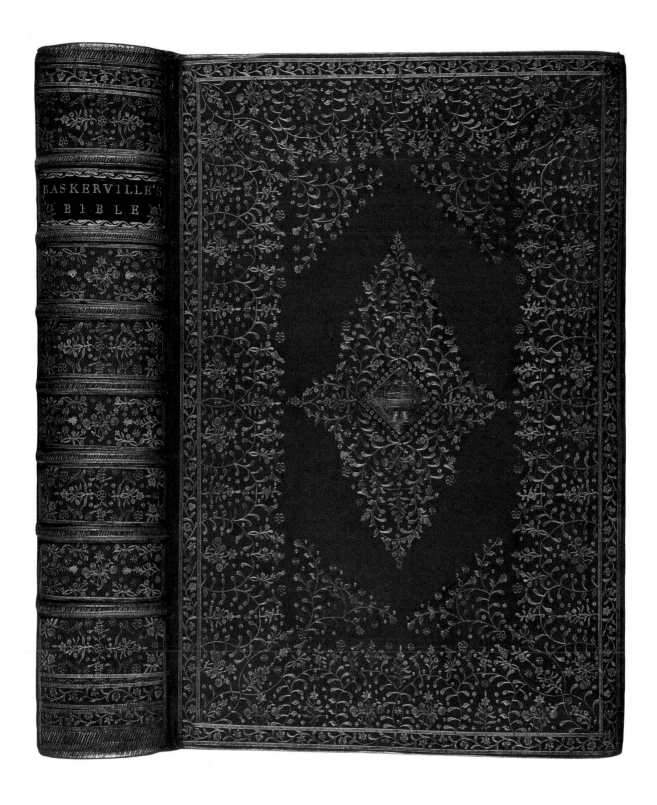

Cat. 42 Bound by the Hallhead Bindery, *ca.* 1775, *The Bible*, upper cover

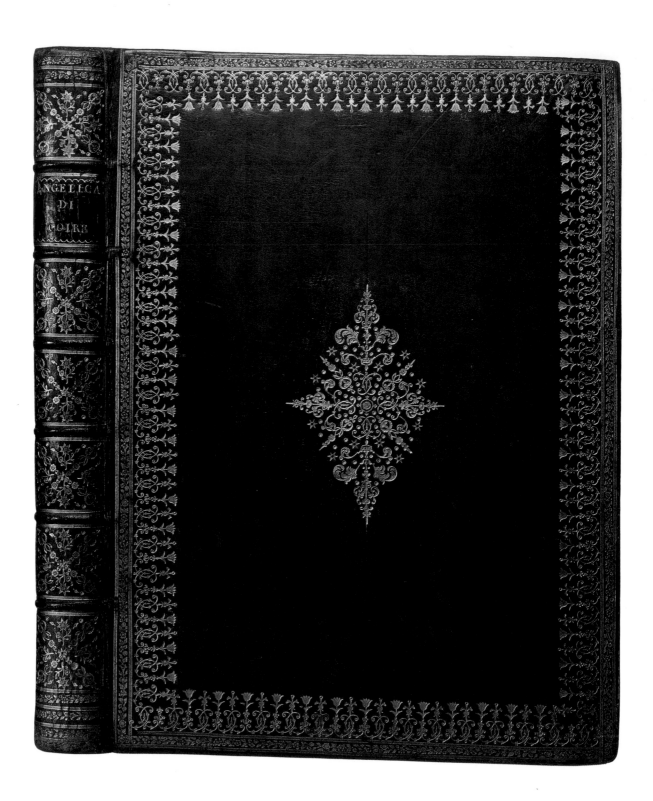

Cat. 43 An Album of Prints by Angelica Kauffman, 1771, upper cover

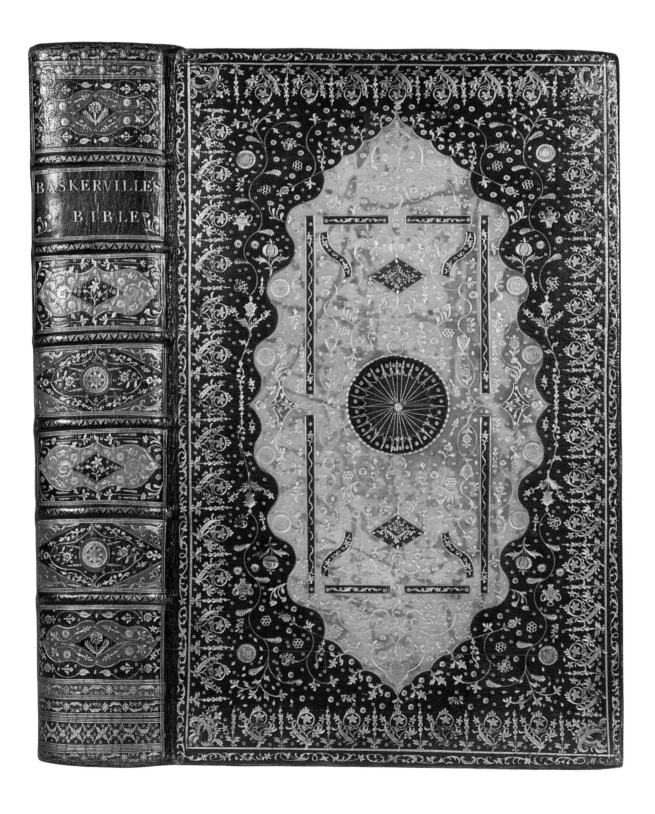

Cat. 44 Bound by the Hillingdon Binder, *ca.* 1785, *The Bible*, upper cover

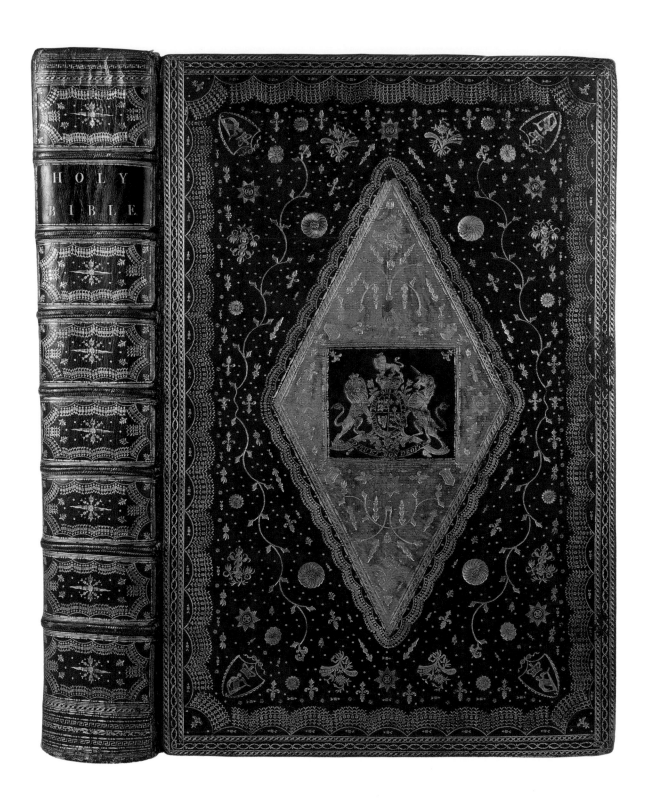

Cat. 45 Bound by the Abraham Bradley King Bindery, 1790s, *The Bible*, upper cover

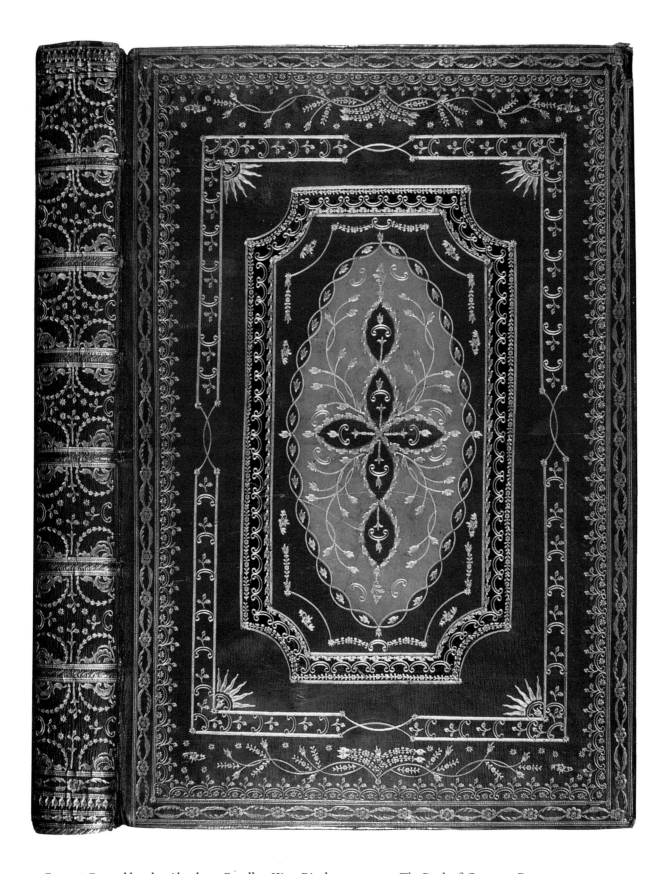

Cat. 46 Bound by the Abraham Bradley King Bindery, *ca.* 1794, *The Book of Common Prayer*, upper cover

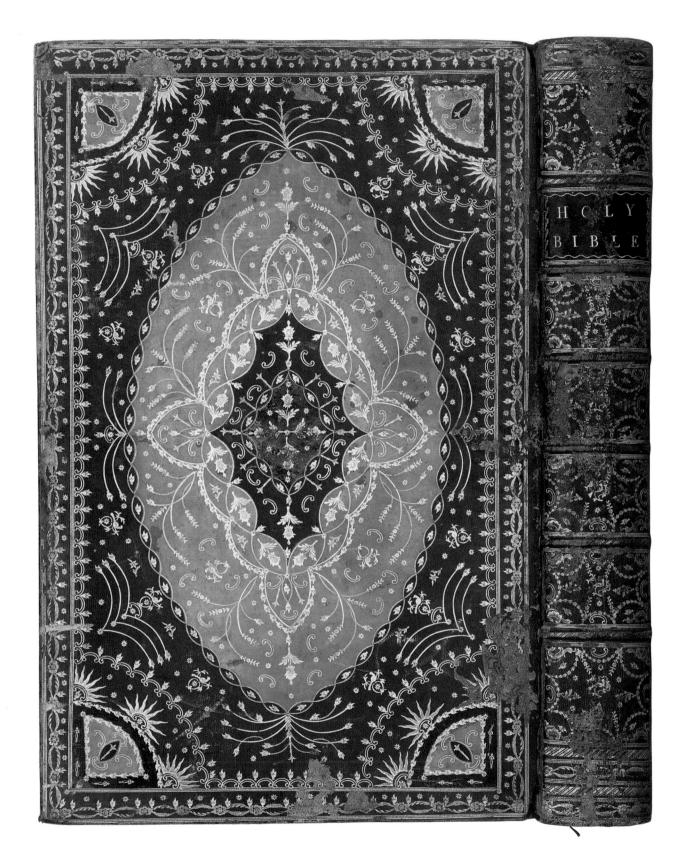

Cat. 47(a) Bound by the Abraham Bradley King Bindery, *ca.* 1794, *The Bible*, lower cover

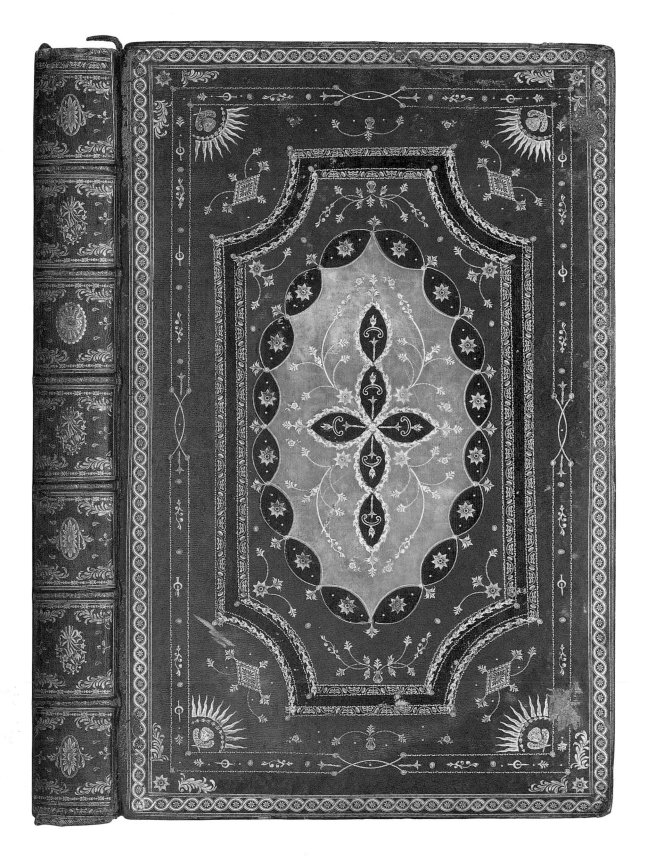

Cat. 47(b) Bound by the Abraham Bradley King Bindery, *ca.* 1794, *The Book of Common Prayer*,
upper cover

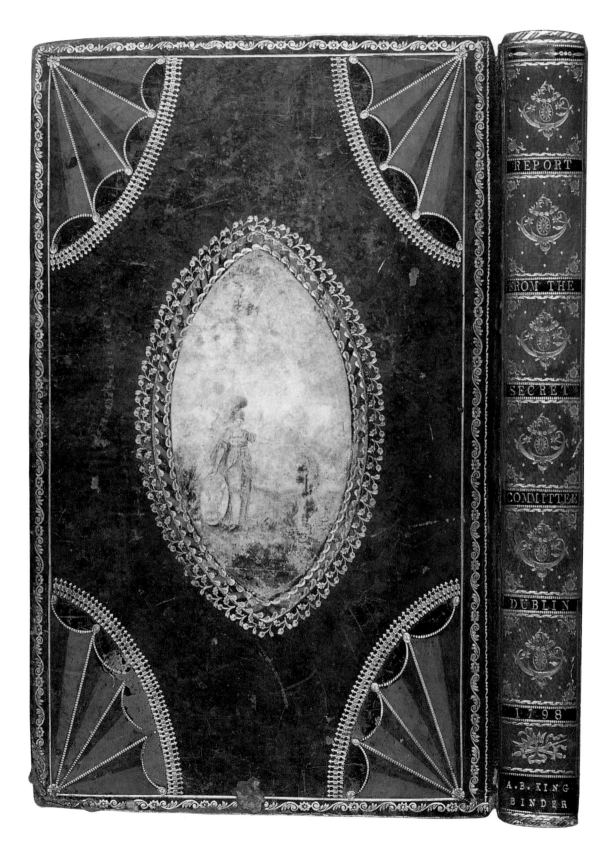

Cat. 48 Bound by the Abraham Bradley King Bindery, 1798,
Report from the Committee of Secrecy of the House of Commons, lower cover

Cat. 49 Bound by the Patrick Wogan Bindery, *ca.* 1793, *Officium Defunctorum*, upper cover

Cat. 50 Bound by I.W. Draper, late 18th century, *Anthologia Hibernica*, lower cover

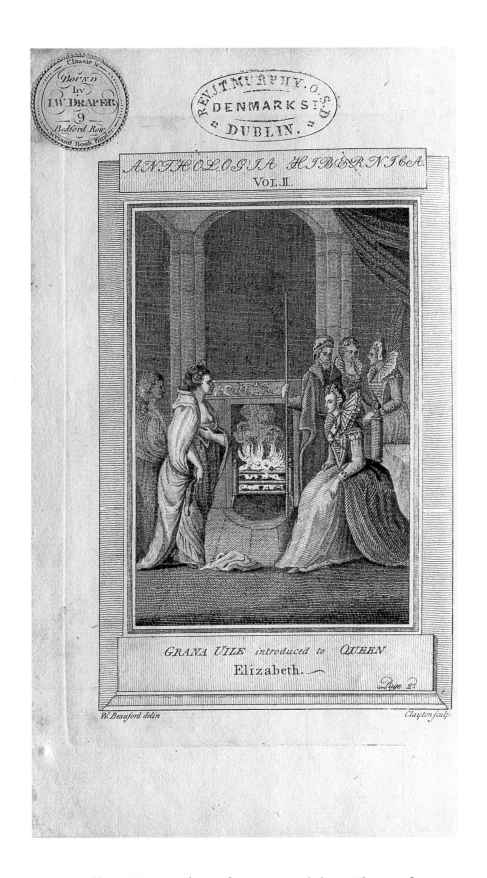

ANTHOLOGIA HIBERNICA.
VOL.II.

GRANA UILE *introduced to* QUEEN
Elizabeth.

Page 2.

W. Beauford delin

Clayton sculp.

Cat. 50 Bound by I.W. Draper, late 18th century, *Anthologia Hibernica*, frontispiece

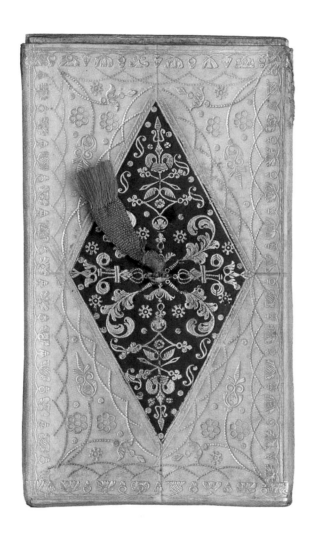

Cat. 51 Dublin Vellum Binding, *ca.* 1764, *Watson's Compleat memorandum Book of the Year 1764*, upper cover

Cat. 52 *Watson's Compleat memorandum Book of the Year 1765*, Rococo borders

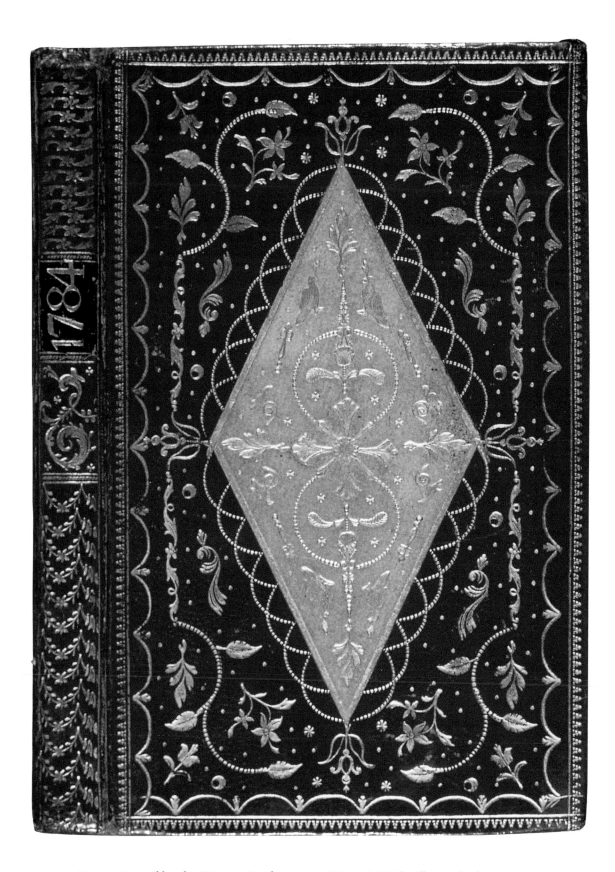

Cat. 53 Bound by the Watson Bindery, 1784, *Watson's Triple Almanack*, upper cover

THE

HISTORY

AND

ADVENTURES

OF THE RENOWNED

DON QUIXOTE.

TRANSLATED FROM THE SPANISH OF

MIGUEL DE CERVANTES SAAVEDRA.

TO WHICH IS PREFIXED,

SOME ACCOUNT OF THE AUTHOR'S LIFE.

BY *T. SMOLLETT*, M.D.

ORNAMENTED WITH ENGRAVINGS,

BY THE FIRST MASTERS,

FROM THE DESIGNS OF THE MADRID ROYAL ACADEMY, &c.

IN FOUR VOLUMES.

VOL. I.

DUBLIN:

JOHN CHAMBERS.

1796.

TO THE

PROVOST,

FELLOWS AND SCHOLARS

OF

Trinity College, Dublin,

THIS EDITION OF

DON QUIXOTE

IS

RESPECTFULLY DEDICATED,

AS

AN ENDEAVOUR TO IMPROVE

THE ART OF PRINTING IN IRELAND,

BY

JOHN CHAMBERS.

Cat. 54 The First Book printed by Hot Pressing in Dublin, 1796,
Cervantes, *The History and Adventures of the Renowned Don Quixote*, titlepage and dedication

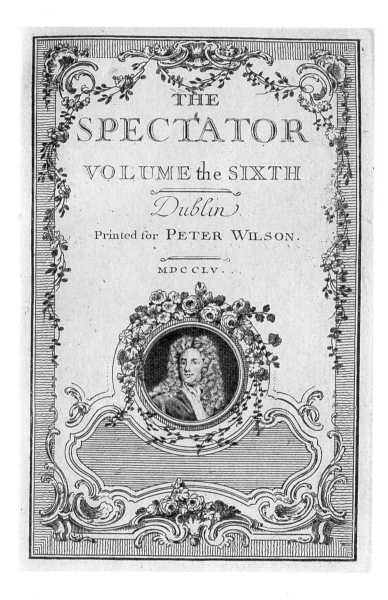

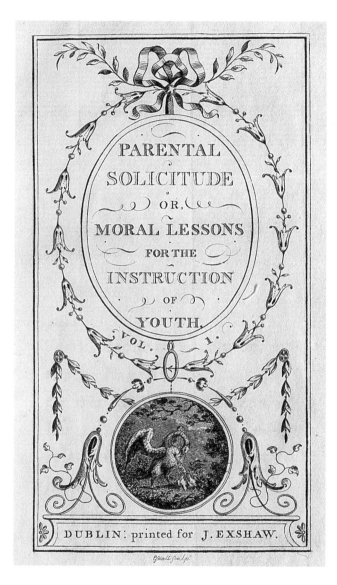

Cat. 55(a) A Rococo Titlepage, 1755, *The Spectator*

Cat. 55(b) A Neoclassical Titlepage, Etched and Engraved by William Esdall, *ca. 1780*, *Parental Solicitude*

Don Quixote attended by the Dutchess's Women P. Simms Sculp.^t

Cat. 55(c) Copying French Engravings, *ca. 1733, Don Quixote attended by the Dutchess's Women*

THE

POETICAL WORKS

OF

WILLIAM PRESTON, ESQ.

IN TWO VOLUMES.

VOL. I.

——— Fuge, quo difcedere geftis:
Non erit emiſſo reditus tibi. Quid mifer egi?
Quid volui? dices, ubi quis te læferit :———

HORACE.

DUBLIN:

PRINTED FOR THE AUTHOR,

BY GRAISBERRY & CAMPBELL, & SOLD BY J. ARCHER,

DAME-STREET.

1793.

Cat. 55(d) An Etching by William Esdall, 1793, *W. Preston's Works*

Cat. 55(e) Embossed endpaper, *ca.* 1733, Cervantes, *Don Quixote*

HIBERNIA DOMINICANA.

SIVE

HISTORIA PROVINCIÆ HIBERNIÆ

ORDINIS PRÆDICATORUM,

Ex antiquis Manuscriptis, probatis Auctoribus, Literis Originalibus nunquam antehac impressis, Instrumentis authenticis, & Archivis, alijsque invictæ Fidei Monumentis deprompta.

IN QUA

Nedum omnia, quæ ad memoratam attinent Provinciam, & Cænobia ejus, tam intra quam extra Regnum *Hiberniæ* constituta (interjectis singulorum Fundatorum Genealogijs) atque Alumnos ipsius, seu Dignitate Episcopali, seu Munere Provinciali, seu Librorum Vulgatione, seu Martyrio, publicave Virtutis Opinione claros, succincte distincteque exhibentur.

SED ETIAM PLURA

Regulares generatim sumptos, Clerumque Sæcularem, necnon & Res Civiles *Hiberniæ*, atque etiam *Magnæ Britanniæ* spectantia, sparsim appositeque, adjectis insuper Notis opportunis, inseruntur, & in perspicuo Ordine collocantur.

PER

P. THOMAM DE BURGO, prælibati Ordinis Alumnum, S. Theologiæ Magistrum, & Protonotarium Apostolicum, necnon *Hiberniæ Dominicanæ* Historiographum, postea EPISCOPUM OSSORIENSEM.

KILKENNIÆ:

Ex Typographia JACOBI STOKES juxta Prætorium. Anno MDCCLXII.

Cat. 56 Kilkenny Printing, 1762, *Hibernia Dominicana*, titlepage

Plate XII

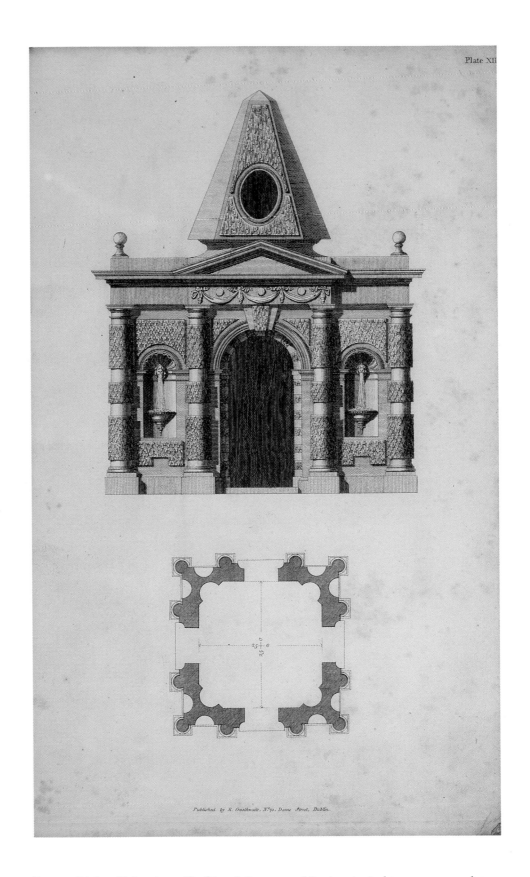

Published by R. Crosthwaite, No 71. Dame Street, Dublin.

Cat. 57 Richard Morrison, *Useful and Ornamental Designs in Architecture*, 1793, plate 12

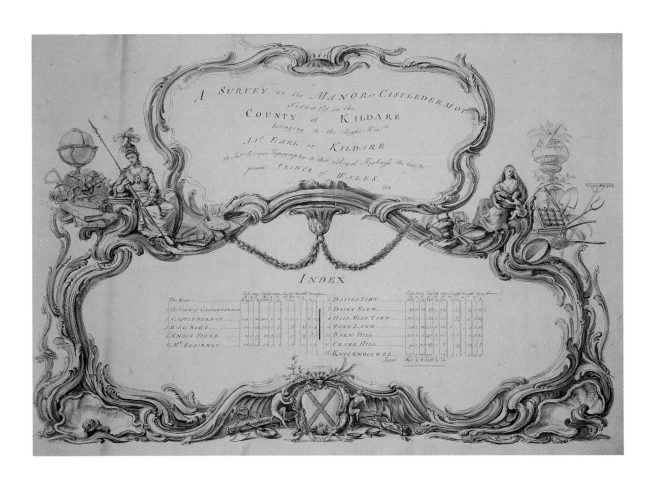

Cat. 58 A Rococo Cartouche Titlepage, 1758, John Rocque, *Survey of the Manor of Castledermot*

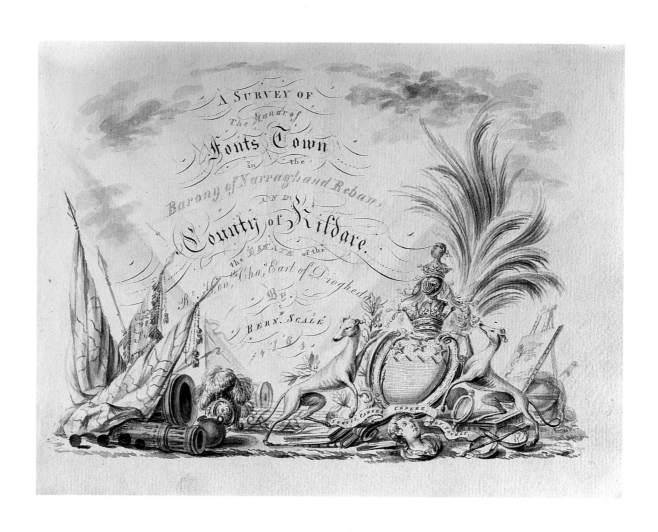

Cat. 59 A Rococo Titlepage, 1764,
Bernard Scalé, *A Survey of the manor of Fonts town in the Barony of Narragh and Reban and County of Kildare*

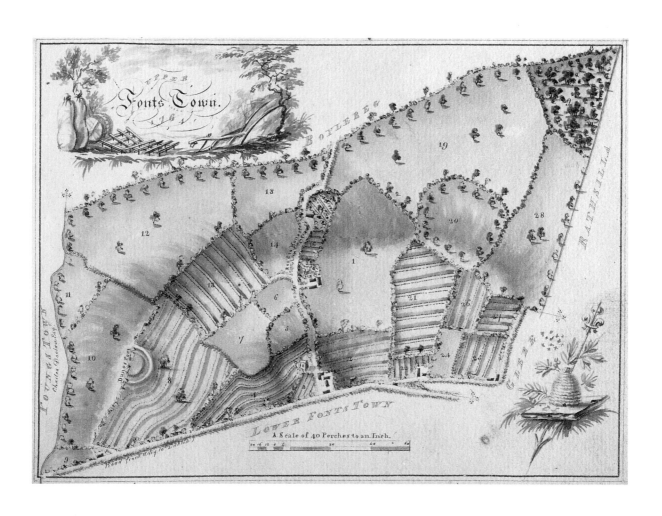

Cat. 59 Bernard Scalé, *A Survey of the manor of Fonts town in the Barony of Narragh and Reban and County of Kildare, 1764, Survey of Upper Font Town*

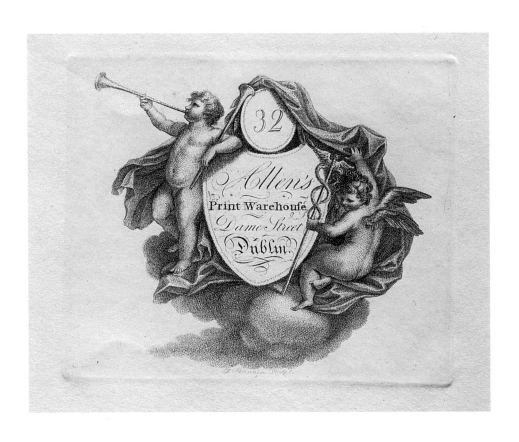

Cat. 60 A Dublin Pattern Book, *ca.* 1800, titlepage

Cat. 61 Manuscript in Irish by John Carpenter, 1744–45, A collection of Gaelic poems, f. 10v

Cat. 62 Bound by E.H. Purcell, Cork, 1800, *A volume of botanical watercolours,* upper cover

Cat. 63 Cathedral Binding, *ca.* 1820,
The History and Antiquities of the Collegiate and Cathedral Church of St Patrick near Dublin, upper cover

Cat. 64 Amateur Binding from Cork, *ca.* 1817, *The Art of Swimming made Safe*, upper cover

Cat. 64 Amateur Binding from Cork, *ca.* 1817, *The Art of Swimming made Safe*, lower cover

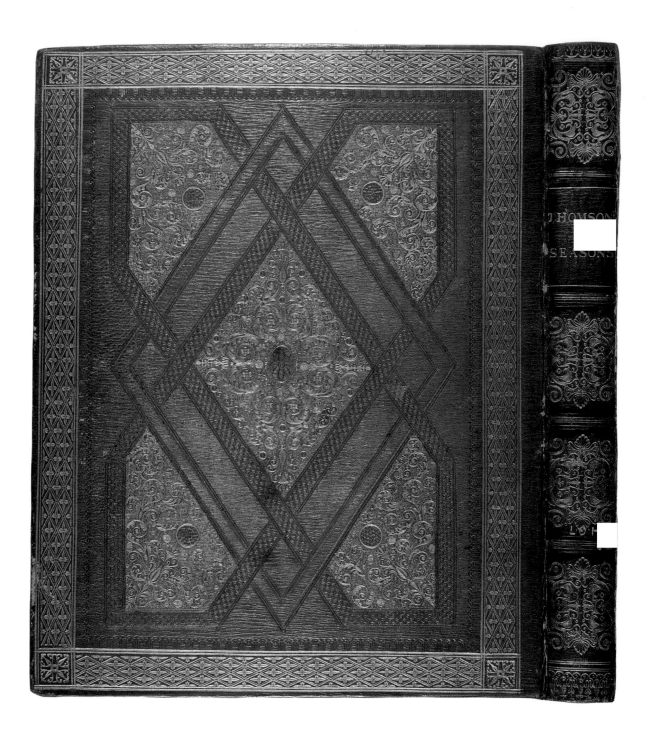

Cat. 65 Bound by George Mullen, *ca.* 1807, Thomson, *The Seasons*, lower cover

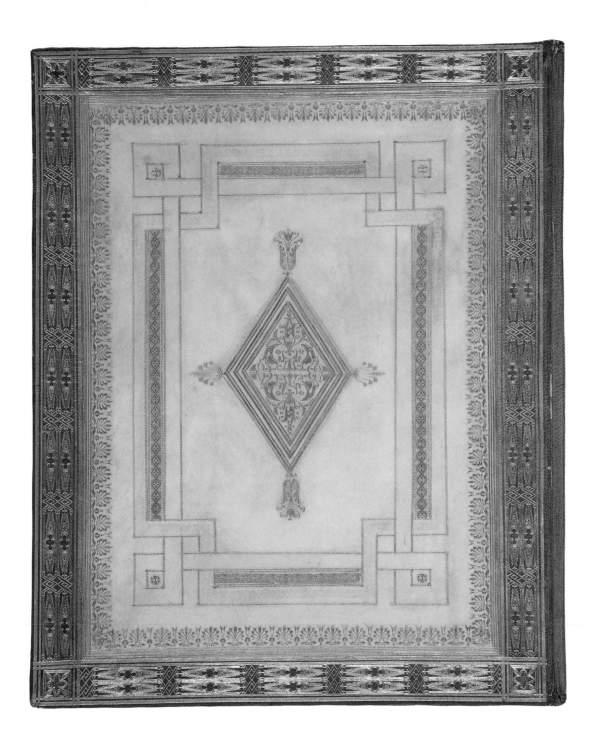

Cat. 65 Bound by George Mullen, *ca.* 1807, Thomson, *The Seasons, doublure*

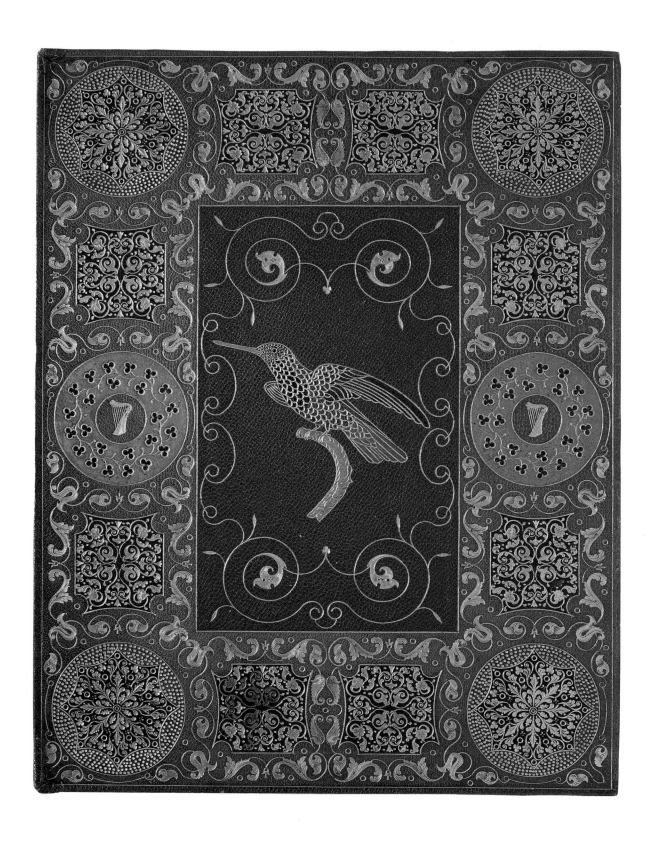

Cat. 66 Bound by George Mullen Junior, late 1830s or early 1840s,
Illustrations of the Scenery of Killarney, doublure

Cat. 66 Bound by George Mullen Junior, late 1830s or early 1840s,
Illustrations of the Scenery of Killarney, facing leaf

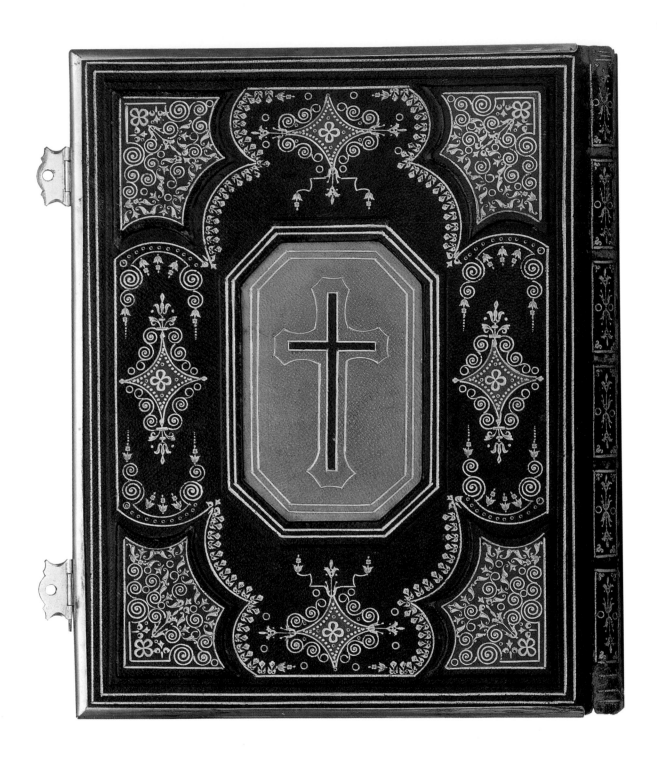

Cat. 67 Bound by Gerald Bellew, mid-19th century, *Stabat Mater*, lower cover

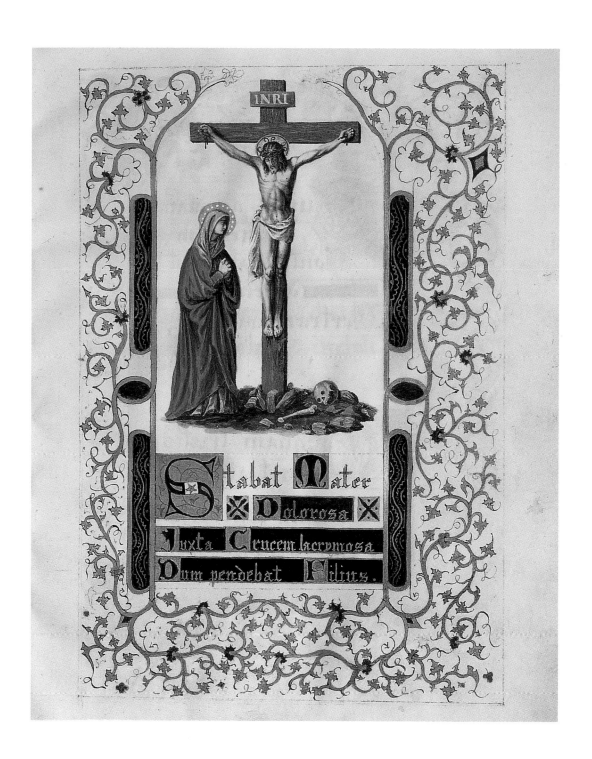

Cat. 67 Bound by Gerald Bellew, mid-19th century, *Stabat Mater*, f. 3r, *Stabat Mater dolorosa*

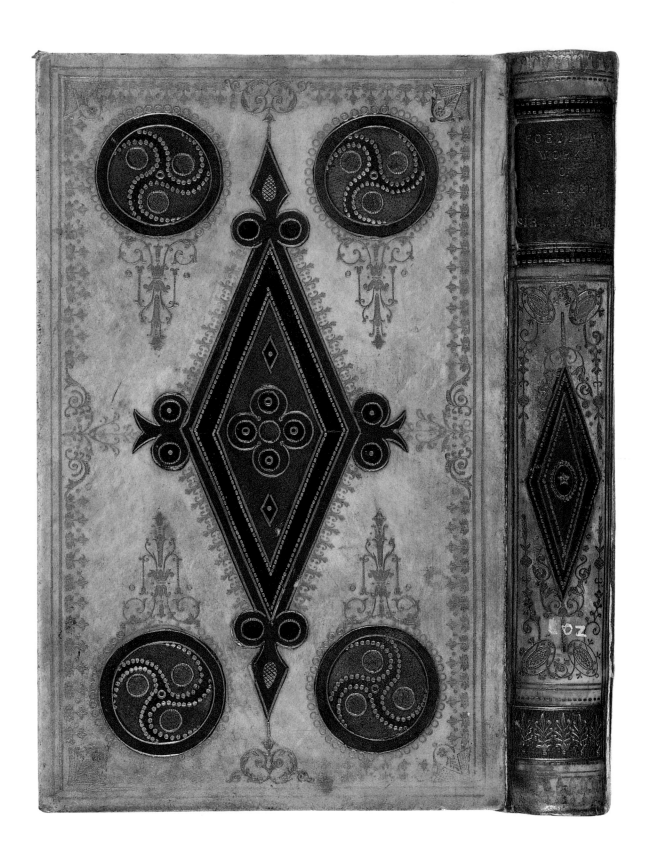

Cat. 68 Bound by Galwey, *ca.* 1857, *Poetical Works of Edmund Waller and Sir John Denham,* lower cover

tomriuſ moiu muipt tpen to-

Ad Temoriam hodie potentiam præpollentem in-

gapum tumott.

Voco Trinitatis.

Cpetim tpeoóataio poiſin

Credo in Trinitatem sub Tῃ

oenóataio in oulemain óail.

Unitate τοῦ numinis elementorum

Atompuuſ moiu muipt gene cpipt co n-a

Apud Temoriam hodie Virtutem nativitatis Christi cum eâ ejus

bathnuy, muipt cpochta co n-a aonocul, muipt

baptismi, Virtutem crucifixionis cum eâ ejus sepulturæ virtutem

n-epeipge co ppepgabail, muipt tomtu oo bpe-

resurrectionis cum eâ ascensionis Virtutem adventûs ad ju-

themnay bpacha.

dicium æternum.

Atompuuſ moiu muipt gpao hipuphin in uplo-

Apud Temoriam hodie virtutem amoris Seraphin in obse-

taio aingel, in ppeipcip epeipge ap cenn poch-

quio angelorum, in spe resurrectionis ad adipiscendum proe-

paice

Cat. 69 MS in Irish and English by Eugene O'Curry, 1846, *St Patrick's Hymn*, f. 2r

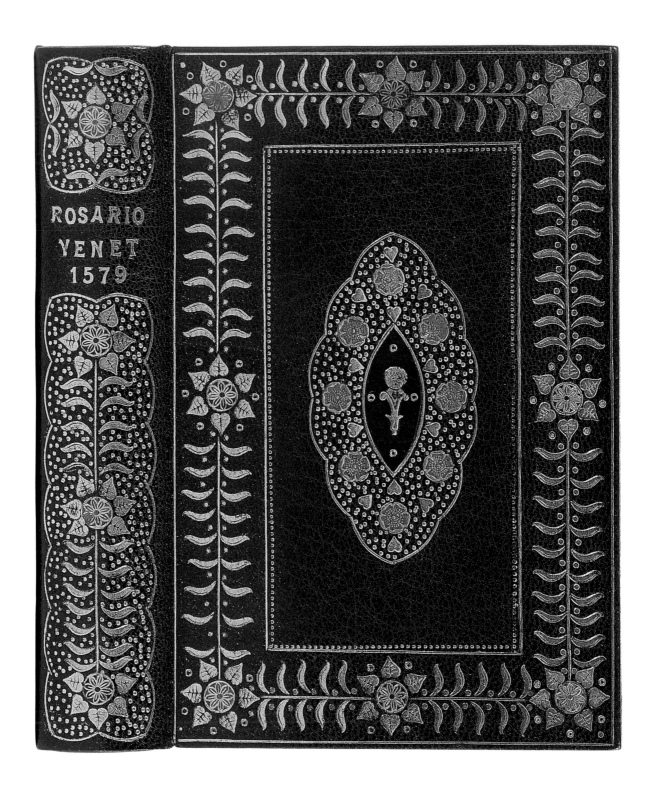

Cat. 70 Binding finished by Sir Edward Sullivan, before 1907, *Rosario*, upper cover

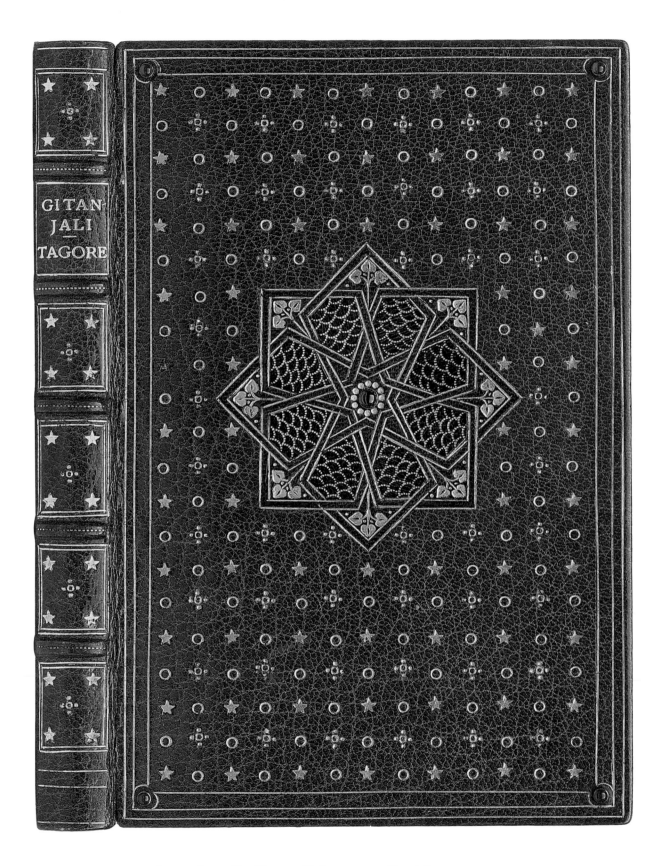

Cat. 71 Bound by Eleanor Kelly, *ca.* 1913, *Gitanjali*, upper cover

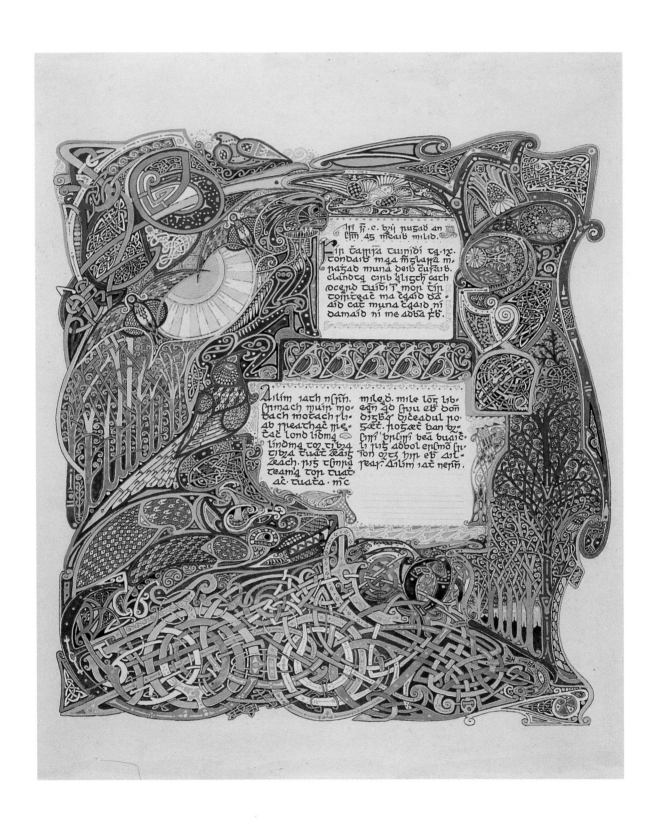

Cat. 72 Illuminated by Art O'Murnaghan, *Leabhar na hAiseirghei* (The Book of the Resurrection),
First Milesians Page

Cat. 73 Illustrated by Jack B. Yeats, 1940, *A Lament for Art O'Leary*, unnumbered illustration

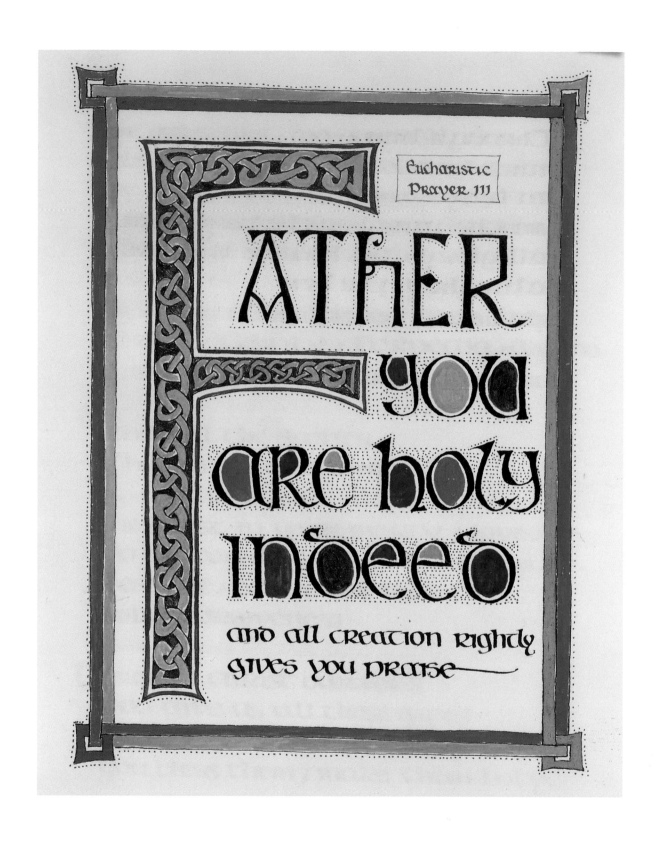

Eucharistic Prayer III

Father you are holy indeed and all creation rightly gives you praise—

Cat. 74 Written and illuminated by Timothy O'Neill, 1981, *The Roscrea Missal*, Eucharistic Prayer

The priest standing at the altar takes the paten with the bread, holding it slightly raised above the altar says:

Blessed are you, Lord, God of all creation. Through your goodness we have this bread to offer, which earth has given, human hands have made. It will become for us the bread of

the people
may respond blessed be God forever life

The deacon or the priest pours a little wine into the chalice saying quietly:

By the mystery of this water, wine may we come to share in the divinity of Christ who humbled himself to share in our
humanity

Then the priest takes the chalice, holding it slightly raised above the altar says:

blessed are you, Lord, God of all creation. Through your goodness we have this wine to offer, fruit of the vine, work of human hands It will become our spiritual
drink

the people
may respond blessed be God forever

Cat. 74 Written and illuminated by Timothy O'Neill, 1981, *The Roscrea Missal*, page from the Mass

Cat. 75 Illustrated by Louis le Brocquy, 1969, *The Táin, The Last Battle*

Cat. 76 Illustrated by Wendy Walsh, 1996, *The Flowers of Mayo, Violets against Moore Hall*

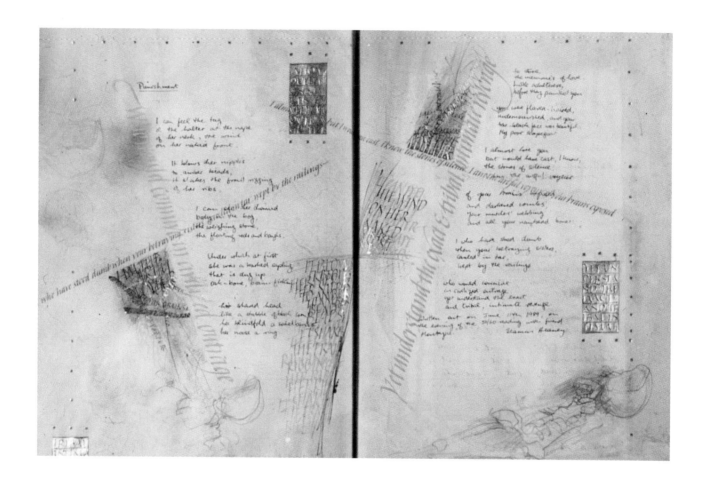

Cat. 77 *The Great Book of Ireland / Leabhar Mór na hÉireann*, 1989–91, Seamus Heaney's poem
Punishment, artist Barry Cooke

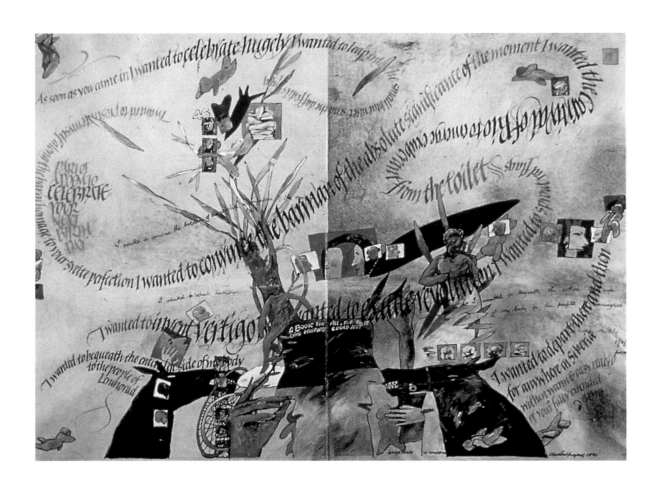

Cat. 77 *The Great Book of Ireland / Leabhar Mór na hÉireann*, 1989–91, Garry Murphy's poem,
artist Charlie Harper

Cat. 78 Illustrated by Felim Egan, *Squarings*, 1991, illustration 3

CATALOGUE

THE SIXTEENTH CENTURY

1 ❧ *Decorated Binding from Ulster, early 16th century*

Life of St Columcille (in Irish), MS on vellum (written before 1544–45). Size: 320 × 245 × 45 mm, 68 folios; eight gatherings, the first and last of 10 leaves, the remainder of 8;[1] double columns, ruled in dry point; decorative initial T at the beginning of the first folio

Scribe: Copied by Eoghan Carrach Ó Siaghail for Niall Óg (Conallach) Ó Neill (died *ca.* 1544–45). The colophon on p. 66 reads in translation:[2] *I am Eoghan Carrach O Siaghail [O Shiel], who wrote this Life of Colum Cille for Nial Og, son of Art, son of Conn, son of Henry, son of Eoghan O Neill, that is, the head of profit to poetry and learning, and a wise sage in the understanding of every knowledge ….* The patron, Niall Óg Ó Neill, was the son of Art the chief of Tír Eóghain (Tyrone) who died in 1519. The original manuscript, of which this is a copy, was compiled on the instructions of Manus O Donnell at his castle in Lifford in Co. Donegal in 1532.[3]

Provenance: Copied by Eoghan Carrach Ó Siaghail for Niall Óg Ó Neill (colophon on p. 66): (?)Franciscan Convent Donegal; in the seventeenth century brought to the Franciscan Convent at Louvain and remained there until the French Revolution; eventually returned to Ireland in 1872

Literature: Henry and Marsh-Micheli 1987, pp. 807–08; Pächt and Alexander 1973, no. 1288; Dillon, Mooney and Dé Brún 1969; Waterer 1968, pp. 70–82; Mooney 1953, pp. 150–56; Walsh 1929, pp. 292–306; Buckley 1915, p. 302, pls. XXVIII–XXX.

THE FRANCISCAN HOUSE OF STUDIES, DÚN MHUIRE, KILLINEY, CO. DUBLIN (MS A. 8)

The binding is made from oak-tanned cattle-hide shaved down to about 2 mm in thickness and stained dark brown or black. The ends of the leather are folded over and back-sewn to an inner lining of chamois-like leather. According to John Waterer, the decoration of the cover is carried out in a technique known as *cuir bouilli*, where the leather in a dampened state is modelled into shape (over moulds made from sand or clay) and worked on with wooden or bone tools.[4]

The front cover consists of three horizontal bands of interlacing with two intermediate bands of fret ornament. The lower cover is made up of twelve squares each, enclosed with interlaced bands. The spine is divided into five compartments, three of which are decorated with an angular interlace pattern. From the middle, and either ends of the spine, project three knotted cords, which are coloured green yellow and (?)white. These knots hold the book together, since they perforate the spine and are laced to the backs of the four leather thongs which are sewn (stab-stitched) through the sides of the leaves. The decoration of the leather is closely related in design and technique to the well known Irish leather book satchels. The design of the back cover should be compared, in particular, to the back of the satchel of the Breac Moedóig in the National Museum.[5]

1. The collation is incorrectly given in Myles Dillon *et al.*, *Catalogue of the Irish MSS. in the Franciscan Library, Killiney*, Dublin 1969, no. A8.

2. Dr Paul Walsh, *Irish Men of Learning*, ed. C. O'Lochlainn, Dublin 1947, p. 162.

3. The manuscript is in the Bodleian Library (Rawlinson MS B514).

4. John W. Waterer, 'Irish Book-Satchels or Budgets', *Medieval Archaeology*, XII, 1968, pp. 70–82, *passim*.

5. The satchel, which probably dates from the fifteenth century, was – more than likely – made to hold a book. It was later reused as a receptacle for the eleventh–twelfth-century metal house-shaped shrine known as the Breac Moedóig from Drumlane, Co. Cavan, National Museum of Ireland, P. 1020 and P. 1022 (illustrated in Waterer 1968, pls. IVb, V; J.J. Buckley, 'Some Early Ornamented Leatherwork', *Journal of the Royal Society of Antiquities of Ireland*, XLV, pt. IV, December 1915, pl. XXVII).

2 ❧ *Blind-stamped (?)Dublin Binding, early 16th century*

The Gormanston Register, MS. Size: 290 × 200 × 90 mm

Provenance: acquired by the National Library from the Gormanston family in 1962

Literature: Kissane 1994, no. 62; Mills and McEnery 1916; Gilbert 1879, p. xiii, pl. 31; *Royal Historical Manuscript Commission* 1874, pp. 573–84

THE NATIONAL LIBRARY OF IRELAND, MS 1646

The volume of 223 parchment leaves was begun in 1397–98 for the purpose of registering the title-deeds of the estates inherited or acquired by Sir Christopher Preston, lord of Gormanston (died 1422). Apparently the volume originally began with the folio numbered 13, the heading of which may be regarded as the title of the book in its original form, *Hec est copia cartarum domini Cristofori de Preston militis facta anno r. r. Ric. secundi vicesime primo....* The folios before 13 were either originally left blank or were subsequently added. They contain additions made during the first half of the fifteenth century and later. The volume is written mainly in Latin but some sections are in French and English.

Bound in tanned leather over bevelled wooden boards and tooled in blind with a central panel divided by broad diagonal fillets into lozenge-shaped compartments filled with rows of a stylized pomegranate tool. Around this panel is a double frame of broad lines with overlapping corners. Between the double frames are repeated impressions of a crocketed cresting tool facing inwards and topped with fleurs-de-lys mainly on the shorter sides. The spine is divided into five panels by four raised bands outlined by blind fillets of double leather thongs which are laced in grooves into the boards. The remains of two white leather clasps hinge on the lower cover; with the original metal catches on the upper cover (in the Netherlandish manner). The edges of the leaves are almost flush with the boards, except for the top edge, which has a square of about 10 mm. The leather at the top of the upper and lower covers is torn away exposing the oaken boards; and two iron staples secure a split in the upper board.

The *Register* has all the appearance of Netherlandish binding, especially if it is compared with the example shown on plate V of J.B. Oldham's *English Blind-stamped Bindings* (Cambridge 1952). This style of binding was introduced into England in the late fifteenth century. For the first forty years after the introduction of printing into England by William Caxton (1476), the book trade seems by and large to have been in the hands of foreigners. Dr Mirjam Foot has shown that the binding trade during this period owed much both to immigrant binders and to the importation of binding designs, tool designs and decorative panels, especially from the Low Countries.[1] The Netherlandish style of binding was apparently known in Dublin at least as early as *ca.* 1526 (see cat. 3 below), and was still current in 1551 when printing was introduced to Ireland by Humphrey Powell, the King's Printer. An incomplete copy of his first publication, *The Book of Common Prayer* (Dublin 1551) with its original binding laid into a later cover was, from the description of E.R. McClintock Dix, clearly in the Netherlandish style.[2] It is interesting in this regard that Powell is recorded as having received several payments for both printing and binding of books during the period 1559–64.[3]

Because the binding of *The Gormanston Register*, at first sight, looks like a Continental product, one is tempted to postulate the existence of a Flemish binder working in Dublin. However, there seem to be certain anomalies, such as the inconsistencies in the finishing, especially the turning inwards of the crocketed cresting and the arbitrary application of the fleur-de-lys tool, which

perhaps point to a local binder copying a Netherlandish examplar. Since there is no record of the *Register* ever leaving the country, it seems very likely that it was bound in Dublin, probably during the first half of the sixteenth century.

1. Mirjam M. Foot, *Studies in the History of Bookbinding,* Aldershot 1993, p. 148 and *passim.*

2. E.R. McClintock Dix, 'Notes upon the Leaves of the First Book printed in Dublin discovered in the Academy',

Proceedings of the Royal Irish Academy, Section C, xxvii, 1908–09, pp. 404–06.

3. 'General accounts of the Vice-Treasurer of Ireland', *Analecta Hibernia,* no. 4, October 1932, p. 299.

3 ✎❧ *Blind-stamped Dublin Binding, ca. 1526*

Cartulary of St Thomas's Abbey, Dublin, MS on vellum, compiled by William Copinger in 1526.
Size: 300 × 200 × 80 mm

Provenance: John Carpenter, RC Archbishop of Dublin 1770–78; Haliday's MSS which passed to the Royal Irish Academy

THE ROYAL IRISH ACADEMY (MS 12. D. 2)

The volume contains transcripts of deeds concerning the possessions of the Abbey in the province of Leinster. The companion volume, also by Copinger, concerning properties other than Leinster, is in the Bodleian Library.[1]

Rebound in the late nineteenth century in brown calf over wooden bevelled boards with the original blind-tooled leather laid down (except for the backstrip which is missing).[2] The decoration consists of an outer frame of three parallel lines overlapping at the corners. The diaperwork inner rectangle contains repeated impressions of a stylized 'pomegranate' tool. This tool is a very close copy of one used by the 'Huntsman Binder', a London shop working at the end of the fifteenth century.[3] Three raised bands divide the spine into three panels.

1. Rawlinson B499; it was rebound by Sir James Ware, early in the seventeenth century, with his armorial stamp on the cover (see *Analecta Hibernia,* no. 1, Dublin 1930, pp. 163–64).

2. According to a note on the flyleaf by J.T. Gilbert, who also states that the metal catches are restorations.

3. See J.B. Oldham, *English Blind-stamped Bindings,* Cambridge 1952, pp. 30, 60, pl. XXV, no. 330.

4 ❦ The First Book printed in Ireland, 1551

The Boke of the common praier and administracion of the Sacramentes, and other rites and ceremonies of the Churche: after the use of the Churche of England, Dubliniae in Officina Humpredi Poweli, M.D.LI. Size: 271 × 186 × 28 mm

Literature: Clarke and Madden 1954, p. 113; McClintock Dix 1932, p. 3

THE BOARD OF TRINITY COLLEGE, DUBLIN

In July 1550, Humfrey Powell, an original member of the London Company of Stationers, was paid £20 by the Privy Council of England for setting up a press in Dublin. In the following year, *The Book of Common Prayer*, a small folio volume of 300 pages, was printed in black letters with an ornamental titlepage. The colophon [see illustration p. 6] gives his address: *Imprinted by Humphrey Powell, printer to the Knyges Maiestie, in his Highnesse realme of Ireland, dwelling in the citie of Dublin in the great toure by the crane. Cum privilegio ad imprimendum solum.*

Woodcut title-border made up from (?)seven ornaments. The Renaissance fountain ornament on the right of the titlepage was previously used (or else, this is a very close copy) on the titlepage of the second edition of vol. 1 of Froissart's *Chronicle of England,* London, [Robert Redman] and William Middleton (*ca.* 1540).[1] The fountain ornament was later used on the Irish broadside of 1571, known from the unique copy in the Library of Corpus Christi College, Cambridge (Archbishop Parker Collection).[2]

The first edition of *The Book of Common Prayer* was published in London in 1549.

1. The titlepage of the Froissart volume is illustrated in Sotheby's sale catalogue of the Bute Library, 15 March 1995, lot 109.

2. Illustrated in E.W. Lynam, *The Irish Character in Print, 1571–1923*, Shannon 1968, pl. 6.

5 ❦ Illuminated Manuscript Book from Connacht, ca. 1578

The Book of the Burkes, MS with 14 coloured illustrations, *ca.* 1578. Size: 260 × 172 × 31 mm

Literature: Henry and Marsh-Micheli 1987, pp. 809–15, pl. 32b; O'Reilly 1927, pp. 50–60, 101–37, and 1928–29, pp. 30–51, 142–67; Blake 1912, pp. 83–101; Abbott and Gwynn 1921, no. 1440

THE BOARD OF TRINITY COLLEGE, DUBLIN, MS 1440 (F. 4. 13)

A volume of 75 folios, 22 of which are blank; it contains a history and genealogy of the Burke or De Burgo family of North Connacht (*Historia et Genealogia Familiae De Burgo*) written in Irish and Latin for Sir Seaán Mac William Burke, who was chosen as head of the MacWilllliam Burkes in 1571 and died in 1580. His mother was a sister of Magnus O'Donnell for whom the *Life of St Columcille* (Bodleian Library, Rawlinson MS B. 514) was written in *ca.* 1532, and she was also a sister of the wife of Niall Connallach O'Neill for whom the copy of the *Life of St Columcille* (see cat. 1 above) was made. Sir Henry Sidney, the Lord Deputy, wrote of Sir Seaán: "I found Mac William very sensible; though wantinge the English tongue, yet understandinge the lattin; a lover of quiett and cyvilitie."

The most interesting portion of the book is the series of fourteen coloured drawings – four of the Passion of Christ, followed by a series of nine Burke 'portraits'. The Passion scenes are very probably influenced by popular German coloured woodcuts, while the portraits may have been inspired by contemporary playing cards.

6 ❧ Gold-tooled (?)London Binding for Sir Richard Shee, ca. 1600

Richard Shee Cartulary, MS, *ca.* 1600. Size: 380 × 260 × 10 mm

Provenance: Major P. Power O'Shee, Garden Morres, Kilmacthomas, Co. Waterford, *ca.* 1954

THE NATIONAL LIBRARY OF IRELAND, ON LONG-TERM LOAN FROM THE POWER O'SHEE FAMILY (MS 2066)

The upper cover of one of three volumes of the transcripts of deeds and titles relating to the Shee family (thirteenth–sixteenth centuries) compiled for Sir Richard Shee, of Uppercourt, and Cloran, Co. Kilkenny, in about 1600.[1] Sir Richard was a member of Gray's Inn, London, and was Deputy to the Lord High Treasurer of Ireland in 1576;[2] he also acted as attorney for Thomas ('Black Tom'), the 10th Earl of Ormond. He founded the Hospital in Kilkenny called after his name in 1582. In his will, dated 23 December 1603, he bequeathed to "my son Marcus Shee all my son Robert's law books, and my own; to my son John all my books of divinity, civill and canon law". A codicil was added the following year, when he made an additional bequest to his son and heir, Lucas Shee (to whom he had already left his furniture, including his tapestries), of "my great double pair of virginals, to remain in my chamber for my heirs male".[3]

The three parchment volumes are in a poor state of preservation as a result of fire damage. A detached cover, and the shrunken fragment of another, are all that remain of the bindings. In its present state the leather is laid down on a (later) leather-covered pasteboard. The cover is gold-tooled to a panel design enclosing a blocked oval cartouche[4] flanked by the owner's name lettered in gilt. The fleur-de-lys tool on each of the corners of the inner rectangle is a very close copy of one found on the bindings of a set of volumes for the famous collector Cardinal de Granville. The Parisian atelier which produced these sumptuous bindings was active between *ca.* 1540 and 1550.[5] An unusual feature of the design is that the sides of the outer panel do not meet at the corners but stop short; perhaps the corners had, or were meant to have, metal corner pieces.

It seems probable that Sir Richard Shee took his manuscripts to London for binding and is the only example, as far as I am aware, of a sixteenth-century Irishman commissioning a gold-tooled binding.

The art of gold-tooled bookbinding is of Arabic origin. The technique of applying heated tools to gold leaf into the leather was known in Morocco at least as early as the thirteenth century. By the mid-fifteenth century it was practised in Italy.[6] Gold-tooling entered France from Italy about the first decade of the sixteenth century. Gradually Italian arabesque designs replaced the French medieval layout of close-set vertical rows of tooling. By about 1535, however, Parisian ateliers had mastered the technique and art of gold-tooled bookbinding to such a degree that their pre-eminence remained unchallenged for most of the succeeding centuries. The earliest English example of gold-tooling probably dates from 1519, "but for the next ten years, the technique remained largely experimental as no one in the country had the specially cut tools for the purpose. The distinction is that in blind-tooling the pattern stands out in relief, while in gold-tooling the previously heated tool is impressed through gold leaf into the leather and pattern shows in intaglio".[7]

1. Ed. Richard J. Hayes, *Manuscript Sources for the History of Irish Civilisation*, IV, Boston 1965, p. 416b.

2. Burke's *Landed Gentry of Ireland*, London 1968, pp. 560–61.

3. Sir John Ainsworth, *Private collections Reports no 167, Power O'Shee papers,* typescript in the National Library of Ireland (Department of MSS Reading Room).

4. For a very similar cartouche, see Dr Ferdinand Geldner, *Bucheinbände aus elf Jahrhunderten*, Munich 1958, plate XLVI, no. 91, on a binding of *ca.* 1580, by the Munich ducal binder Heinrich Peisenberg. Also compare an English cartouche of a similar type on a binding dated 1573, in Bernard Quaritch's catalogue 945 (1974) no. 5; such correspondences illustrate the mobility of tool designs and, indeed, binding styles in sixteenth-century Europe and later.

5. M. Piquard, 'Les Livres du cardinal de Granville', in *Les Trésors des bibliothèques de France*, edd. R. Cantinelli and E. Dacier, Paris 1942–46, XXVI, pl. V, pp. 24–25. A matching binding on an Apollodorus MS is in the Bodleian Library (MS D'Orville 1; see I.G. Philip, *Gold-tooled bookbindings* (Bodleian picture books, 2), Oxford 1951, pl. 7).

6. A.R.A. Hobson, *Humanists and Bookbinders*, Cambridge 1989, *passim.*

7. Howard Nixon and Mirjam M. Foot, *The History of Decorative Bookbinding in England*, Oxford 1992, pp. 25–26.

THE SEVENTEENTH CENTURY

7 The Book of Common Prayer *in Irish, 1608*

Leabhar na Nur-Naightheadh Gcomhchoidchiond, Dublin, Shéon Ffrancke alias Ffranckton Priontoir an Riog an Eirin, 1608 (Short-Title Catalogue 16433). Size: 288 × 193 × 40 mm

Provenance: inscribed *Bealla foile* on the frontispiece

Literature: Clarke and Madden 1954, pp. 130; McClintock Dix 1898–1912; McClintock Dix 1904–06, pp. 221–26

THE NATIONAL LIBRARY OF IRELAND (LO 1206)

Engraved architectural titlepage with Netherlandish strapwork cartouche.[1] Translated by William Daniel or O'Donnell, who later became archbishop of Tuam. The imprint date is 1608 but the dedication to Chichester, the Lord Deputy, who had commissioned the translation in 1605, is dated 1609.

Bound in brown leather over bevelled wooden boards and decorated with a rectangle formed by a blind roll which resembles one current in England in the 1530s and 1540s;[2] rebacked, the gatherings are sewn on to two leather thongs which are laced into groves in the boards.

In his dedication to Sir Arthur Chichester, Lord Deputy General of Ireland, the translator, William Daniel (O Domhnuill), Archbishop of Tuam wrote: "It Pleased your Lordship to impose upon myselfe, the burden of translating the booke of common Prayer (the Liturgy of the Famous Church of England) in the mother tongue (for the comfort of the meere Irish Churches)… And having imbraced it, I humbly pray your Lordship to send it abroad in the country churches, together with the elder brother the New Testament, to be fostered and formented – from my House in Sainct Patricks Close Dublin the XX. of October, 1609."

1. R.B. McKerrow and F.S. Ferguson, *Title-page Borders used in England and Scotland 1485–1640*, London 1932, no. 244.

2. J.B. Oldham, *English Blind-stamped Bindings*, Cambridge 1952, pl. 53, RP. b (1) 897.

8 *Illuminated Heraldic* MS, 1607

Daniel Molyneux, Ulster King of Arms, *A Visitation Begonne in the Cittie of Dublin 1607*. Size: 286 × 220 × 30 mm

THE NATIONAL LIBRARY OF IRELAND (GENEALOGICAL OFFICE MS 46)

In 1607, Daniel Molyneux, the Ulster King of Arms, and principal Herald of all Ireland, began a tour of the country, beginning with Dublin. The visitation was undertaken "to observe the arms … of all noblemen … and to correct all false armour and all such as without their consent do presume to bear arms …".[1]

Coloured architectural frontispiece, bearing the Royal Arms, together with those of Ireland and the city of Dublin. At the bottom of the page are the initials AL which may be those of the herald painter. Herald painters were much employed on charters, peerage patents and the purveying of land titles, and they probably had recourse to Continental engraved pattern books for much of the

ornamental motifs found on the charters and patents which were issued from the Office of the King of Arms.

1. Ed. Noel Kissane, *Treasures from the National Library of Ireland*, Dublin 1994, no. 92.

9 ❦ *Architectural Titlepage, 1636*

Statutes of Charles I, Dublin, Societie of Stationers, 1636. Size: 275 × 190 × 25 mm

ARRANMORE COLLECTION OF EARLY IRISH BOOKS

One of four engraved architectural titlepages found on seventeenth-century Dublin imprints.[1] The crowned arms of Ireland with putti supporters stand on a pillared archway. In the previous year a similar titlepage but crudely executed was signed by S. Gleg and R. Morton.

1. Listed in R.B. McKerrow and F.S. Ferguson, *Title-page Borders used in England and Scotland 1485–1640*, London 1932, pls. 244, 274, 303 and 304.

10 ❦ *Irish or English* Pointillé *Binding, 1639–40*

MS *A New Year's gift for Sir William Wentworth*, 1639–1640, a collection of congratulatory verses in Latin and Greek, compiled as a New Year's gift for Sir William Wentworth, the son of the Lord Lieutenant, the Earl of Strafford, from his fellow students at Trinity College, Dublin, dated 1 January 1639–40. Size: 223 × 178 × 14 mm

Literature: O'Sullivan 1955, p. 13

TRUSTEES OF OLIVE, COUNTESS FITZWILLIAM CHATTELS SETTLEMENT AND SHEFFIELD ARCHIVES, SHEFFIELD LIBRARIES AND INFORMATION SERVICES (WWM STR. P. 38)

Bound in black goatskin and tooled in gold to a panel design with *pointillé* curl tools in the inner corners. Apart from the present example, the only other recorded seventeenth-century Dublin book with a *pointillé* tooled binding is W. Ince, *Lot's Little Ones*, Dublin, John Crooke and Richard Sergier, 1640 (Trinity College Dublin), which is perhaps English workmanship.[1]

In the 1630s in Paris, new developments in tool design began to emerge. Rolls began to resemble lace patterns, and small tools have little dotted elements as well as solid lines, which eventually became fully dotted in contour, hence: *pointillé*. These new *pointillé* tools gave a jewel-like sparkle to richly tooled bindings, an effect described by Michon as "un aspect extrêmement élégant de filigrane".[2] *Pointillé* tools were quickly copied in London; see, for example, the binding presented to Charles I *ca.* 1635, on John Selden's *Marc Clausum* (London 1635).[3]

1. Craig 1954, pp. 1–2.
2. L.M. Michon, *La Reliure française*, Paris 1951, p. 91.

3. Illustrated in Mirjam M. Foot, *The Henry Davis Gift: A collection of Bookbindings*, London 1983, II, no. 86.

11 ❧ *Blathmac's* Poems, *17th century*

Size: 205 × 159 × 10 mm

Provenance: Edward O'Reilly, Phillips MS

Literature: Kissane 1994, no. 73; Nessa Ní Shéaghdha 1961

THE NATIONAL LIBRARY OF IRELAND (MS G. 50)

A seventeenth-century paper manuscript which contains the religious poetry of the eight-century monk Blathmac. His poems to the Virgin Mary are only known from this late recension, and it demonstrates in a remarkable way the long scribal tradition in Ireland. The poet has been identified as a son of Cú Bretan, who is mentioned in the saga of the Battle of Allen, and who died in AD 739 according to an entry in the annals of Ulster. It seems that Blathmac was a monk and his poem throws light on the importance of the cult of the Virgin in the eight century.[1]

The poem begins on the third line of the opened page.

Blathmac mac Con Bretan Maic Conguso do Feraibh Rois
do-rigni in ndúthracht-sa do Mairi & dia mac.

It is Blathmac son of Cú Bretan son of Congus of the Fir Rois has made this devoted offering to Mary and her son.

Tair cucum, a Maire boíd
do choíniuth frit do rochoím;
dirsan dul fri croich dot mac
ba mind már, ba masgérat.

Come to me, loving Mary,
that I may keen with you your very dear one.
Alas that your son should go to the cross,
he who was a great diadem, a beautiful hero.[2]

1. Gerard Lyne, chapter VIII, in Kissane 1994.
2. Edited and translated by James Carney, *Irish Texts Society*, Dublin 1964.

12 ❧ *Illuminated* MS *Book from Holy Cross Abbey, Co. Tipperary, 1640*

Revd John alias Malachy Hartry, MS *Triumphalia*

Vellum manuscript of 50 leaves, now detached and mounted separately. Size: 305 × 203 × 20 mm

Literature: Crookshank and the Knight of Glin 1994, p. 18; Stalley 1987, pp. 115–16; Morris 1986, pp. 1–3, ill. 2; Murphy SJ 1891

ST PATRICK'S COLLEGE, THURLES, CO. TIPPERARY

The manuscript contains two distinct works written in the same hand. The first bears the title *Triumphalia Chronologica Monasterii Sanctae Crucis in Hibernia 1640* (The glorious history of the monastery of Holy Cross in Ireland 1640). Bound with this is another work, *Synopsis Nonnullorum Illustrium Cisterciensium Hibernorum, 1649* (Famous Irish Cistercians). There are also additions dating from the eighteenth century. The first part of the manuscript has a coloured titlepage and a full-page illustration of the relic of the True Cross carried in procession.

The Cistercian abbey of Holy Cross in Co. Tipperary was founded by Donal Mór O'Brien, king of Thomond in 1185–86. The combined patronage of the Earls of Ormond and the acquisition of a relic of the True Cross transformed a previously modest building into the most distinguished

building of fifteenth-century Ireland. The abbey escaped dissolution under Henry VIII by being transformed into a college of secular priests. In 1563, Queen Elizabeth granted the buildings and the estates to 'Black Tom', the 10th Earl of Ormond. He was tolerant towards the monks who continued an association with the place. Pilgrims continued to come to venerate the relic. In 1567, Sir Henry Sidney, Lord Lieutenant of Ireland, complained to the Queen of "the detestable idolatry used to an idol called the Holy Cross, whereunto there is no small confluence of people daily resorting". Sir John Dowdall, writing in 1600, explained that the relic was used for swearing oaths and "is of greater reckoning with the Irish than all the other idolatries in Ireland". In 1611 Fr Luke Archer, a Kilkenny priest who had joined the Cistercians, was appointed abbot of Holy Cross and Vicar General of the Order with the task of reviving the Cistercians in Ireland. The Counter-Reformation revival was under way and in this spirit Abbot Luke commissioned Fr Malachy Hartry, a Cistercian monk, to write a history of the abbey and give an account of the "miracles wrought by the Saving Wood of the Holy Cross" which had brought such fame to the Abbey.

Fr Hartry also refers to the illustration accompanying his description of the procession of the relic of the Cross (p. 165): "a Representation of the manner in which our Holy cross was carried respectfully outside the Monastery in Catholic times. To gratify and console the sick who lived at a great distance from the monastery, the practise as adopted in ancient times by the Rev. Lord Abbots of sending two monks abroad bearing the saving Cross with all reverence, accompanied by some lay friends. In going thus from one diocese to another, a white silk banner with a purple cross on it set in the middle was bourne before the Sacred Relic on the public roads and elsewhere. The Relic was received by the most Illustrious and Reverend Lords the Archbishops and Bishops or their Vicars with singular reverence and honour, and the most Illustrious Prelates and others of every ecclesiastical rank showed great veneration to it, and never allowed it to be profaned by any wicked or unjust usurper who strove to appropriate it, or another to be substituted for this under pretext that it was the true Cross, as was often done by some ….

"I have taken pains to give here a representation of the Procession when the miraculous holy Cross used to be carried to Kilkenny and elsewhere each year at the urgent request of the people. In those times this is done secretly and seldom, and only when grave necessity requires it."

13 ❦ Jesuit (?)Dublin Binding, early 17th century

Ioan. Michael Constantiensis, *Enchiridion seu manuale quotidianorum exercitiorum spiritualium*, Cologne 1598.
Size: 116 × 95 × 44 mm

Provenance: *Resi. Dubl:* inscribed on the titlepage and underneath the later signature of Edwardus Chamberlinus SJ (with the letters S. J. scored through); stamp of Carlow College; acquired by Milltown Park at the dispersal of the library of Carlow College in the 1960s

THE JESUIT LIBRARY, MILLTOWN PARK, DUBLIN (IR. MISSION BK. D8 / C7)

Bound in brown calf, the cover is tooled with a border of two double blind fillets on each side of a gilt fillet, enclosing a gilt stamp centrepiece of the Sacred Monogram surrounded by an oval sunburst. The spine is divided into five panels by four raised bands with a gilt horizontal tool in the centre of each panel.

Probably bound in Dublin in the first half of the seventeenth century. The narrow horizontal tool on the spine is very similar to a tool found on London bindings at the beginning of the century and copied by Dublin binders.

Writing about his tour of Ireland in 1635, Sir William Brereton commented on the recently closed Jesuit church and college in the Back Lane (site of the present Tailors Hall), near Christ Church Cathedral:[1] "I saw also the church, which was erected by the Jesuits, and made use by them two years. There was a college also belonging unto them, both these erected in the back lane. The pulpit in this church was richly adorned with pictures, and so was the high altar, which was advanced with steps, and railed out like a cathedral; upon either side thereof was there erected places for confession; no fastened seats were in the middle or body thereof, nor was there any chancel; but that it might be more capacious, there was a gallery erected on both sides."

The church and residence of the Jesuits as described by Brereton were opened in 1627 during a period of toleration towards Catholics, following the marriage of Charles I and Henrietta Maria, youngest daughter of the king of France. Richard Boyle, the Great Earl of Cork, watched with alarm the activities of the Jesuits and wrote to an English correspondent, Lord Dorchester: "The Jesuits' house … is a new-erected and goodly fabric, the chapel whereof … is 75 feet long by 27 broad. It is seated round about with an altar with ascents, a curious pulpit and organs, and four places for confession neatly contrived, galleried above round about with rails and turned ballasters, coloured, a compass roof, cloister above, with many other chambers, all things most fair and graceful, like the banqueting house at Whitehall."

The Jesuit church and college in the Back Lane were shortly afterwards closed by the government and the building was annexed to Trinity College. The above volume, though it was in the Jesuits' later Dublin House, and bears the signature of Fr Edward Chammberlin, who arrived in Dublin in 1681, is perhaps one of the volumes from the Back Lane residence.

1. McDonnell, *Ecclesiastical Art*, 1995, pp. 3–4.

14 ∻ *Jesuit Kilkenny Binding, 1649*

Matthew King, MS, Kilkenny 1649. Size: 210 × 160 × 40 mm

Provenance: Matthew King, initial on the covers; presented to the National Library of Ireland by George Noble, Count Plunkett

Literature: MacLochlainn 1995; McDonnell, *Ecclesiastical Art*, 1995, no. 64

THE NATIONAL LIBRARY OF IRELAND (MS 9,952)

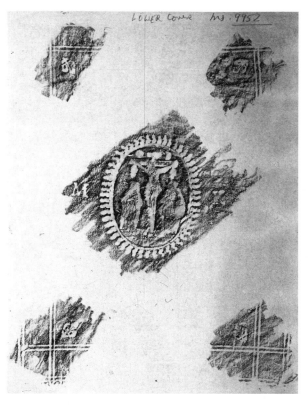

Rubbing of lower cover of cat. 14

A manuscript volume of philosophical notes written on paper in the Jesuit College, Kilkenny, and dated 1648 on the colophon. The writer can be identified as a certain Matthew King from a letter found in the binder's waste and from the initials M K on the covers.

The covers, which are now detached, are bound in dark brown calf and tooled in blind to panel designs. Two pairs of fillets, overlapping at the corners, frame the centre panel which contains the blocked oval stamp of the Crucifixion with the figures of the Virgin and St John, surrounded by flame tools and flanked by the initials M K; in the corners of the inner panel are fleur-de-lys tools.

A unique example of a seventeenth-the Crucifixion were common on the bindings of liturgical books and works of devotion in France during the reign of Henri III (1574–89).

After the Jesuits were expelled from Dublin by the government, they moved to Kilkenny, where they set up a college and noviciate; there a printing press (and no doubt a bindery) were installed in about 1645. In a letter dated May 1646 from Rinuccini to Cardinal Pamphili, the Nuncio mentions that he has given to the Jesuits a house of the Augustinians "for the use of a college or seminary, which had all but been made over to them before my arrival".[1] In 1647 the press was under the control of the Jesuit Brother and printer George or Nicholas Sarrazin who later went to Portugal and died there in 1657. The press was used for printing official documents and academic material such as scholastic theses. Several proof-sheets of previously unknown broadsides were discovered as binders' waste inside the covers of the present volume.

In 1650 Cromwell reached Kilkenny where the Jesuit house was ransacked and burned down by his soldiers. "It seems that the devil himself wants us to be destroyed, so there is nothing left on earth", wrote Fr Young, the Master of Novices, in a letter to Rome after the event.

1. A. Hutton (trans.), *Rinuccini's Embassy in Ireland*, Dublin 1873.

15 ⁋ *Bound by the Devotional Binder, ca. 1675*

Richard Connell, MS *The Genealogy and descent of the Most Illustrious Prince his Grace James Duke of Ormond,*[1] *Chancellor of the Universities of Oxford and Dublin, Lord Lieutenant General and General Governor of his Majesties Kingdom of Ireland. Knight of Garter.* Size: 325 × 200 × 40 mm

Provenance: The Marquess of Ormonde, Kilkenny Castle

THE NATIONAL LIBRARY OF IRELAND, ON LONG-TERM LOAN FROM THE ORMONDE ESTATE (MS 23,517)

Manuscript on paper *ca.* 1675 (the latest date recorded on p. 159). Richard Connell, who compiled the work and dedicated it to "the most vertuous, and religious lady, her Grace, the Lady Elizabeth Dutchess of Ormond", is probably the same person who leased lands in Kilkenny from the Duke in 1684[2] and was JP and mayor of Kilkenny in 1685.[3]

James Butler (1610–1688), 12th Earl of Ormond, who came from an old Norman-Irish family, rose to great prominence by his service to the English Crown. During the Commonwealth period he accompanied the exiled King Charles II on his travels in Europe and was rewarded with a dukedom by a grateful king on his restoration to the throne in 1660. The Duke of Ormonde was three times Lord Lieutenant of Ireland and held the office of Lord Steward of the King's household.[4] In 1669 he was made Chancellor of Oxford University. As Chancellor he presumably received the monarch during his visits to the University and perhaps arranged for suitable gifts to be made – usually finely bound books – as on the occasion in 1685 when he received James II, with his wife and court. The King was presented with a volume bound in purple velvet, and most of the nobility received books bound in black "Turky" leather.[5] As he divided his time between England and Ireland, the duke had residences in both countries; in Ireland his principal seat was at Kilkenny Castle.

Bound in contemporary black goatskin, and tooled in gold to a panel design with the letter 'O' in garland in the centre; the spine is divided by six raised bands into seven compartments, all gold-tooled;[6] edges of the leaves gilt.

The tools are those of the 'Devotional Binder' and include nos. 1, 25 and 28 from Hobson's list.[7] This binder was so named by G.D. Hobson in 1929 because nearly all his bindings are found on the devotional literature ascribed to Richard Allestree (Regius Professor of Divinity at Oxford, 1663–79) or on other pious texts. They were probably bound for presentation, such books being, as a wit once observed, more blessed to give than to receive.[8] The Devotional Binder was active between the years 1675 and 1685, but it is not known where this anonymous binder was established. Hobson thought that his shop was located in Oxford, while Howard M. Nixon suggested London as more likely.[9] The tools of the Devotional Binder are distinctive, being larger and bolder in outline than those of his immediate contemporaries. The forty-year period following the Restoration of Charles II to the throne in 1660 is regarded as the golden age of English bookbinding. As Howard M. Nixon remarked, the binders of Oxford, London and Cambridge were not content to follow Parisian fashions, but developed their own original styles with newly designed tools.

A binding by the Devotional Binder in the Broxbourne Library,[10] covering a seventeenth-century Anglican devotional manuscript entitled *A Manual of Directions and Helps to your Private Devotions,* has a contemporary inscription on the flyleaf: *To his Grace James Duke.* Nixon suggested that this referred to James, the Duke of York, the future James II. As the contents of the manuscript were strictly Anglican and James was an avowed Roman Catholic by the time the Devotional Binder started work, it seemed possible according to Nixon that the book was presented to the Duke of

York by some Anglican divine who hoped that it might cause his Grace to see the light. A more likely explanation, perhaps, is that the inscription referred to James, Duke of Ormonde, a devout Anglican, as the many sumptuously bound Service and devotional books, such as the "two large Common Prayer books, richly bound with cuts, purple strings and fringe" listed in an inventory of the ducal possessions at Kilkenny Castle, attest.[11] Also listed are six books (by Richard Allestree)':[12] "all richly bound in red Turkey leather" including the *Art of Contentment* (Oxford 1677). Perhaps this is the same copy as that reproduced in G.D. Hobson's *English Bindings, 1490–1940, in the Library of J.R. Abbey*, London 1940, no. 48, bound by the Devotional Binder, and with an Ormond provenance.[13]

A number of Dublin imprints between 1674 and 1682 are bound with the tools of the Devotional Binder. To date, only the presentation copy of Thomas Tonge's *Meditationes*, Dublin 1675, to the Lord Lieutenant, the Earl of Essex, has been identified (cat. 16). To this can now be added the following: (1) a finely bounded copy in 'mauve-violet' goatskin of Andrew Sall's *Sermons*, Dublin 1674, again with the tools of the Devotional Binder (illustrated in the introduction as fig. 7);[14] (2) two identically bound copies in calf of Archbishop Bramhall's *Works* (Dublin, printed at his Majesties Printing-house, 1676) are decorated in blind with the tools of the Devotional Binder;[15] (3) Narciscus Marsh's *Institutiones Logicae* (Dublini: apud S. Helsham ad insignia Collegi, in vico dicto Castle-street, 1681) is also bound in calf, and decorated with a single gilt tool in each corner, apparently from the Devotional Binder's kit;[16] (4) and, finally, Richard Lawrence's *The Interest of Ireland*, Dublin, printed by J. Ray for J. North … and Will. Norman 1682 (cat. 17), is found in two identically bound copies in black goatskin and gilt with the tools of the Devotional Binder, possibly for presentation. The book is dedicated to James, Earl of Ossory (1665–1744), grandson and heir to the Duke of Ormonde.

William Norman, the Dublin bookseller and stationer, listed in the imprint of Lawrence's book, described himself, in some of his later titlepages, as "bookbinder to his Grace the Duke of Ormond".[17] William Norman is first heard of in the Guild Records where he was sworn free in 1676, and also admitted free of the city in the same year. Nothing is known about his background, but his long absence in England in the late 1670s is noted in the Guild Records, and perhaps indicates that he had relatives there. At all events, William Norman became a prosperous bookseller and stationer, employing several apprentices and journeymen, and was master of the Guild of St Luke on several occasions. His publications, for the most part, were of pious tracts. John Dunton in his book *Dublin Scuffle* describes him as a little squat man, who took great pride in his garden: "From his House he had me to his Garden, which though not very large, is to be admir'd for the curiousness of the Knots, and variety of choice Flowers that are in it; he being and excellent Florist."[18]

It seems from the (above) evidence of the tools, that the anonymous craftsman (known as the Devotional Binder) and William Norman, the Duke of Ormonde's binder, were associated in a way as yet unspecified.

1. The two Dukes of Ormonde spelt their names with a final 'e'. Members of the family did not. However, this is not always correct in contemporary manuscripts or imprints.

2. Trinity College Dublin, Dept. of MSS Miscl. vellum deeds, no. 51 (see R. Hayes (ed.), *Manuscript Sources for the History of Irish Civilisation*, Boston 1965).

3. National Library of Ireland, Genealogical Office MS 104, p. 7.

4. Carte's *Life of the Duke of Ormonde*, 2 vols., London 1851, *passim*.

5. G.D. Hobson, *Bindings in Cambridge Libraries*, Cambridge 1929, pl. LXII.

6. One of the tools on the spine also occurs in the same place on another binding by the Devotional Binder – *The Ladies Calling*, Oxford 1676 – in the Henry Davis Gift in the British Library (see H.M. Nixon, *English Restoration Bindings*, London 1974, pl. 86).

7. Hobson, *op. cit.* note 5, pl. LXII.

8. *Ibid.*

9. H.M. Nixon, *Broxbourne Library, Styles and Designs of Bookbinding*, London 1956, p. 157.

10. *Ibid.*

11. *Calendar of MSS at Kilkenny Castle* (Historical Manuscripts Commission, New Series), VII, 1912, pp. 526–27.

12. The six books are: *The Lively Oracles*; *The Decay of Christian Piety*; *The Gentleman's Calling*; *The Ladies Calling*; *The Art of Contentment* and *The Government of the Tongue*.

13. Sold at Sotheby's, 21 June 1965, lot 15 with illustration.

14. Charles Traylen, Catalogue 24, 1953, no. 733. The volume had the bookplate of Wm. Charles Earl Fitzwilliam. I am indebted to Maurice Craig for a photocopy of his rubbing of the volume.

15. Seen in a Galway antiquarian bookshop *ca.* 1990; the second copy was sold in Mealy's, *ca.* 1991.

16. Trinity College Dublin (SS. nn. 37); this edition was dedicated to the Duke of Ormonde; presentation copy from the author to Saml. Foley, 1680 (Samuel Foley, 1655–1695, bishop of Down and Connor; the sale catalogue of his library was distributed *gratis* at the house of Thomas Servant bookbinder, at the sign of the Bible in Golden-lane in 1695, see cat. 18 below); later bookplate of Claudius Gilbert. See M. Pollard, 'The Provost's Logic: An unrecorded First Issue', *Long Room*, no. 1, spring 1970, pp. 38–40.

17. The earliest recorded is on the titlepage of Sir James Ware's *Hunting of the Romish Fox*, Dublin: Joseph Ray for Will. Norman, 1683; and again, in 1687, in Sir W.D. Knight, *A Discourse on the Plurality of Worlds*, Dublin: Printed by Andr. Cook and Samuel Helsham, for William Norman, Bookbinder his Grace the Duke of Ormonde.

18. John Dunton, *Dublin Scuffle*, London 1699, p. 342.

16 ✶ *Bound by the Devotional Binder, ca. 1675*

Thomas Tonge, *Meditationes*, Dublin, Joseph Wilde, 1675, 12mo. (Wing T. 1887). Size: 134 × 78 × 20 mm

Provenance: The dedication copy to Arthur Capell, Earl of Essex, and on the reverse of the titlepage is the bookplate of Algernon Capell, Earl of Essex, dated 1701; Dr. T.P.C. Kirkpatrick collection (sold at Sotheby's, 28–29 November 1955, lot 261); Maggs Bros. Catalogue 845 (1957), no. 54 and again in their catalogues 893 (1964) and 996 (1975)

PAUL GETTY, KBE, WORMSLEY LIBRARY

Bound in deerskin or very light calf, and tooled in gold with the tools of the Devotional Binder. The covers are decorated with a central lozenge built up with floral tools, and four oval compartments made up two facing impressions of the same segmental tool, which is also used singly in the middle of each side. Smooth spine divided into six panels by gilt tooling.

All the tools used on the covers can be found on a binding by the Devotional Binder *ca.* 1675 in the Broxbourne Library, which also has a similar lozenge centrepiece (see cat. 15).[1]

1. H.M. Nixon, *Broxbourne Library*, London 1956, pp. 165–66.

17 🪶 *Bound by the Devotional Binder, ca. 1682*

Richard Lawrence, *The Interest of Ireland in its Trade and Wealth Stated*, Dublin, printed by Jos. Ray, for Jo. North, Sam. Helsham, Jos. Howes, W. Winter, El. Dobson and Will. Norman Booksellers, 1682. Dedicated to James, Earl of Ossory. Size: 163 × 108 × 26 mm

Provenance: the signature of *Austin Cooper 1777* appears on the titlepage; Mealy's sale, 10 September 1981, lot 189

PRIVATE COLLECTION

Black goatskin, tooled in gold to a panel design with a large kite-shaped floral tool facing outwards at each corner of the centre rectangle, while a small asymmetrical foliage tool faces inwards;[1] spine divided by five raised bands into six panels, each outlined by double fillets; edges of the boards decorated with a gilt roll; edges of the leaves gilt with the title written in black ink; white endpapers.

Another copy of this book, identically bound, was in Patrick King's Bulletin 5, 1984, no. 50 (see cat. 15 above).

1. The two tools are those of the Devotional Binder and are also found on a binding in the Broxbourne Library *ca.* 1675 and on a volume in the Henry Davis Gift in the British Library (see H.M. Nixon, *English Restoration Bookbindings*, London 1974, pls. 84 and 87).

Instructions to the binder of cat. 18

THE EIGHTEENTH CENTURY

18 ❧ *Bound by David Servant, ca. 1703*

Daniel Thomson, MS *Carmen Triumphate or A Congratulary Poem to His Excellency Prince James Duke of Ormond on his success at Vigo and arrival in Ireland,* 1703. Size: 270 × 197 × 10 mm

Provenance: Acquired with the Ormonde collection from Kilkenny Castle by the National Library

THE NATIONAL LIBRARY OF IRELAND (MS 9,838)

Bound in contemporary black goatskin and tooled in gold to a double panel design, with a single floral tool at the outer corners; flat spine with gilt lines; all edges gilt.

The floral tool is identical to that found on the binding of a MS book of letters, 1701 (National Library of Ireland MS 16,210). The front paste-down of this volume has lifted, revealing the instructions to the binder:

"Mr. Servant, Pray Lett these 2 Quires be bound in 2 Bookes (one Qu[ire] Each) in Calfes leather and Letterd on the outside as y[ou] have formerly done 'em (Book of Letters) I must needs have 'em to morrow being for the new Lords [?]fu[…] April ye 9th. 1702/ Asrs [in lighter ink] W. Dowdall

Pray send one of your Srvts immediately f[or] some Work"

"Mr. Servant" is, of course, Thomas Servant, the bookbinder singled out by John Dunton in his *Dublin Scuffle*:[1] "I never met with a more scrupulous, or consciencious man in my whole Life: he's punctual to his word in the smallest matters, and one that manages all his affairs with Discretion, courteous and affable in his Conversation, and ready to do every one what good he can."

Servant was a bookseller and publisher as well as a binder. He was admitted free of the Guild of Stationers in 1683[2] and elected Master of the Guild in 1708.[3] Servant is listed as living at the Sign of the Bible in Golden Lane in the library sale catalogue of Samuel Foley, bishop of Down and Connor, in 1695.[4] Later he moved to Castle Street and died in 1711.[5]

William Dowdall, who sent the book of letters to Servant to bind, was a bookseller in Castle Street. He was sworn free of the Guild in 1703,[6] though from the above evidence he was apparently in trade by 1701.

1. John Dunton, *Dublin Scuffle*, London 1699, p. 358.

2. Robert Munter, *The Print Trade in Ireland, 1550–1775*, New York 1988, p. 224.

3. Guild of St Luke Records, National Library of Ireland MS 12,123, p. 115.

4. *A Catalogue of Books distributed gratis at the house of Thomas Servant, Bookbinder, at the Sign of the Bible in Golden-Lane,* [Dublin] printed by Joseph Ray, at the 3 Naggs Heads in Essex St., 1695.

5. Munter, *op. cit.* note 2, p. 244.

6. Guild Records, *op. cit.* note 3, p. 81.

19 ❧ *Bound by the First Parliamentary Binder, ca. 1705*

Sir James Ware, *The Antiquities and History of Ireland* (title printed in red and black), Dublin, printed by A. Crook, Printer to the Queens most Excellent Majesty, for W. Dobson in Castle-Street, and M. Gunne at Essex-Street-Gate, 1705, the Dedication Copy to the Lord Lieutenant, the Duke of Ormonde. Size: 314 × 210 × 65 mm

Provenance: The dedication copy to James, 2nd Duke of Ormonde, with his arms in gilt on both covers; bookplate of Baron Pengwern; bookplate of Charles Arthur Wynne Finch 1878; acquired by the present owner from E. de Búrca in 1983

PRIVATE COLLECTION

Brown calf, marbled and tooled in gold to a panel design with the centre rectangle stained black; in the middle the gilt arms of the 2nd Duke of Ormonde[1] surrounded by drawer-handle tools. The spine is divided by five raised bands into six panels, each decorated with identical centre-and-corner tools, except for the second panel, which has a (later) lettering-piece.[2]

The marbling technique and many of the tools are found on the bindings of the Commons' Manuscript Journals for 1703 and 1704–05 (vols. 11 and 12). Robert Thornton, the first King's Stationer in Ireland, was appointed in 1692 and joined by Joseph Ray (perhaps as his deputy) in 1705. Nominally the holder of this lucrative office was to provide all the stationery ware including binding work for government use, but in practice, the bookbinding was farmed out.

James Butler (1665–1745) succeeded his grandfather as the 2nd Duke of Ormonde in 1688. He was Lord Lieutenant of Ireland from 1703 to 1707, and again from 1710 to 1713. Impeached in 1716 for his Jacobite sympathies, he had already fled to the Continent where he died in exile in 1745.

1. The same armorial block occurs on a binding of a copy of the Irish *Statutes*, Dublin (Benjamin Tooke) 1678 (Wing 1356; University College, Dublin, Library, special collections 30. S. 13.).

2. Another copy with a very similar design and many of the tools of the present volume is in a Dublin institutional library.

20 ❧ *Bound by the Second Parliamentary Binder, 1714*

The Holy Bible [together with] *The Book of Common Prayer*, Dublin, A. Rhames for Eliphal Dobson, at the Stationers-Arms in Castle street, and William Binauld in Eustace-street, 1714. Size: 385 × 265 × 125 mm

Provenance: Bible, *H. Davis 1714* lettered on the fore-edge; an inscription on the titlepage reads: *The gift of Hannah Davis to the Revd. Mr. Isaac Weld, Mar. ye 25th. 1758*; Bishop C.K. Irwin, sold at Sotheby's, 31 July 1956, lot 510; Maggs Bros. Catalogue 845 (1957), no. 103

THE WALTERS ART GALLERY, BALTIMORE, MARYLAND

Bound in contemporary red goatskin with onlays of black and citron, decorated on the sides to a 'cottage-roof' pattern enclosing a central rectangular panel with citron goatskin cornerpieces and an irregular-shaped centrepiece of black goatskin opening to a citron quatrefoil. Spine divided by six raised bands into seven panels, the first and seventh identically tooled to a centre-and-corner pattern, the second and sixth with citron and black onlays, arranged in a centre-and-corner pattern, third and fifth panels framed by an undulating black ribbon, the middle panel is also tooled to a centre-and-corner design; gilt edges; the fore-edge lettered *The Holy Bible, H. Davis, 1714*.

This binding is of particular importance since it is the only known surviving elaborate binding which approaches the scale of the early Parliamentary bindings. Several tools are identical to those found on the bindings of the manuscript Commons *Journals* for 1707 and 1709 (vols. 13 and 14). The Commons *Journal* for 1707 was the first elaborately bound volume of the series which continued until the act of Union in 1800. The series of the Lords' *Journals* began only late in the second decade of the century. All the previous volumes were bound or rebound in the early 1730s by Parliamentary Binder A (see remarks in the Introduction).

Other bindings from this shop: (1) *The Book of Common Prayer*, 8vo, Dublin 1712, has an almost identical onlaid centrepiece with the above binding, as well as many of the same tools (Rorborough Library, Exeter; rubbing in the possession of Dr Craig); (2) MS *Extracts of Several odd Papers to be mett with in Rymer's Faedera, December 17th, 1715*, bound in crimson goatskin and tooled in gold to a panel design, exhibited Foyles' *Exhibition of Irish Bindings 1954*, no. 60 (rubbing Dr M. Craig).

21 ᵺ *Bound by Parliamentary Binder A, ca. 1725–30*

[The Constitution of ye. Exchequer of Ireland 1693], lettered on the upper cover (see photograph).
Size: 382 × 248 × 25 mm

Provenance: Probably made for presentation to John, 2nd Lord Carteret (1690–1763), later Earl Granville, during his term as Lord Lieutenant of Ireland (1724–30); bookplate of the 6th Lord Carteret of Hawnes, dated 1841

Literature: Craig 1966, pp. 322–24, fig. 1; *Exhibition of Irish Bindings* 1954, no. 2A; Nixon 1954, pp. 216–17

THE MARQUESS OF BATH, LONGLEAT HOUSE, WILTSHIRE

The original manuscript of the above title was removed, probably in the nineteenth century, when a collection of letters of the Carteret family was inserted on blank leaves.

Bound in red goatskin, onlaid in black and fawn and tooled in gold to a panel design. The outer panel, which is bordered by five lines and a narrow roll, is powdered with dots and small daisy-like flowers; floral sprays issuing from the four corners are separated by incurved triangular compartments of fawn-coloured onlays; the inner rectangle is also bordered by a narrow roll and fillets which encloses a field of powdered dots and of daisy-like flowers; in the centre is an eight-sided fawn onlay compartment with concave sides crested with small tools; in the centre of the upper cover is the title of the manuscript, lettered in gilt – now covered by a nineteenth-century label. The gilt spine has eight raised bands and nine compartments, with every second one stained or onlaid in black. This is the finest surviving binding by Parliamentary Binder A, at an early stage of his development. The same binder was responsible for binding approximately thirty-five vols. of the Parliamentary MSS *Journals* (destroyed in 1922, see Introduction pp. 16–17): Lords 1743 (Sullivan 1905, p. 53), Lords 1634, Lords 1710, Lords 1745, Commons 1749 (Sullivan 1908, pp. 313–16), Commons 1749 (Sullivan 1914, p. 1), Lords 1697, Lords 1745, Commons 1747, Commons 1749 (Craig 1954, plates 1–3 and frontispiece).

Other bindings from this shop include: (1) John Digby MS written in the form of letters to members of his family dated 1730 and later, (*Exhibition of Irish Bindings* 1954, no. 2; rubbing in the possession of Dr Craig); (2) set of five identically bound vols. of the writings of (?) Dr Richard Allestree – four of the set are now in the Chester Beatty Library, and the fifth was in Maggs Bros.' recent bookbinding Catalogue 1212, no. 101, now in an Irish private collection (Craig 1954, p. 29, no. 25); (3) Justinus, Dublin, G. Grierson, 1727 (in McDonnell and Healy 1987, no. 102); (4) *TCD Charter*, Dublin, A. Bradley, 1735, Trinity College Dublin, 195 U. 8 (formerly Gall. 12. hh. 125); (5) Pine's Horace, 2 vols., London 1733, 1737, ex-libris of J.C. Gaisford St Lawrence (in H.M. Nixon, *The Oldaker Collection of British Bookbindings in Westminster Abbey Library*, London 1982, no. 68); (6) Samuel Clarke's *Paraphrases on the Gospels*, Dublin, printed by S. Powell for E. Exshaw, 1737, ex-libris of Viscount Powerscourt, E. McC. Dix gift to TCD (1909), Trinity College Dublin, Armoire and vol. 2 Royal Irish Academy (Craig 1954, p. 29, no. 31; Craig 1976, pl. 2); (7) Bishop Hort's *Sermons*, Dublin, George Grierson, 1738, two copies: (A)

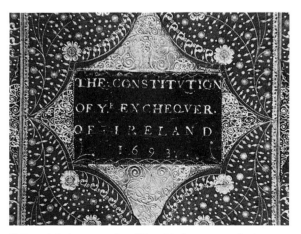

Photograph during conservation of the original upper cover of cat. 21 (courtesy of the British Museum)

Gilbert Library, Pearse Street, Dublin, (B) private collection, acquired from Maggs Bros.; (8) E. Chambers, *Cyclopaedia*, Dublin, 1740, two copies: (A) Trinity College Dublin, Gall. LL. 36. 13–14, (B) University College Dublin, Special Collections; (9) Rider's *British Merlin for 1742*, London 1742, Trinity College Dublin, Armoire; (10) E. Borlase, *History of the Irish Rebellion*, Dublin, for Oli. Nelson & Charles Connor, 1743, three identically bound copies: (A) University Library Cambridge, Hib. 3. 7431.1, (B) private collection, (C) private collection; (11) [Dodsley], *The Oeconomy of Human Life*, Dublin, G. Faulkner, 1751, Trinity College Dublin, Armoire, formerly Lecky A. 1. 24 no. 1; (12) Lord Orrery's *Remarks on the Life of Swift*, Dublin, G. Faulkner, 1752, two copies: (A) Lord Rothschild's Collection, Trinity College, Cambridge (*The Rothschild Library* 1954, no. 1490), (B) Pickering & Chatto, *Fine books from five Centuries*, List 87, November 1989, no. 52 (Craig 1954, p. 38, nos. 8 and 9).

22 ❦ *Bound by Parliamentary Binder A, ca. 1733*

Cervantes, *Don Quixote, translated by Skelton and Blunt with curious cutts from the French by Coypell*, Dublin, printed by and for S. Hyde and J. Dobson, and for R. Owen Booksellers, 1733, 4 vols., 12mo. Size: 170 × 105 × 20 mm

Provenance: Signature of Amelia Palmer on the free leaf facing the titlepage in vol. II; presented by T.C. Sankey Barker to the National Museum in 1941, and since transferred to the National Library (see also cats. 55(a), 55(b))

Literature: Craig 1976, ill. on the front flap; Craig 1954, p. 29, no. 27a

THE NATIONAL LIBRARY OF IRELAND (LO 2574 / BD)

Bound in tan goatskin with black staining and tooled in gold by Parliamentary Binder A; panelled cover design with black-stained triangular compartments in the outer frame; the inner rectangle encloses an oval centrepiece formed by four black-stained *vesicae*, touching point to point. An exquisitely tooled binding, showing the mastery of Parliamentary Binder A on a small scale.

23 ❦ *Bound by the Worth Binder, ca. 1729*

P. Ovidius Naso, *Metamorphoseon … ad usum serenissimi Delphini*, Dublin, Ex Officina Georgii Grierson, 1729. Size: 239 × 182 × 45 mm

Provenance: On the first paste-down a circular cream-coloured label with the gilt armorial bookplate of Baron Cremorne (1866–97)

Literature: McDonnell and Healy 1987, p. 76, cat. no. 3, p. 88, pls. II, C.; illustrated in Mitchell 1968; National Library of Ireland MS 5229, Catalogue of the Library of Dartrey, Cootehill, Co. Cavan (*ca.* 1888)

THE NATIONAL LIBRARY OF IRELAND (LO 2509)

Red goatskin with gold tooling and black staining; covers decorated with wide borders and central lozenges, mostly made up from gouges and small floral tools; gilt spine. The earliest known Irish binding in the Harleian style, characterized by a broad border and a tooled lozenge centrepiece.

24 ℚ *Bound by Joseph Leathley's Binder, 1730s*

Ovid, *Metamorphoses* (title in red and black), Dublin, George Grierson, 1729. Size: 243 × 192 × 60 mm

Literature: McDonnell and Healy 1987, chaps. 4 and 6

GEORGE MEALY AND SONS, CASTLECOMER

Bound by Joseph Leathley's binder in red goatskin and black staining and tooled in gold to an Irish Harleian design (see previous). The gougework and black staining of the lozenge is clearly inspired by the Worth Binder (cat. 23). The peacock roll used on the outer border is similar to that used by the Parliamentary Binders.[1] This previously unrecorded binding is probably the earliest Harleian-style binding from this shop.

Joseph Leathley, the Trinity College bookseller from about 1734 onwards, was also responsible for supplying stationery, including binding work. He probably had a bindery or employed a binder on his premises, as Dr Edward Hill (1741–1830), who visited the shop of Leathley's widow, Ann, recorded payment for binding work in the early 1760s (in his unpublished memorandum and account book): "To Leathly … paid for gild'g of Pembroke's *Arcadia* 3vs 2/3".[2]

1. McDonnell and Healy 1987, plate XC, R26.
2. See Patrick King, *Bulletin 22*, 1994, no. 70.

25 ℚ *Bound by the Worth Binder, ca. 1728*

Voltaire, *La Henriade*, London, 1728. Size: 300 × 235 × 29 mm

Provenance: Dr Edward Worth

Literature: McDonnell and Healy 1987, appendix 1, no. 21, pp. 76–77; McCarthy 1986, pp. 29–35

THE WORTH LIBRARY, DR STEEVENS'S HOSPITAL, DUBLIN (1.3.3)

Bound in calf with red onlays and tooled in gold by the so called Worth Binder. The sides have a wide border of floral sprays and dotted ground, similar to that of the Parliamentary bindings of the 1717–21 period. Dr Edward Worth (1678–1733) left his library of over four and a half thousand volumes to Dr Steevens's Hospital in Dublin.

26 ℚ *Bound by Joseph Leathley's Binder, 1738*

Plato, *The Seven Select Dialogues* (Greek text), ed. John Hawkey, Dublin, E Typographia Academiae, 1738 (large paper copy). Size: 228 × 141 × 43 mm

Literature: McDonnell and Healy 1987, p. 47, cat. no. 22, p. 120, pls. xv, xcix; Craig 1954, no. 38, p. 29

THE NATIONAL LIBRARY OF IRELAND (LO 2504)

Bound in dark-blue goatskin and tooled in gold to a Harleian design; spinc gilt. One of the ten "blew Turky" copies supplied by Joseph Leathley at a cost of ten shillings indicated in a bill submitted on 2 November 1738 (Trinity College Dublin, Mun/Lib/10/102).

27 ❧ Bound by Joseph Leathley's Binder, 1745

P. Terentius Afer, *Comoediae*, ed. John Hawkey, Dublin, E Typographia Academiae, 1745 (large paper copy), the dedicated copy to Lord Chesterfield. Size: 224 × 147 × 40 mm

Provenance: The armorial bookplate of Lord Chesterfield on the front paste-down; Sotheby's sale, 8 April 1919; Maggs Bros. Catalogue 407, no. 306; National Museum Dublin with circular stamp: *Science & Art Museum Dublin 228*, 1921; later transferred to the National Library of Ireland

Literature: McDonnell and Healy 1987, no. 39, pls. XXIX, CI; Craig 1954, p. 38, no. 5

THE NATIONAL LIBRARY OF IRELAND (LO 2543)

Bound in scarlet goatskin and tooled in gold to an Irish Harleian design. The dedication copy to the Lord Lieutenant, Philip Dormer Stanhope, 4th Earl of Chesterfield. Chesterfield had been appointed Lord Lieutenant in January 1745 and arrived in Dublin in July. His period in office was short and he departed the following year after making a favourable impression.

28 ❧ Bound by the Watson Binder, 1730

MS *C. Julii Caesaris Commentaria*, 15th century, 210 vellum folios. Size: 300 × 235 × 29 mm

Provenance: Arms of Alain de Coetivy (ob. 1479)

Literature: Craig 1954, p. 29, no. 27

Bound in contemporary red goatskin and tooled in gold to a panel design; the spine has five raised bands and six compartments, all gold-tooled; edges gilt.

On page 13 of the Visitation Records in Marsh's Library is the following note: "21st Visitation, 28 October 1730, Rev. Mr. John Wynne Librarian and Rev. James King Sub-Librarian, did appear before ye Governors …"; and on page 13v: "Ordered that ye manuscript called Caesars Commentaries be new bound." Marsh's Library Account book 1731–1953 records on p. 3: "Paid Mr. Watson for binding gilding & lettering a Ms. of Caesar's commentaries by order of the Governours at the twenty first visitation, [£] 0: 9 : 6."

Watson, whose name appears further on in the Account book for supplying various books to the Library, was probably the bookseller and publisher John Watson of Merchant's Quay, the publisher of the well known Watson's *Almanacks*.

29 ❧ Bound by the Exshaw Bindery

Thomas Wilson, *Instructions for the Lord's Supper*, Dublin, S. and J. Exshaw, 1749. Size: 136 × 84 × 15 mm

Literature: McDonnell and Healy 1987, pp. 44, 51 notes 6, 334b; Craig 1976, pl. 5; Craig 1954, pl. 26

THE NATIONAL LIBRARY OF IRELAND (LO 181)

Bound in red goatskin and tooled in gold to an Irish Harleian design. The border is decorated with the distinctive fox and peacock roll; lozenge built up from small tools; the spine has four raised bands and five panels, all gold-tooled, except the second which is lettered; all edges gilt.

Since this volume was identified as a product of the Exshaw shop, four other bindings can now be added to the list: (1) A folio *Book of Common Prayer*, London 1701, which belonged to the Earl of Kildare; it is bound in red goatskin and decorated with gold tools to a panel style;[1] (2) a small folio

red goatskin *emboîture,* tooled in gold to a panel design, and lettered on the upper cover: *The gift of Mrs Foster to ye Parish Church Collon* [Co. Louth], 1766, National Library of Ireland, Dubl. 1796, Dix LB; (3) John Winstanley, *Poems,* Dublin, 1751, Cambridge University Library (Hib. 7. 742. 21); (4) another copy, similarly bound, was in Patrick King's Bulletin 18, 1990, no. 50, and again in Maggs Bros. Catalogue 1212, 1996, no. 112.

1. *Church Representative Body, Watson collection,* [n.d.], no. 31.

30 ℬ *Bound by Parliamentary Binder A, mid-18th century*

Sallust (C. Crispus), *Opera,* ed. John Hawkey, Dublin, E Typographia Academiae, 1747. Size: 189 × 120 × 20 mm
Provenance: Sir Edward Sullivan, 2nd Bt.; Judge O'Brien bequest to the Jesuit Library, Milltown Park
Literature: *Folye's Exhibition of Irish Bindings* 1954, p. 9, no. 11a; Craig 1954, p. 11, pl. 22; Sullivan 1905, p. 59
THE JESUIT LIBRARY, MILLTOWN PARK, DUBLIN

Bound in contemporary red goatskin with black-stained *vesicae*; the covers gold-tooled with a wave-and-bird border enclosing a lozenge centrepiece which has a white leather onlay. A matching Horace (1745) is in the Rothschild Collection in Trinity College, Cambridge.[1] Another set is divided between three different collections: (1) Sallust, Dublin 1747, National Library of Ireland (LO 2542/bd.), (see Craig 1954, p. 30 no. 52); (2) Horace, Dublin 1745, Shrewsbury School; (3) Virgil, Dublin 1745, British Library, Henry Davis Gift P 654 (see Mirjam M. Foot, *The Henry Davis Gift,* London 1983, II, no. 252); A Horace, Dublin 1745, perhaps from another set, is in The Philadelphia Free Library (Mills 611).[2] A similarly bound Juvenal, Dublin 1745, is in an Irish collection (formerly Henry B. Wheatley collection, sold at Sotheby's, 9 April 1918, lot 335). A set of five Hawkey Latin Classics, Dublin University Press, 1745–47, in red goatskin, and tooled in gold by Parliamentary Binder A, including his peacock roll, is in the Cambridge University Library, Hib. 7. 745.1–3, 746.10, 747.13 (Craig 1954, p. 30, no. 53).

1. *The Rothschild Library* 1954, no. 2738.
2. D. Miner, *The History of Bookbinding 525–1950,* exhib. cat., Baltimore Museum of Art, Maryland, 1957–58, no. 512, pl. XCIX.

31 ℬ *Bound by Edward Beatty (Parliamentary Binder B), ca. 1755*

MS Vitruvius, *etc* by Michael Wills. Size: 484 × 310 × 60 mm
Literature: McDonnell 1992–93, pp. 52–56, pls. 11 and 15; Craig 1976, pl. 10; Craig 1954, p. 8f.
THE TRUSTEES OF THE CHESTER BEATTY LIBRARY, DUBLIN (WESTERN MS 192)

Bound *ca.* 1755 in red goatskin and tooled in gold. The covers are edged by a border which encloses a large white-paper central lozenge with featherwork tooling. The spine has six raised bands and seven compartments, gold-tooled. Edward Beatty is now known to have been paid £3. 15s. 7d. for binding this volume by the Parliamentary Binder B. One of Beatty's former apprentices, John Fox, later became head of the bookbinding department in Abraham Bradley King's establishment.

Other bindings from this shop include: (1) *The Ladies Memorandum-book,* Dublin, n.d. (Craig 1954,

pl. 33); (2) Charles Smith, *The Ancient and Present State of the County and City of Waterford*, Dublin, A. Reilly, 1746, 2 vols., The British Library, C. 128. c. 4, and Charles Smith, *The Ancient and Present State of the County and City of Cork*, Dublin, A. Reilly, 1750, 2 vols., The British Library, C. 108. d. 17; (3) *Observations made by the Commissioners on Barracks*, Dublin, printed by Abraham Bradley, 1760, Irish Architectural Archive, Dublin; (4) Thomas Gray, *Designs by Mr. R. Bently, for Six Poems by Mr. T. Gray*, London 1753, with the signature of the famous collector Judge Robert Hellen on the titlepage (see Maggs Bros. Catalogue 1212, 1996, no. 118).

A Bible, Cambridge, 1668, no. 11 in Edward Baytun-Coward, Catalogue 3 for George Bayntun, Bath was incorrectly described as having the tools of Edward Beatty (Parliamentary Binder B). The tools mentioned in the catalogue are similar but not identical to those used by Beatty.

32 ❦ *Bound by Edward Beatty (Parliamentary Binder B), ca. 1756*

Thomas Leland, *All the Orations of Demosthenes*, Dublin, printed at the University Press by William Sleater, 1756. Size: 272 × 218 × 25 mm

Provenance: On the verso of the first free leaf is the armorial bookplate of Robt. Tayler M.A.; on the top left corner of the same sheet the number *95* is written, and *IV* in a puce pencil; on the final white endleaf are the following letters in ink: *u j t/ S T* [underneath].

Literature: McDonnell 1992–93, pp. 52–56; *Das Gesicht der Bücher* 1987, pl. 41; Craig 1976, pl. 11; Craig 1954, pp. 14–15, pl. 31; *Livre Anglais* 1951, no. 422, pl. 15

MUSEUM FÜR KUNSTHANDWERK, FRANKFURT AM MAIN (INV. LB 106)

Bound in red goatskin and tooled in gold to an all-over design including leaf sprays, flame-tools crescents, dots, cornucopiae, an acanthus-tool and featherwork decoration.[1] Like the Parliamentary bindings by Edward Beatty (Parliamentary Binder B), the surface is squared up in blind to guide the finisher in placing his tools. In the centre of each cover is a red circular gold-tooled onlay, added about 20–25 years later, possibly masking an inscription or an armorial device. The gilt spine is divided by five raised bands into six compartments, of which the second and third have blue labels with title and imprint lettered in gold; edges of the boards and turn-ins decorated with foliage roll; red and white double endbands, dark-green silk marker.

The Board of Trinity College had agreed to take two hundred and fifty copies of the work, to be distributed as premiums, and a specially bound copy was presented to the Duke of Cumberland, Chancellor of the University.[2] Among the subscribers to the book was Lord Charlemont, to whom it was dedicated. He took twenty copies, as did Francis Andrews, the Provost of Trinity College.

This is the second recorded copy of Leland's Demosthenes in a featherwork binding by Edward Beatty (Parliamentary Binder B). The first was discovered by John Hayward in 1951 (then in the library of Lady Celia Milnes-Coates) and shown in Paris the same year at the Exposition du Livre Anglais in the Bibliothèque Nationale. The binding apparently caused quite a stir, particularly since the featherwork anticipated by two centuries the similar style and technique of Paul Bonet, the leading French bookbinder/designer.

1. The term was used by Maurice Craig to describe the use of curved tools called 'gouges' in converging or radial patterns. See Introduction.

2. McDonnell and Healy, 1987, pp. 31–32, 40 note 46.

33 ⤳ Bound by George Faulkner's Binder (formerly known as the Rawdon Binder), mid-18th century

The Book of Common Prayer, Dublin, Crook and Took, 1680. Size: 233 × 185 × 33 mm

Provenance: inscribed on the titlepage *Hellen Rawdon My Book Drougheday*

Literature: McDonnell, 'Coote Armorial Bindings', 1995, pp. 6–7, notes 27–30; Craig 1976, pl. 6; Craig 1954, appendix and pp. 30 (no. 57a) and 45

THE BOARD OF TRINITY COLLEGE, DUBLIN (33.b.64)

Bound in dark-blue goatskin and tooled in gold. The sides decorated with *dentelle* borders and converging gouge work in the corners. The centrepieces similarly tooled with gouge work (both *au pointillé* and solid) in addition to the usual tools. The Rawdon Binder is to be identified with George Faulkner's Binder, who appears to have been part of one of the largest binding establishments in the city.

A similar binding, on a MS Book of Hours of the Use of Rouen, also owned by the Rawdon family, is in the University Library, Cambridge (Add. MS 4092), and has been published by Craig.[1] To this can be added another Book of Hours of the Use of Rouen in a similar binding of blue goatskin (but no featherwork) in the Victoria and Albert Museum, Reid 17 (A.L. 1658–1902), where the binding is described as English. Like the Cambridge volume it has a label on the spine entitled: *Mass Book*.

Other bindings from this shop in addition to the list given in McDonnell, 'Coote Armorial Bindings', 1995: (1–5) Craig 1954, pls. 24, 25, 27, 29, 30; (6) Pine's Horace, London 1733, 1737 (see H.M. Nixon, *The Broxbourne Library*, London 1956, no. 88; Craig 1954, p. 29, no. 34); (7) Grotius, *De Veritate Religionis Christianae*, The Hague 1734 (see Craig 1954, p. 29, no. 29; rubbing in the possession of Dr Craig); (8) Bible, Edinburgh 1744, vol. 2 only (see Craig 1954, p. 29, no. 40a; rubbing in the possession of Dr Craig); (9) *Book of Common Prayer*, Dublin, Grierson, 1742, University Library Cambridge, Hib. 4. 742. 1 (Bradshaw 855); (10) *Book of Common Prayer*, Dublin, 1745, University Library Cambridge, Hib. 9. 745. 1. (Bradshaw 861); (11) Peter Browne, *Sermons*, Dublin, printed for George & Alexander Ewing, 1749, University Library Cambridge, Hib. 7. 749. 79; (12) Charles Smith, *History of Waterford*, Dublin 1750, University College Dublin, Special Collections, 24. Y. 4.; (13) [Samuel Madden], *Boulter's Monument*, London 1745, three copies similarly bound: (A) The British Library, C. 109.BB4; (B) Gilbert Library, Pearse Street, Dublin; (C) private collection (see Craig 1954, p. 30, no. 47).

1. M. Craig, 'Irish Bookbinding', *Apollo*, October 1966, pp. 322–25, fig. 4.

34 ﷯ *Bound by The Coote Binder, 1760s*

La Fontaine (Jean de), *Fables Choises mises en vers par J. de la fontaine*, 4 vols., Paris, chez Desaint & Saillant, Durand, De Imprimerie de Charles Antoine Jombert, 1755–59. Size: 413 × 274 × 106 mm

Provenance: Dawsons of Pall Mall, London; sold at Sotheby's, 18 February 1957, lot 43; Maggs Bros. Catalogue 1000, no. 56

Literature: McDonnell, 'Coote Armorial Bindings', 1995, p. 7, note 24; Opperman 1983; Girardin 1913, pp. 217–36, 277–92, 330–47, 386–98

PAUL GETTY, KBE, WORMSLEY LIBRARY

"The most heroic enterprise in the history of the rococo illustrated book ... the 276 compositions reflect equal credit on the redrawing and on the 42 engravers turn and turn about signing the plates, as well as the banker who originally financed the work as a non-profit-making operation, and on the sponsor who ruined his own fortunes during the nine years he occupied in seeing the four volumes through".[1] The celebrated edition, illustrated after sketches by the artist Jean Baptiste Oudry (1686–1755), consists of 276 engraved and etched plates. Oudry began to make a series of drawings to illustrate the fables of La Fontaine about twenty-five years before their publication. The artist executed the drawings in his spare time from his official duties as painter for the Royal tapestry works at Beauvais. He envisaged using them for tapestries, but when he died in 1755 the 275 sketches were bought by a collector who handed them over to Charles Nicolas Cochin *fils* (1715–1790) to adapt them for engraving. The three first volumes of the book were published in 1755 and 1756. The publishers then found themselves in financial difficulties, and were only able to publish the fourth volume in 1759 with the assistance of a royal grant. The flower painter Jean Jacques Bachelier (1724–1806) was commissioned to produce the tailpieces which were then engraved on wood by Jean Michel Papillon (1698–1777) and Nicolas Le Sueur (1691–1764).

Bound in red goatskin and gold-tooled to a Harleian design by the Coote Binder. The gilt spine has seven raised bands, and eight compartments with title in the second. This anonymous binder gets his name from a number of Coote armorial bindings which are all bound with the same set of tools. It seems from all the available evidence that they were owned by Charles Coote, the Earl of Bellamont (1738–1800). Two other binders, or shops, also bound for this patron but on fewer books. Charles Coote's career is amply chronicled in contemporary letters and journals, mostly on account of his notoriety.

1. Owen E. Holloway, *French Rococo Book Illustration*, London 1969, p. 6.

35 ﷯ *Bound by Boulter Grierson's Binder, 1765*

The Statutes at large passed in the Parliaments held in Ireland: from 1310 ... to 1761, Dublin, Boulter Grierson, 1765, vol. III. Size: 370 × 234 × 55 mm

Provenance: Sold at Sotheby's (de Zoete sale), 8 April 1935

Literature: Kissane 1994, no. 12; McDonnell 1992–93, p. 56, note 11; Craig 1976, front cover; Craig 1954, pp. 17–18, pl. 40; *The Rothschild Library* 1954, no. 2739, pl. LX

THE IRISH GEORGIAN SOCIETY (GIFT OF PAUL GETTY KBE)

Bound in red goatskin and tooled in gold with a wide border composed of floral and curved tools (gouges), and a white curved leather onlay with *vesicae* stained black, and opened in the centre to display a dark blue inset. The gilt spine has six raised bands and seven compartments with the title and volume number in the second on a dark ground; the third compartment has a yellow onlay with the date. The complete set of *Statutes* consists of eight volumes. Of this set the Irish Georgian Society possess volumes I–V; vol. VI is in the Rothschild Collection, Trinity College Cambridge, and volume VII is in the National Library. The Royal Copy (British Library 21. e. 1–8), which is complete, is the only other known set with coloured onlays. Boulter Grierson charged £22. 15s. 0d. for binding the set or £2. 16s. 10d. per volume, as indicated in a copy of his bill in the National Archives (MS 2446, 17 December 1765):

"An Account of the Expence of Printing and Binding a New Edition of the Statutes at large in this Kingdom pursuant to Govts. Order to Boulter Grierson, His Ma^tys Printer Genl. in Ireland, dated the 27th. April 1762.

The Expence of one Set delivered in Great Britain {1736 Sheets at 2d each £14 9 4}
{bindg. 8vols. at £2-16-10- ea 22-15} [£] 37-4-4
The Expence of one Set delivered in Ireland {1736 Sheets at 2d. each £14-9-4}
{bindg. 8 Vols. at 10s ea £4___ } [£] 18-9-4
No. of Sets deld. by Govt. Order

1 To His Ma^ty, elegantly bound in Turkey and ornamented with gold	£37-4-4
1 To His Royal Highness the Duke of York	37-4-4
1 to His Excellency the Lord Lieutenant	37-4-4
2 to their Exices the Lords Justices	74-8-8
2 to the Speakers of both Houses of Parlt. in Great Britain	74-8-8
1 to the Rt. Honble. Genl. Conway, one of His Ma^tys Principal Secrys of State	37-4-4
1 to his Grace the Duke of Grafton Do	37-4-4
1 to the Marquess of Rockingham, first Lord of the Treasury	37-4-4
1 to the Earl of Halifax	37-4-4
1 to the Earl of Northumberland	37-4-4
200 to the Rt. Honble. the House of Lords in this Kingdom	3693-6-8
310 to the Rt. Honr. & Honr. the House of Commons	5724-13-4
9 to the Judges of the Several Courts in this Kingdom	170-5-"
4 to His Ma^tys four Courts	73-17-4
1 to Trinity College	18-9-4
2 to the Secry's Offices in Ireland	36-18-8
	£10164-2-4

Deduct so much received on account 3911-19-7
Remains to Compleat £6252-2-9

N.B: Eight of the above mentd. Sets sent ot Great Britain are consigned to Mr. Johnston, Bookseller, Ludgate Street London, to be by him delivd. to the Abovemend. Persons.
{County of the City of Dublin to wit} Boulter Grierson of the City of Dublin His Maty's Printer Genl. in Ireland, came this Day before me and maade Oath on the Holy Evangelists, that he hath delivered all the Books in the manner mentioned in the above Account, and that he hath charged no more than the usual Prices which his Ordinary Customers pay him.
Sworn before me in Dublin this 3rd. Day of Decr. 1765, Boulter Grierson. Francis Booker."

Other presentation sets or part sets: (1) Lord Brownlow, Belton House, sold at Sotheby's, 8 November 1971, lot 144, bookplate of Sir John Cust, Bt., Speaker of the House of Commons 1761–1770, (2) Earl Fitzwilliam, Wentworth Woodhouse set: vol. IV is in the National Library (LO), vol. V is in the British Library (C. 108.i.13), vol. VII is in the Mills Memorial Library, McMaster University, Hamilton, Ontario (ex J. Barry Brown Collection, Co. Kildare), vol. VIII in Maggs Bros. Catalogue 1212, no. 134; C. Traylen, Catalogue 27, 1953, no. 27 illustrates another volume from this set (Craig 1954, p. 39, no. 15b.) (3) vol. II (only) from the de Zoete sale at Sotheby's, 8 April 1935, lot 321, later in the J.R. Abbey collection, sold at Sotheby's, 23 June 1965, lot 633, now in the Henry Davis gift to the British Library (see M.M. Foot, *The Henry Davis Gift*, London 1983, II, no. 261); (4) set sold at Sotheby's, 18 February 1957.

Other bindings from this shop: (1) Bible, Cambridge, J. Baskerville, 1763, folio with silver cornerpieces and elaborate onlays like the Getty *Statutes*, but larger (illustrated in E.C. Lowe Catalogue, 1952, no. 76; Craig 1954, p. 38, no. 14a); (2) *Book of Common Prayer*, Dublin, Boulter Grierson, 1766, 12mo., red goatskin with onlays like the Getty *Statutes*, leather book label: *Nichos. Gibton, New Row, Thomas Street Dublin* (The directories of the period list Gibton as a farrier), private collection; (3) Matthew Henry, *The Communicant's Companion*, Dublin, printed by S. powell for George Risk, at Shakespeare's Head, in Dame Street, 1736, leather label (now removed): *The gift of Nichos. Gibton [sic], Jun to his Dear and well Beloved cousin Elizabeth McMullen in testimony of my esteem 1768*, University Library Cambridge, SSS. 31. 15 (8473) (Craig 1954, pl. 34).

36 ❧ *Bound by Boulter Grierson's Binder, ca. 1765*

Sylvester O'Halloran, *A Complete Treatise on Gangrene and Sphacelus; with a new method of Amputation*, London [Limerick], for Paul Vaillant, 1765, first edition, 8vo. Size: 203 × 130 × 25 mm

Provenance: with a specially printed six-page dedication on thick paper to Francis, Earl of Hertford, Baron of Ragley, Lord Lieutenant of Ireland, with the Ragley Hall bookplate; Sotheby sale, 20 July 1970, lot no. 97; Maggs Bros. Ltd, *Bookbinding in the British Isles*, Catalogue 1075, pt. 2, no. 180

Literature: Cameron 1916; Widdis 1949; Lyons 1963, pp. 217–32

THE IRISH GEORGIAN SOCIETY (GIFT OF PAUL GETTY, KBE)

The dedication copy to the Lord Lieutenant, the Earl of Hertford. The book was printed in Limerick by A. Walsh but issued with Limerick or London imprints (the latter probably fictitious). Bound in red goatskin with black staining and tooled in gold, by Boulter Grierson's Binder.

Sylvester O'Halloran (1728–1807) was born in Limerick on 31 December 1728. He was one of three sons of Michael O'Halloran, a prosperous farmer from Caherdavin in Co. Limerick. The eldest son, Joseph Ignatius, entered the Jesuit College in Bordeaux where he eventually joined the Society and became a professor of philosophy. After the suppression of the Jesuits in France he returned to Ireland and ministered as a priest in Townsend Street Chapel in Dublin until his death in 1800. The youngest son, George, became a silversmith and jeweller in Limerick where he acquired considerable property. Sylvester, after receiving his early education locally, studied medicine at Leyden and Paris universities before returning to Limerick to practise. He had a special interest in the eye, at a time when treatment of this organ was left chiefly to quacks, and first attracted attention with his paper *A critical analysis of the New operation for a Cataract*.

In July 1764 a notice appeared in the *Dublin Magazine*, stating that "Mr. O'Halloran hath published proposals for printing by subscription – A treatise on the different Disorders that require Amputation; in which will be described a new method of performing this operation – The price to subscribers is six British shillings, Subscriptions are taken in by the Editor of this Magazine." In the following year, *A Complete Treatise on Gangrene* was published; O'Halloran wrote in the appendix to this work 'Proposals for the Advancement of Surgery in Ireland', which led to the foundation of the Royal College of Surgeons in Dublin. As well as his medical writings, O'Halloran wrote on Irish antiquities, and his *History of Ireland* ran into several editions. A contemporary wrote of him as a "tall, thin doctor in his quaint French dress, with his gold-headed cane, beautiful Parisian wig and cocked hat".

37 ෴ *Bound by the Bible and Prayer Book Binder, mid-18th century*

The Book of Common Prayer, Oxford, Thomas Baskett, 1754. Size: 196 × 120 × 44 mm

Provenance: Signature on the titlepage of Sir Richard Butler. Presentation inscription on the endleaf from his wife, Lady Butler, to their daughter Frances Butler. Stamp name of Frances Butler on the portrait and title. Nineteenth-century inscription of M.M. Elwyn of Philadelphia (Sir Richard Butler (1699–1768), 5th Bt. of Garryhunden, Co. Carlow, and MP for Co. Carlow. His third son (and Francis Butler's brother), Pierce Butler, was living in South Carolina by 1771, where he married Mary Middleton. He was a representative in the State Legislature between 1778 and 1789, when he was elected to the Senate. He died in Philadelphia in 1822. The M.M. Elwyn whose signature is also on the endleaf is more than likely Mary Middleton Mease who married Alfred Langdon Elwyn in 1832 and lived in Philadelphia); The Book Block, Cos Cob (Greenwich) Connecticut, USA; Maggs Bros. Ltd, *Bookbinding in the British Isles*, Catalogue 1212, no. 119

PAUL GETTY, KBE, WORMSLEY LIBRARY

Bound in red goatskin and tooled in gold, with a centrepiece of scalloped cream paper onlay, opening to red ground; the spine has six panels, two of which are onlaid on cream paper and tooled with acorns stained black This anonymous craftsman binder has been given the name 'The Bible and Prayer Book Binder' because his tools – to date – are found only on such books.

Other bindings from this shop: (1) *Book of Common Prayer*, Dublin, A. Rhames for J. Hyde etc., 1724, 12mo., National Library of Ireland, LO (Craig 1954, p. 28, no. 20); (2) *Book of Common Prayer*, Cambridge, Baskerville, 1762, 8vo. (Abbey Sale, Sotheby's, 19 June 1967, lot no. 1791), an important Irish Collection; (3) *Book of Common Prayer*, Cambridge, Baskerville, 1762, 8vo. (Foyles' *Exhibition of Irish Bindings* 1954, no. 16); (4) Bible, Cambridge, John Baskerville, 1763, folio elaborately bound in red goatskin with curvilinear lozenge onlays, sold at Sotheby's, 17 January 1974, lot 196 (illustrated), now in an important Irish Collection; (5) *Bible,* Cambridge, J. Baskerville, 1763, folio, Broxbourne Library (Bodleian, Oxford) no. 112. 1; (6) *Book of Common Prayer*, Dublin, Grierson, 1765, 8vo., lettered: *Michael Seymour 1779* on the upper cover, The British Library C. 66. b. 18 (Craig 1954, p. 35, no. 147); (7) *Book of Common Prayer*, Dublin, Grierson, 1765, 8vo., signature of *Robt. Gregory, Coole near Gort* on the titlepage, National Library of Ireland, LO (Craig 1954, p. 32, no. 94).

38 ᖫ *Bound by Josiah Sheppard, ca. 1770*

Edward Bayly, *A Sermon preached on the opening of Chapel of the Magdalen Asylum for Female Penitents, in Leeson Street, on Sunday 31 Jan 1768, by the Rev. Edward Bayly, Dean of Ardfert, Chaplain to Her Royal Highness the Princess Dowager of Wales and to His Excellency the Lord Lieutenant. And printed at the desire of His Excellency Lord Viscount Townsend, Lord Lieutenant of Ireland, etc.*, Dublin, Printed for Josiah Sheppard, in Skinner-Row; Bookseller & Stationer to the Asylum [bound with] Edward Bayly, *A Sermon preached on the opening of the New Chapel of the Magdalen Asylum, in Leeson- Street, Dublin, … Sunday 18 March 1770*, Dublin, Printed for J. Sheppard, in Ann-Street, Stephen's Green, 1770. Size: 260 × 205 × 23 mm

THE BRITISH LIBRARY (C. 109. f. 16.)

Red goatskin with onlays in centre and corners of dark blue or black and tooled all over in gold; in the centre is an anchor, the symbol of Faith; spine has five bands and six compartments, all gold-tooled. On page 64 it is stated that "Mr. Josiah Sheppard, bookseller, in Ann-street, Stephen's green, gave a large Bible and two Prayer Books for use of the Chapel".

Josiah Sheppard, bookbinder, was sworn free of the Guild on 11 February 1755.[1] He was one of the master bookbinders, together with his son Henry, who took part in the dispute with the booksellers in 1760s.[2] He had a number of apprentices, including a Jacob White, who left after one year and went to William Whitestone, stationer, and enrolled on 11 May 1760.[3]

Other bindings from this shop: (1) John Butley, ed., *The Bible Illustrated and Explained*, 2 vols., London, Printed for H. Woodgate, & sold by Mr Prince, at Oxford, … Williamson in Dublin 1762, private collection; (2) John Leland, *The Advantage and Necessity of Christian Revelation*, 2 vols., Dublin, Printed for S. Cotter, and J. Sheppard, in Skinner-Row 1766, bookplate of Ragley Hall, sold at Sotheby's, 20 July 1970, lot 77, illustrated, Irish private collection; (3) Georges Edmond Howard, *A Collection of Apothegms*, Dublin, by and for Sarah Cotter, in Skinner Row, 1767, three copies – (A) the dedication copy to the King and Queen, Victoria and Albert Museum, Weale 86 (illustrated in Craig 1954, pl. 45); (B) National Library of Ireland, LO 2,498/bd., signature on title *Cholmondely Dublin 1767*, bought from Maggs 2/8/1939; (C) University of London Library, I. 14. 31 (Craig 1954, p. 32, no. 102); (4) *Scythian Friendship or Secret History of the Theban Conspiracy*, Dublin, Josiah Sheppard, Ann St., Stephen's Green, 1772, the dedication copy to the Duchess of Leinster, bookplate of Carton Library, formerly in the collection of Israel Cohen (Craig 1954, p. 33, no. 114). The following were possibly bound in Sheppard's shop: Richard Lewis, *The Candid Philosopher*, vol. I (only), Dublin, Byrn and Son for the Author, 1778, Gilbert Library, Dublin Corporation (Craig 1954, pl. 51; Craig 1976, pl. 15); Hugh Maffett, *The Cataline and Jugurtine Wars*, Dublin, Stewart and Spotswood 1772, Lord Moira's copy, J.R. Abbey collection, sold at Sotheby's, 21 June 1967, lot 2147, private collection.

1. National Library of Ireland ms 12,124, index.
2. J.W. Phillips, 'The Origin of the Publisher's Binding in Dublin', *Transactions of the Cambridge Bibliographical Society*, II, Part 1, winter 1954–55, pp. 92–94.
3. National Library of Ireland MS 12,131, pp. 58, 64.

39 ᖫ *(?)Belfast Binding, ca. 1771*

[Thomas Marryat], *Sentimental Fables, design'd chiefly for the use of Ladies*, Belfast, for the Author, 1771. Size: 199 × 130 × 36 mm

Provenance: Maggs Bros. Catalogue 1075 (1987), no. 191

THE IRISH GEORGIAN SOCIETY (GIFT OF PAUL GETTY, KBE)

Bound in red goatskin with black staining and gold-tooled to an all-over design; a circular centrepiece with four black-stained *vesicae*. Possibly a Belfast binding, influenced by both the Scottish 'wheel' design and Dublin workmanship, such as the black-stained *vesicae*. No other elaborate eighteenth-century Belfast bindings have been published..

40 🐎 *Bound by the Whitestone Bindery, ca. 1779*

Charles Praval, *The Syntax of the French Tongue*, Dublin, printed for W. and H. Whitestone, No. 29 Capel-Street, 1779. Size: 175 × 105 × 23 mm
THE BOARD OF TRINITY COLLEGE, DUBLIN (Q. hh. 36)

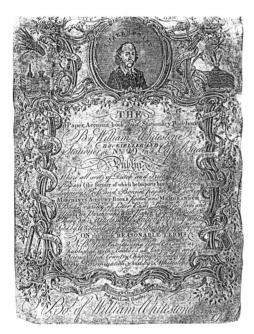

Billhead of William Whitestone, the only extant Rococo billhead of a Dublin bookseller (whereabouts unknown)

1. National Library of Ireland MS 12,131, p. 16.
2. *Freeman's Journal*, 24–26 May 1770, p. 429b).

Bound in red goatskin and tooled in gold; the sides bordered with two gilt rolls and corner tools; flat spine, gold-tooled. The narrow foliage roll occurs on the binding of Mant's *Hebrew Bible* (Oxford 1776) in Marsh's Library (A3 1 16), for which payment is recorded in the Library Accounts to the firm of Whitestone.

William Whitestone served his apprenticeship to George Ewing (enrolled 8 March 1744).[1] He had a number of apprentices including Jacob White who left Josiah Sheppard, the bookbinder, in 1760 (sec cat. 38 above). Whitehouse was established as a bookseller and stationer in Skinner Row. In 1770 he opened a new paper warehouse.[2]

Other bindings from this shop: (1) Thomas Newton, *Paradise Regained, A Poem in four Books*, Dublin, printed for John Exshaw, at the Bible in Dame Street 1754, Cambridge University Library, Hib. 5. 754. 26, bound in green goatskin with *dentelle* border and corner tools; (2) *Bible*, Dublin, G. Grierson, 1768, National Library of Ireland 22052 b. 10, Dix collection; (3) *The Book of Common Prayer*, Dublin, David Hay, assignee of the late Boulter Grierson, 1772, (Maggs Bros., *Bookbinding in the British Isles*, Catalogue 1075, no. 190).

41 🐎 *Bound by the William Wilson Bindery, ca. 1779*

Johann Ulrich Krauss, *Historische Bilder Bibel*, Augsburg 1702. Size: 190 × 135 × 34 mm

Provenance: Inscribed *Donum Johannis Ussher/ Charo Amico Gulielmo Tighi/ Juni, Anno Domini 1779*; engraved bookplate of William Tighe; Sanders of Oxford, Miscellany 106, no. 216

PRIVATE COLLECTION

Bound in red goatskin and tooled in gold. The cover is edged with a Rococo roll, inside is a white-bordered, splashed-marbled paper lozenge, opening to the ground leather. The marbled-paper

lozenge is tooled in gold, a technique only previously encountered on the Parliamentary bindings of the 1750s.

William Wilson, bookseller and stationer of Dame Street, was the son of Peter Wilson, the publisher of the famous *Dublin Directory*. William Wilson was supplying tree calf bindings as early as 1778 to Theophilus Clements.[1] The Wilsons father and son obviously maintained a bindery judging from the number of advertisements in the contemporary newspapers. William Wilson, for example, inserted an advertisement leaf in his *Directory* which stated that the books were bound and finished under his inspection.

Other bindings from this shop: (1) Taylor and Skinner, *Maps of the Roads of Ireland*, Dublin 1783, bound in red goatskin with olive and dark-green onlays, provenance: bookplates of Patrick Kincaid and Henry LaBouchere, Mortimer L. Schiff library, sold at Sotheby's, 23–25 March 1938, lot 459 (Craig 1954, p. 39, no. 23); (2) another copy in a private collection; (3) Wilson's *Post Chaise Companion*, Dublin, printed for the author, 6 Dame St., 1786, red goatskin gilt back, Jesuit Library, Milltown Park, Dublin; (4) another copy, private collection; (5) Robertson's *America*, Dublin 1777, formerly in the collection of John Pyne; (6) Samuel Watson (compiler), *The Gentleman's and Citizens Almanack* (with) *The English Registry for 1785* (with) *Wilson's Dublin Directory for 1785*, Dublin, William Wilson, 1784 (Patrick King, catalogue 10, no. 25); (7) another edition for 1796, private collection; (8) Thomas Stewart, *The Gentleman's and Citizens Almanack* (with) *The English Registry*, Dublin, J. Exshaw; and *Wilson's Dublin Directory 1799*, Dublin, Wilson (Patrick King, *Antiquarian Book Monthly Review*, July 1978).

1. McDonnell and Healy 1987, p. 82, note 17.

42 ❧ *Bound by the Hallhead Bindery, ca. 1775*

The Bible, Cambridge, 1763. Size: 505 × 330 × 98 mm

Provenance: Sir Richard Cox arms on the front cover; McClintock Dix presentation to Trinity College Dublin

Literature: McDonnell and Healy 1987, pp. 50, 57–59, 70, 71, 79, 228–43, 323 no. 5; Craig 1976, ill. on back cover; Craig 1954, p. 16, pl. 48

THE BOARD OF TRINITY COLLEGE, DUBLIN

Bound in red goatskin and tooled in gold with wide *dentelle* borders surrounding a central lozenge. Gilt spine with eight panels and seven raised bands; blue lettering-piece. A brilliantly executed binding – "it represents the apex of the naturalistic style, before neoclassicism set in" (Craig 1954, p. 16). A similar binding on another Baskerville Bible is in Maynooth Library.[1] The volume came from the Hibernian Bible Society collection and contains the signature of a member of the Goodbody family.

William Hallhead took over the business as Trinity College Dublin bookseller after the death of his aunt Anne Leathley in 1775. He married a Miss Sarah Casson of King Street, St Stephen's Green, in 1779 and died in 1781. His widow married William McKenzie in 1783, who took over as bookseller and stationer to Trinity College. It is unlikely that Hallhead himself worked at the bench, but he employed probably the most outstanding finisher of the period in his shop.

1. Illustrated in *Maynooth Library Treasures*, ed. Agnes Neligan, Dublin 1995, p. 68.

43 &ersand; *An Album of Prints by Angelica Kauffman, 1771*

Angelica Kauffman (1741–1807), album of 24 prints on 19 sheets of paper, interleaved with 37 blank pages.
Size: 409 × 310 × 40 mm

Provenance: Inscribed on the front flyleaf *Dono d'Angelica Mariana Kauffman*

Literature: Helbok 1979

THE NATIONAL GALLERY OF SCOTLAND, EDINBURGH (P 2883)

Bound in green goatskin and tooled in gold to a Harleian style (*i.e.* wide tooled borders with a centre lozenge). Gilt back divided by six raised bands into seven compartments, with the lettering piece in the second.

Angelica Kauffman came to Ireland in 1771 and stayed for six months with various families. The present volume is reputed to have been a present by Kauffman to one of her hosts on that occasion. It was bought in the 1960s by a prominent Dublin antiquarian bookseller who sold it to a collector in the West of Ireland; acquired by the National Gallery of Scotland in 1993.

The contents are as follows: plate (1) *Young man thinking* (engraving, signed *A.K.*).

(2) *Bearded man with a staff in his right hand* (engraving and mezzotint, inscribed *A M Kauffmann fec 1762*) [plates (1) and (2) printed on to the same sheet].

(3 and 4 [on the same sheet]) *Mother and child holding an apple* (engraving, inscribed *A.K. fec. in Firen. 1763*); *Young woman reading a book resting on a cushion* (engraved and etched, inscribed *A.K.*).

(5) *Two bearded men studying the Ancients* (engraving and etching, inscribed *Angelica Kauffman fec. a Napoli 1763*).

(6) *Holy Family with Madonna feeding the Christ Child from a plate held by an angel*, after Barocci (engraving, inscribed *Barroccio Pinx: Ange: Kauffman inci.*).

(7) *The Betrothal of St Catherine* (half-length), after Correggio (engraved, inscribed: *Coreggio pinx: A.M. Angelica Kauffman inc.*).

(8) *Hope* (engraving, inscribed *Dedicato all'Illustre, e Nobilissima Accademia di S. Luca / Angelica kauffman, inven. dipins. ed incis. in Rom. 1765*).

(9) *Seated woman lost in thought* (engraving, inscribed: *A M Kauffman dipinto, e inc: a Ven: a 1766*).

(10) *Woman with an urn* (in memory of General Stanwix's daughter who was lost in her passage to Ireland (etched and engraved, inscribed *Angelica Kauffman fecit, London 1767*, and a verse: *On the dark Bosom of the faithless Main, / Where stormy winds and roaring Tempests reign, / Far from her native Fields and friendly Skies, / In early death's Cold Arms* FIDELIA *lies. / Ah! spare to tell (for she is now no more) / What Virtue, Beauty, Sweetness, charm'd before: / Here let the pensive Muse in silence Mourn, / Where friendship to her Name ras'd the sacred Urn.*.

(11) *Woman reading a book* – profile (etched and engraved in brown ink, inscribed *Ang: K: fec Lon 1770*).

(12) *Seated semi-naked woman from behind* (etched and engraved, inscribed *Angelica Kauffman fec. 1770*).

(13) *Venus and Cupid mourning the death of Adonis*, after Annibale Carracci (engraved and etched, inscribed *Ca: Pinx, Ang: K: inc: Lo: a 1770*).

(14) *Rinaldo and Armida* (engraved and etched, inscribed *Angelica Kauffman. fecit*).

(15) *Juno with a peacock* (engraved and etched, inscribed *Ange: Kauffman fec: Lon: 1770*).

(16) *Woman reading a book* (engraved and etched, inscribed: *Ange:Kauffman fec: Lon: 1770*).

(17 and 18 [on the same sheet]) *Mother with a child holding an apple* (engraved and etched, inscribed *A.K. f.*); *Half-length portrait of a young woman with a band in her hair* (engraved and etched).

(19 and 20 [on the same sheet]) *Bust of a man in profile, with a book lying to the left* (engraved and etched, inscribed *A M Kauffmann fac a Ischia 1763*); *Johann Friedrich Reiffenstein*, half figure facing, holding a pen in left hand (engraved and etched, inscribed *A M Kauffmann f. a Ischia 1763*).

(21) *Johann Joachim Winkelmann*, seated at a desk (engraved and etched, inscribed *Angelica Kauffman dipin. e. inc. in Roma anno 1767. / 10.* WINKELMANN / *Antiq. Pontif. et Prof. Graec. L. in Biblioth. Vatic.*).

(22 and 23 [on the same sheet]) *Portrait of Raphael* (engraving and etching and mezzotint); *Young woman leaning on a book resting on a cushion* (engraved and etched, inscribed *A.K.*).

(24) *Half-length portrait of young woman leaning on a book* (engraved and etched, inscribed *Ange Kauffmann fec: Lon: 1770*).

44 ℰ *Bound by the The Hillingdon Binder, ca. 1785*

The Holy Bible, Cambridge, John Baskerville, 1769. Size: 428 × 269 × 82 mm

Provenance: Lord Hillingdon, Wakefield Lodge, Potterspury, Northampton, library sold Sotheby's 29 February 1932, lot 56; Maggs Bros. Catalogue 572, 1932, no. 70, illustrated, £105

Literature: Van Leeuwen 1983, no. 105; Craig 1954, p. 39 no. 18

KONINKLIJKE BIBLIOTHEEK, THE HAGUE (163 B9)

Red goatskin with white and green onlays and gold-tooled. The covers are decorated with large white oval centrepieces with curving sides, and with inner frames of green onlays, opening at the centres to the ground leather. Spine with six raised bands and seven compartments, all decorated with onlays and gold-tooled.

Another Baskerville folio bible in a similar binding was sold at Sotheby's (from the collection of the Hon. Colin Tennant, 24 November 1980, lot 23), now in an Irish collection. The National Library of Ireland has an octavo Prayer Book, Dublin, Hay, 1778, in dark-green goatskin decorated with the tools of this binder (National Library of Ireland, LO).

45 ℰ *Bound by the Abraham Bradley King Bindery, 1790s*

The Bible, Cambridge, John Baskerville, 1763. Size: 498 × 333 × 80 mm

Provenance: Sir Edward Sullivan, 2nd Bt., sold at Sotheby's, 13 December 1926, lot 115

Literature: Craig 1954, pp. 5, 22, 38, 14; Hobson 1926, pl. XXX; Sullivan 1905, p. 58

THE SPECIAL COLLECTIONS DEPARTMENT, GLASGOW UNIVERSITY LIBRARY (BDAI – Y.II)

Red goatskin tooled in gold, the covers with onlaid cream-paper centrepieces, opening to the ground leather, and blocked with the Royal arms, *dentelle* borders with the field decorated with scattered tools; spine with seven raised bands and eight compartments, with onlays of green goatskin and cream paper.

Sir Edward Sullivan suggested that this volume was identical with that delivered to the House of Lords in 1773 by Abraham Bradley: "One Bible Royal folio gilt Barbary leather with silk strings and registers, £5 10s." The style, however, points to the 1790s as the likely date of execution.

Abraham Bradley King was the King's Stationer in Ireland, from 1780 with his grandfather and from 1784 to 1801 on his own. He probably never worked at the bench but ran a bookbinding department as part of his stationery business.

The execution of this volume was obviously left to the top finisher in the Bradley King shop sometime in the 1790s. A number of other large folio volumes can be assigned to this finisher, which are characterized by the superbly executed arrow-fringe dentelles, the shield with the crowned harp in the corners (not in all cases), and the scattered tools in the field – like certain antique mosaics: (1) Lords' ms Journal 1776–79 (vols. 48–49); (2) Lords' ms Journal 1790 (Sullivan 1905, p. 55); (3) Lords ms Journal 1793 (illustrated in Craig 1954, pl. 15); (4) Bible, British Bible Association (Craig 1954, pl. 15); (5) Bible, Dublin 1750, with Parliamentary prayers, 1792 (Nixon 1956, no. 95; Craig 1954, p. 37, no. 177).

46 ⚬ *Bound by the Abraham Bradley King Bindery, ca. 1794*

The Book of Common Prayer, Dublin, George Grierson, 1750. Size: 441 × 295 × 53 mm

Provenance: Circular stamp with the inscription *Science & Art Museum, Dublin 1921, Art 429*; later transferred to the National Library

Exhibited at the New York World's Fair in 1939 (US customs ticket no. 1782 present)

THE NATIONAL LIBRARY OF IRELAND (LO 2,622/BD.)

Bound in red straight-grained red goatskin with black and white onlays and tooled in gold. The sides decorated to a panel style with large centre oval of white paper opening to the ground leather; spine with six raised bands and seven compartments and tooled in gold; endpapers watermarked: *J Whatman 1794*. Many of the tools were used on the Parliamentary bindings of the 1790s. A very similar binding on a Grierson prayer book (Dublin 1750) is in the British Library (C. 46.17). A number of similarly bound prayer books have appeared in the London and Dublin antiquarian book trade in the last twenty years.

47 ⚬ *Bound by the Abraham Bradley King Bindery, ca. 1794*

(a) *The Bible*

London, Charles Eyre and William Strahan, 1772. Size: 495 × 335 × 75 mm

Provenance: the signature of Margaretta Ferrard, 1798, on the titlepage; the flyleaf is inscribed *January 1798/ chap. to the House of Commons/ Presented by the Revd. John Willm. Keatinge to Margaretta Viscountess Ferrard his Aunt/* [in another hand] *this was the Prayer book of* . . .

THE MUSKERRY FAMILY THROUGH BANK OF IRELAND

Bound in red goatskin with black staining and white paper onlays and tooled in gold; the covers with white corner onlays and black staining; in the centre large white paper oval onlays opening to the red ground with an inner black lozenge. Gilt spine divided by six raised bands into seven compartments with a black lettering-piece in the second; green silk double endbands, two purple silk markers; white end leaves countermarked J. Whatman paper 1794.

(b) *The Book of Common Prayer*

Dublin, George Grierson, 1750. Size: 450 × 300 × 53 mm

Provenance: same inscription as the Bible above.

THE MUSKERRY FAMILY THROUGH BANK OF IRELAND

Bound in red goatskin with white paper onlays and black staining, and tooled in gold; the covers decorated with white oval paper onlays inside covered rectangles stained black. Gilt spine divided by six raised bands into seven compartments. Both volumes were used in the Irish House of Commons in the mid-1790s. A Bible and Prayer Book belonging to the Revd William Knox, a previous chaplain to the House of Commons, is now on deposit in the Bodleian Library.[1]

1. Paul Morgan, 'Two Irish Bindings from the workshop of
A.B. King', *The Book Collector*, autumn 1991, pp. 407–11.

48 ❦ *Bound by the Abraham Bradley King Bindery, 1798*

Report from the Committee of Secrecy of the House of Commons, Dublin 1798. Size: 292 × 180 × 40 mm

Provenance: (?)Lord Castlereagh; W.L. Micks

Literature: Craig 1954, p. 22 and pl. 56

THE NATIONAL LIBRARY OF IRELAND (LO 2,484/BD)

Bound in the fashionable 'Etruscan style' which favoured terracotta and black-stained calf for bookbindings rather than the traditional red goatskin (though the spine of this volume is in the more conventional mode). The oval centrepiece is painted in grisaille and depicts Hibernia pointing to a (?)boat; *doublures* of pale green and blue paper; red leather joints. Signed at the tail of the spine: *A.B. King*. As Dr Craig points out, "it is probably signed as a political gesture, for the book it covers is exceedingly controversial", and it is very unlikely that Abraham Bradley King himself worked at the bench. A number of similar Etruscan-style bindings from this shop are known.

49 ❦ *Bound by the Patrick Wogan Bindery, ca. 1793*

Officium Defunctorum, Dublin, Patrick Wogan, 1793. Size: 180 × 115 × 20 mm

Front endpapers include an eight-and-a-half-page manuscript poem signed *D.K.*

Provenance: Chrisr. & Francs. Bellew, Fancybury, tooled on the front cover; acquired by the National Library in 1941

Literature: McDonnell, *Ecclesiastical Art*, 1995, no. 77

THE NATIONAL LIBRARY OF IRELAND (LO 2722)

Bound in dark-green goatskin and gold-tooled. The sides are decorated with a central lozenge made up from small floral, bird tools, with the Sacred Monogram over a winged skull. The upper cover is lettered: *Chrisr. & Francis Bellew, Fancybury*. Smooth spine with five red onlays and decorated with Neoclassical tools and the Sacred Monogram; green and white striped endpapers with small floral motifs.

Patrick Wogan became the leading Roman Catholic bookseller at the end of the eighteenth century. In 1773, he announced himself as follows: "as the said Wogan is a new beginner, he takes particular care to have all his books bound strong and elegant; and he binds all kinds of books for those who are pleased to employ him".[1] His success can be gauged by a report in *The Dublin Evening Post* for Saturday, 24 October 1789: "At a sale of books, in quires, announced by Mr. Wogan, of the Old Bridge, for Wednesday last, at the Eagle in Eustace-Street, the Booksellers Company were entertained in a stile of spirit and splendour very unusual of at the expence of an individual in the community – a very sumptuous dinner followed up in a stile of hospitality and good fellowship, and attended by the band of music belonging to the Train of Artillary, accompanied the business of the evening, which was concluded with an excellent supper, devised by the gallantry and politeness of Mr. Wogan, in compliment to the ladies, which was attended by the wives and daughters of the company. The spirit of the entertainer, operated with such glee on the guests, that they came to a resolution on the spot, of having two general subscription balls, every winter in future."

Other bindings from this shop: (1) Jean N. Grou SJ, *Moral Instructions*, trans. A. MacKenzie, Dublin, printed for P. Wogan, no. 23, on the Old Bridge, 1792, red goatskin, very similar to the Bellew binding, Jesuit Library, Milltown Park, Ir. 082. 4183 / W 8 / G 882; (2) *Missale Romanum*, Dublin, Wogan, 1795, red goatskin, gilt back, signature of Revd J. Corballis (Maggs Bros. Catalogue of Provincial Bookbinders 1981, no. 43, incorrectly given to W. McKenzie).

1. Quoted by T. Wall, *The Sign of Doctor Hay's Head*, Dublin 1958, p. 8.

50 ❧ *Bound by I.W. Draper, late 18th century*

Anthologia Hibernica, or Monthly Collections of Science, Belles-Lettres and History, 4 vols., Dublin, printed for Richard Edward Mercier and Co. Booksellers, No. 31, Anglesea-Street, 1793. Size: 237 × 145 × 35 mm

Provenance: Initials J.D. inscribed on the titlepages; ex-libris of James J. Murphy OP on the first paste-downs; stamp of Bib. Con. S. Mariae. Magdalenae. Pontanae (Drogheda)

PRIVATE COLLECTION

Bound in mottled calf and tooled in gold to a panel design; flat spine also gold-tooled with black lettering-piece. The binder's circular label is present in three of the volumes: *Bound by I.W. Draper, 9 Bedford Row, Classic & account Book Binder*. Presumably this is the same person as the William Draper, no. 3, Bedford Row, listed in the *Dublin Directory* for 1808.[1] The better known James Draper, bookbinder, is listed among the subscribers of the *Anthologia*.

1. Ramsden 1954, p. 233.

51 ⁊ₛ *Dublin Vellum Binding, ca. 1764*

Watson's Compleat memorandum Book for the Year 1764, and The Kalendar, calculated by John Watson, Bookseller,
Dublin, S. Powell for John Watson, 1764. Size: 123 × 70 × 18 mm

Literature: McDonnell and Healy 1987, p. 79; Craig 1954, pl. 39; Lewis 1941, IX, p. 418, and X, pp. 16 and 18

PRIVATE COLLECTION

Slipcase of white vellum with a blue lozenge inlay and tooled in gold, with green silk tabs, enclosing
the book bound in vellum and tooled with a thistle roll. A comparable vellum-covered volume with
blue lozenge onlay and bound by the Watson Bindery (see cat. 53 below) was illustrated in
McDonnell and Healy 1987, no. 100.

Dublin vellum bindings have attracted some discussion in the literature chiefly on account of
their elusiveness. Horace Walpole twice requested an example from his friend George Montagu
during his stay in Dublin; writing on 30 December 1761, he remarked: "I am told that they bind in
vellum at Dublin better than anywhere: pray bring me any one book of their binding, as well as it
can be done, and I will no mind the price", and later, "don't forget … a book bound in vellum".
Montagu promised in return: "I shall get some one of the best printed books at the College, and
have it bound in the best manner in vellum for you."

The fame of these vellum bindings puzzled Sir Edward Sullivan, writing in 1914: "I have never
seen any exceptionally good pieces of Irish work in that material", and he believed that Walpole
was in error.[1] Vellum bindings Sullivan presumed could only be meant in a somewhat restricted
sense, referring to the appearance of a white leather or vellum centrepiece on a goatskin binding –
such was the popular conception of an Irish binding.

The discovery by Wilmorth Lewis of a 1724 Grierson duodecimo edition of Virgil, bound in
vellum with a 'thistle' roll border and a centre lozenge in gold indicates that Walpole was better
informed than has been presumed. The volume is inscribed: *Ex dono Georgii Montagu armig. de Roel
in comitatu Glocestriae, 1763, H.W.*[2]

1. Sir Edward Sullivan, *Decorative Bookbinding in Ireland*
(Opuscula no. LXVII, Ye Sette of Odd Volumes),
London 1914.
2. A.T.A. Hazen, *A Catalogue of Horace Walpole's Library*,
p. 279, no. 2263.

52 ⁊ₛ *Rococo Borders, 1765*

Watson's Compleat memorandum Book for the Year 1765, [Dublin], Engraved for Saml. Watson in Dame-Street.
Size: 128 × 72 × 10 mm

Pages decorated with engraved Rococo frames

GLIN CASTLE, CO. LIMERICK

All the pages of the memorandum book have identically engraved Rococo borders.

53 ❧ *Bound by the Watson Bindery, 1784*

Watson's Triple Almanack, Dublin, 1784. Size: 163 × 100 × 15 mm

Provenance: Inscribed *Emily Percy given her by Charlotte Percy, June 1st. 1795*; bookplate of William Loring Andrews, New York; Courtland Bishop collection, sold at Sotheby's, 10 March 1952, lot 2371; reproduced in Sawyer's catalogue 211 (1952), no. 92

Literature: McDonnell and Healy 1987, pp. 50, 78–79; Craig 1954, p. 66 no. 162, and p. 39 no. 23a

THE NATIONAL LIBRARY OF IRELAND (LO 2,531/BD)

Bound in smooth crimson goatskin, with cream onlaid paper lozenge and tooled in gold to an all-over design. An exquisitely tooled binding.

The Watson Bindery was evidently a large establishment, and therefore I shall list only a few similar bindings: (1) Watson's *Gentleman's and Citizens almanack*, Dublin 1779, Victoria and Albert Museum, Weale 87, (J. Harthan, *Bookbindings*, London 1961, pl. 51); (2) Joseph Ritson, *The Spartan Manual, etc* London 1776 (illustrated in J. Baer, Catalogue, no. 750, no. 236; Craig 1954, p. 39, no. 20); (3) Watson's *Gentleman's and Citizens Almanack*, Dublin 1783, Cambridge University Library, Hib. 8 733. 71; (4) Watson's *Gentleman's and Citizens Almanack*, Dublin 1788, Gumuchian Catalogue xii, no. 310 with illustration (Craig 1954, p. 39, no. 25); (5) An Enquiry, etc., London 1774, Sawyer's Catalogue 250 (1959), no. 101, pl. 2; (6) Book of Common Prayer, Cambridge, J. Baskerville, 1762, 8vo., red goatskin with white lozenge and initials A.H. tooled in gold on the upper cover, private collection in the West of Ireland.

54 ❧ *The First Book printed by Hot Pressing in Dublin, 1796*

Miguel de Cervantes, *The History and Adventures of the Renowned Don Quixote*, trans. T. Smollett, frontispiece and 21 engraved plates by William Bromley, 4 vols., Dublin, John Chambers, 1796, 8vo. Size: 222 × 142 × 38 mm

The dedicated leaf in vol. 1 reads: *To the Provost, Fellows and Scholars of Trinity College, Dublin, This edition of Don Quixote is Respectfully Dedicated, as an endeavour to improve the Act of Printing in Ireland, by John Chambers.*

Provenance: Bookplate of Nicholas Browne Esq. of Mount Hazel

Literature: Pollard 1989, pp. 203–09; Pollard 1964

PRIVATE COLLECTION

John Chambers was one of the most active members of the book trade in Dublin during the last quarter of the eighteenth century as a printer and publisher. He published at least ninety-one titles in 107 editions. In his four-volume illustrated edition of *Don Quixote* Chambers strove to reach the highest standards of typography utilizing the latest equipment, as he announced in *The Dublin Evening Press* (22 March 1796). "The execution of the letterpress (under the immediate inspection of the publisher) in all the properties of excellence, whether as to uniform colour, impression, &c. and aided by the beautiful art of pressing, in the manner of the continent, of which he has been the first introducer in this country, will he trusts … evince a spirit of liberal enterprize in his profession."

In 1791 Chambers became a founder member of the United Irishmen, and was one of the Executive Directory who escaped arrest in March 1798. After the suppression of the rebellion he was imprisoned and remained a state prisoner until 1802, then spent three years in France and finally emigrated to New York in 1805. He opened a stationery business in Wall Street and died in 1837.

55 ❧ *Titlepages, Illustrations and Endpapers, 18th century*

(a) *A Rococo Titlepage*

The Spectator, Dublin, Peter Wilson, 1755, vol. 3, titlepage. Size: 176 × 109 × 25 mm
PRIVATE COLLECTION

Probably the first Rococo titlepage on a Dublin publication, with a strong French flavour. For the next twenty years or more, it was copied and adapted by various publishers and booksellers. For example, it was copied in reverse by James Williams as the titlepage to his edition of Swift's *Works* in 1767. In 1774 Thomas Armitage used a modified version of the titlepage for his seven-volume edition of the *Works* of Laurence Sterne. Finally, in 1778 William Wilson, the son of Peter, used a new cutting of the original 1755 titlepage for a re-issue of *The Spectator.*

The illustrations, by Francis Hayman (*ca.* 1708–1776), are from the 1747 London edition of *The Spectator.*[1]

1. Hanns Hemmelmann, *Book Illustrators in Eighteenth-Century England,* ed. and completed by T.S. Boase, New Haven and London 1975, p. 52.

(b) *A Neoclassical Titlepage, Etched and Engraved by William Esdall, ca. 1780*

Parental Solitude, Dublin, J. Exshaw, *ca.* 1780. Size: 178 × 110 × 24 mm
GEORGE MEALY AND SONS, CASTLECOMER

Engraved titlepage in the Neoclassical style. The new style, which originated in England, had by and large ousted the Rococo titlepage by 1780. A similar Neoclassical titlepage is found in the *Works* of Laurence Sterne, published in Dublin in 1780 by D. Chamberlaine, J. Potts and W. Colles, Booksellers.

(c) *Engravings following French example*

Miguel de Cervantes, *Don Quixote, translated by Skelton and Blunt, with curious cuts from the French by Coypell,* Dublin 1733 (see cat. 22 above). Size: 170 × 105 × 20 mm
Literature: Wildenstein 1964, pp. 267–74
THE NATIONAL LIBRARY OF IRELAND (LO 2,574/BD)

Don Quixote attended by the Dutchess's Women, engraving from volume 3 (facing p. 233). One of the ten engravings copied by Philip Simms from Charles-Antoine Coypel (1694–1752), whose celebrated illustrated edition of *Les Principales Adventures de l'admirable Don Quichotte* was published in four folio volumes in Paris between 1723 and 1724. Philip Simms (*fl.* 1725–49) was one of the busiest engravers in Dublin in the first half of the eighteenth century. In 1733 he was living in Crown Alley where he advertised that "Gentlemen and Ladies may have their coats of arms curiously engraved for their books or on plate".[1] Simms was employed mainly by George Grierson and other Dublin publishers in copying foreign illustrations for the home market. In the above example the Irish engraver was clearly not able to capture the flavour of the original designs, and it was not until the second half of the century that Dublin managed to produce really talented illustrators such as Patrick Halpin, George Byrne, and – above all – William Esdall (see cat. 55c).

1. Quoted in Strickland 1913, II, p. 354.

(d) *An Etching by William Esdall*

W. Preston's *Works*, Dublin, 1793. Size: 217 × 140 × 32 mm

Literature: Strickland 1913

GEORGE MEALY AND SONS, CASTLECOMER

William Esdall (died 1795), the etcher, was the son of the booksellers James and Anne Esdall. He practised for many years in Dublin as an engraver, mostly on book illustrations. He was trained at the Dublin Society's school which he entered in 1766, and first exhibited at the Society of Artists in 1772. He readily found work as an engraver in the fashionable magazines of the period such as *Exshaw's London Magazine*, between 1774 and 1794, and also in the very popular *Hibernian Magazine*. One of his most original compositions from this period is his signed Rococo titlepage to *The Laughing Philosopher*, published in Dublin by James Williams in 1777. Perhaps his best work is to be found in books published in the early 1790s, such as the present volume, which shows his skill as an etcher of charming vignettes and tailpieces, often from his own drawings.

(e) *Embossed Endpapers*

Miguel de Cervantes, *Don Quixote, translated by Skelton and Blunt with curious cutts from the French by Coypell*, Dublin 1733 (see (c) above and cat. 22). Size: 170 × 105 × 20 mm

THE NATIONAL LIBRARY OF IRELAND (LO 2,574/BD)

Purple ground with gilt floral sprays, putti, masks, birds, hounds *etc*, probably of Augsburg manufacture. The same pattern was used as endpapers in a copy of Gilbert Burnett's *History of His Own Time*, Dublin (A. Rhames) 1724–34, 2 vols. (private collection).

56 ⚜ *Kilkenny Printing, 1762*

Thomas De Burgo OP (Thomas Bourke OP), *Hibernia Dominicana*, Kilkenny 1762. Size: 233 × 190 × 57 mm

Provenance: Stamp of a French religious institution: *Congn. du St. Esprit et du S... de Marie/Bibliothèque de la Maison*

Literature: McDonnell, *Ecclesiastical Art*, 1995, no. 72; Thomas Wall, introduction to the Gregg reprint, 1970

GEORGE MEALY AND SONS, CASTLECOMER

Thomas Burke was born in Dublin in 1710. At the age of fourteen he was sent to the Irish Dominican Convent of St Sixtus in Rome where his grand-uncle was prior. He returned to Dublin, a Dominican priest, in 1743 and ministered from the Order's house in Church Street. He was elected by his superiors to compile a history of the Order, which he worked on for four years. In 1759 he was appointed Bishop of Ossory and went to reside in the cathedral city of his diocese, Kilkenny. It was here that his history of the Dominican Order in Ireland (*Hibernia Dominicana*) was issued, mostly with a fictitious Cologne imprint. Some copies have the Kilkenny imprint of James Stokes, such as the present one and the copy in the National Library which once belonged to the Novitiate of St Sixtus in Rome. Other copies, like the one in the Jesuit Library, Milltown Park, have the imprint of Edmund Finn who, like Stokes, was a well known Kilkenny printer.

57 ❧ *An Irish Architectural Book, 1793*

Richard Morrison, *Useful and Ornamental Designs in Architecture, composed in the Manner of the Antique and most approved Taste of the Present Day* (Dedicated to Charles Agar, Archbishop of Cashel), Dublin, Printed by Robert Crosthwaite, no. 74 Dame-street, 1793. Size: 366 × 233 × 8 mm

Modern binding

Provenance: Contemporary engraved bookplate of Joseph Grubb (Benj), Clonmel; presented to the National Library by E. Frayle, 28 November 1916

Literature: McParland, Rowan and Rowan 1989; De Breffny 1983, pp. 157–58

THE NATIONAL LIBRARY OF IRELAND (LBR 7288)

Sir Richard Morrison (1767–1849), son of the architect John Morrison, was born in Co. Cork and was trained under James Gandon. He published the above volume while still in his twenties, and claimed in the introduction that it was the first work of the kind that had been attempted in Ireland, notwithstanding John Aheron's *General Treatise on Architecture* of 1754 and John Payne's *Twelve Designs of Country Houses* of 1757. Morrison's designs despite being "bookish and old-fashioned", had penetrated as far as Philadelphia by 1795. He worked for his father initially, but later set up his practice in Clonmel where he became very successful and much sought after. As the authors of the recent monograph on the Morrisons justly remark: "He had supplied Ireland with some of her grandest and some of her most elegant buildings and although he could design with great panache when called upon to do so he was also expert at restrained and mannerly alterations and additions where appropriate."

58 ❧ *A Rococo Cartouche Titlepage, 1758*

John Rocque, MS *Survey of the Manor of Castledermot for the Earl of Kildare*, 1758. Size: 530 × 754 × 18 mm (oblong folio)

Rococo titlepage in pen and wash

Literature: Kissane 1994, no. 84; Andrews and McDonnell 1994, p. 73; Hodge 1994; Andrews 1985; Horner 1971, pp. 57–76

THE NATIONAL LIBRARY OF IRELAND (MS 22,003)

Bound in red goatskin with a gold-tooled dentelle border framed by a peacock roll. The peacock roll was previously used by Parliamentary Binder A from 1731 to 1747 on the now destroyed Parliamentary Journals. The upper cover is lettered in gilt: *A Survey of The Manor of Castledermot belonging to the Rt. Honourable James Earl of Kildare.*

The volume of twelve maps entitled *A Survey of the Manor of Castledermot situat'd in the County of Kildare belonging to the Right Honble. Jas. Earl of Kildare by Jn. Rocque Topographer to their Royal Highness* [sic] *the late & present Prince of Wales 1758*, is prefaced by a large Rococo titlepage decorated in pen and wash. This is in the form of a cartouche enclosing the title above and the index to the volume below. On the left is the figure of Minerva surrounded by emblems of the Arts and Sciences, and on the right is a personification of Nature with the implements of husbandry. At the base of the cartouche is the armorial device of the Earl of Kildare with supporters.

John Rocque (*ca.* 1704–1762) arrived in Dublin in 1754 to make a map of the city, which he

published in 1756. He was then commissioned by the Earl of Kildare to survey his lands, which occupied him and his team from 1756 to 1760. This resulted in the production of a series of eight splendid folio volumes of estate maps, each with a pictorial titlepage. Almost nothing like this French Rococo style of drawing had been seen in Ireland before. The bold plasticity of the *rocaille* and the delightful pastoral vignettes embellishing the maps had an immediate impact, leading not only to the foundation of the so called French school of Dublin land surveyors, but also to the appearance in Dublin of French *rocaille* engravings in such areas as bill heads and bookplates.

Despite the fact that Rocque's name appears on the titlepage, it is very unlikely that he was responsible for its ornamentation or for the embellishments of the maps, as he was, apparently, an indifferent draftman. Rocque had a number of assistants, including some who passed through the Dublin Society's schools, to carry through the production of each volume. The Castledermot volume, which dates from 1758, is the sixth in the series; the remaining volumes were dispersed at auction in the 1960s.

59 ℰ *A Rococo Titlepage, 1764*

Bernard Scalé, *A Survey of the manor of Font town in the Barony of Narragh and Reban and County of Kildare, The Estate of the Rt. Hon.ble Chas. Earl of Drogheda, 1764*. Size: 80 × 230 × 15 mm (small oblong folio)

Titlepage and nine maps with Rococo embellishments. The titlepage is decorated with an ink-and-wash drawings of the asymmetrical armorial device of the Earl of Drogheda with supporters and motto, as well as emblems of the Arts and military trophies. Bound in tree calf with a border decorated with a gold-tooled Rococo roll.

Literature: Andrews 1985; W.G. Strickland, *A Dictionary of Irish Artists*, 2 vols., Dublin and London 1913.

THE HON. DESMOND GUINNESS

Bernard Scalé (*fl.* 1755–80) was brother-in-law and pupil of John Rocque (see above), as he informs us in an advertisement in Sleater's Public Gazette, 23 September 1758: "P. Bernard Scalle[1] [*sic*] Takes this method of acquainting the Nobility and Gentry, that he surveys Counties, Cities, Gentlemen's Estates, &c. topographically, after the Manner of Mr John Rocque his Brother-in-law, by whom, he was instructed. He gives an accurate Drawing of his Survey, on which is laid down the just bends of the Roads, Brooks, Hedges, Banks, &c. &c. As also the true Bounds and Quality of each Field. He assures those Gentlemen that shall please to honour him with their Commands. That he will take a particular Care to acquit himself to their Satisfaction, and his own credit Plans and Maps copied, enlarged or reduced, and Plans for Lease, carefully drawn, gentlemen shall be waited on by directing for him to Mr Sleater, Bookseller, on Cork Hill, or at Miss Lyons, Milliner, in Skinner-row."

Scalé, a fine draftsman, and a master of the Rococo style, as the present volume shows, appears also to have a large share in the embellishment of the Kildare Estate maps, which Rocque and his team worked on between 1756 and 1760 (see previous entry). Scalé exhibited his topographical and other drawings regularly a various venues, including the Society of Artists in William Street, Dublin, in 1766, 1767 and 1770. In 1776 he published in London his well known *Hibernian Atlas, or General Description of the Kingdom of Ireland*.

1. His name appears as "Peter Bernard Scalé" in the subscription list to Rocque's *Map of Dublin*, 1756.

60 ❧ *A Dublin Pattern Book*, ca. 1800

Allen's Print Warehouse, Dame Street Dublin

18 leaves, stitched marbled-paper wrapper. Size: 160 × 223 × 24 mm (oblong folio)

A book of 18 engraved leaves without letterpress, issued in stab-stitched marbled-paper wrappers, the titlepage etched by J. Mannin, the following two pages are etched by A. McDonnell.

Apparently an unrecorded copy.

Literature: Crookshank and the Knight of Glin 1994, pp. 134–35

GEORGE MEALY AND SONS, CASTLECOMER

The firm of William Allen was Dublin's main art supplier from about 1780 to 1870. The address was at 88 Dame Street from 1781 to 1786, moving to 32 Dame Street 1787–1832 and finally to Westland Row. Alen's map and print business also dealt in "masks, fancy dress, bows, quivers etc. for the masquerade" (*Dublin Journal*, 6 July 1780).[1] They also advertised a circulating subscription collection of drawings and prints for "the attention of the artist and Amateur", and offered over a thousand drawings and prints of "Flowers, Fruit, Shells, Landscapes, Figures, and Historical Subjects". Allen also published booklets for copying, such as *No. 4. A new Book of Landskips proper for Youth to draw after, price 6d.*, Dublin, printed by Wm. Allen, 32 Dame Street (n.d.). Their main publication was *The Student's Treasure, a New Drawing Book, consisting in a variety of Etchings and Engravings executed by Irish Artists after the following great Masters, viz. Cipriani, Bartolozzi, Wheatley, Angelica* [Kauffmann], *Vivares, West, Bernard, Rowlandson, Stubbs, Zucchi, Mortimer, Howit, Gilray, Boucher, Gainsborough, &c., Second Edition*, Dublin, printed for, and published by, William Allen, Map and Print Seller, No. 32, New Buildings, Dame Street, 1804 (the first edition appeared in 1799).[2] The etched vignette on the titlepage is the same as that of this pattern book, except it is missing Mannin's signature.

John Mannin (*fl. ca.* 1775–91) became a pupil of the Dublin Society's Schools in 1770, and afterwards practised as an engraver, mostly of portraits. Richard Allen published his stipple portrait, after Horace Hone, of Mary Sophia Matilda, Hone's daughter, entitled *Innocent Thought*. The following appeal appeared in the *Dublin Chronicle* of 27 January 1791: "To the humane and apulent, and in particular the Lovers of the Fine Arts, the case of John Mannin, engraver, is humbly admitted. From a series of illness these some years past he has not been able to do much work, but for three months last past has been totally unable to perform any, and the physician who attends him is of opinion that if there be not immediate relief this vaulable artist, who does honour to our country, will be inevitably lost to society. His abilities in the line of his profession are pretty well known to those who interest themselves in the prosperity of the arts in this Kingdom, and specimens of his works are to be seen in the hands of Mr William Allen, No. 32 Dame Street, who will receive and see properly applied such benefactions as may offer."[3] As there were no further references to Mannin in the newspaper, it is presumed that he died soon after the date of the appeal.

1. Andrews 1985, p. 365.
2. Crookshank and the Knight of Glin 1994, pp. 134–35.
3. W.G. Strickland, *A Dictionary of Irish Artists*, 2 vols., Dublin and London 1913, vol. 2, p. 101.

61 ❧ *Manuscript in Irish by John Carpenter, 1744–45*

A collection of Gaelic poems. Size: 205 × 163 × 25 mm

Literature: Kissane 1994, no. 74; Nessa Ní Shéaghdha 1976, G. 82

THE NATIONAL LIBRARY OF IRELAND (MS G. 82)

This volume of Gaelic poems was transcribed by John Carpenter, the son of a Dublin merchant tailor. After his education for the priesthood was completed in Lisbon, he returned to the capital and ministered there until appointed RC Archbishop of Dublin in 1770. As well as a Gaelic scribe and scholar, he was an active collector of manuscripts and books. After his death in 1786, his library of books was sold and the following notice appeared in *Faulkner's Dublin Journal*, 14 July 1786: "Books, Being the library of the late Most Rev. Doctor Carpenter, now selling by auction, by James Vallence, at his auction room in the court lately occupied by the Post Office. They consist of upwards of 4,000 volumes in the various branches of literature. Likewise to be sold, a very elegant mahogany book-case and a pair of globes."

Many of Carpenter's books were in fine bindings, such as the Grolier volume now part of the Quin bequest in Trinity College Dublin (H.M. Nixon, *Bookbindings from the Library of Jean Grolier, Loan Exhibition, British Museum*, London 1965, no. 30); he also owned the MS that is cat. 3 above.

62 &✠ *Bound by E.H. Purcell, Cork, 1800*

A volume of botanical watercolours. Size: 325 × 230 × 23 mm

Provenance: An inscription on the flyleaf reads: *This book of Botanical Drawings belonged to Emma M. Gray, Dau. of the late Pope Gray of Gray's Island and Pope's Quay Co-city of Cork*; inserted is a bill from the binder: "Miss Gray to E.H. Purcell Dr. To binding in morocco gilt Extra one Folio book of Botanical Drawings £1-2-9, To one quire of Tissue Paper £0-1-1. Recd. the Contents E. H. Purcell, Cork the 25th July 1800."; Marlborough Rare Books, catalogue 50, no. 5215, £150 (18/7/63)

THE NATIONAL LIBRARY OF IRELAND (MS 12,817)

Bound in red goatskin and tooled in gold with a roll around the borders; flat spine divided by seven gilt bands into six panels, each containing a single radial tool except for second panel which has the title lettered in gilt.

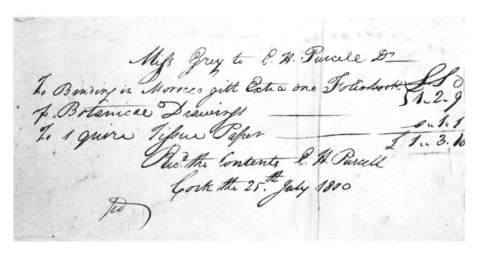

Bill to the binder of cat. 62

63 &✠ *Cathedral Binding, ca. 1820*

W. Monck Mason, *The History and Antiquities of the Collegiate and Cathedral Church of St Patrick near Dublin*, Dublin 1820. Size: 283 × 230 × 45 mm

Provenance: Engraved armorial bookplate of Robert Day on the first paste-down; John Pyne, sale of his library at Mealy's, 5–6 December 1990, lot 443 with illustration

GEORGE MEALY AND SONS, CASTLECOMER

Bound in russia (a specially prepared calf or cowhide) and tooled in gilt and blind to a 'cathedral' design, an English style popular on books dealing with ecclesiastical antiquities between 1812 and 1825;[1] flat spine with four false raised bands tooled in blind and gilt; turn-ins gilt; marbled

endpapers; edges of the leaves gilt; yellow and pink endbands. George Mullen (see cat. 65 below) also bound in this Gothic-revival style, but the tools on this binding belong to a different shop.

1. H.M. Nixon, Broxbourne Library, London 1956, no. 101 is
an example of *ca.* 1820, by the London binder J. MacKenzie
on Smith's *Antiquities of Westminster*, London 1807–09.

64 ❧ *Amateur Binding from Cork, ca. 1817*

Benjamin Franklin, *The Art of Swimming made Safe*, Cork, 1817. Size: 173 × 110 × 4 mm
GEORGE MEALY AND SONS, CASTLECOMER

Bound in tanned sheep and decorated with a gilt narrow roll around the sides; the upper cover is lettered: *For Master. D.O. Grady and Master W.W.O. Grady*, whilst the lower cover is inscribed: *A Present From Uncle Joe The Fidler*. One of the features of the book trade in nineteenth-century Ireland is the large number of ticketed provincial bookbinders, which are only now being recorded.[1]

1. See DeBurca Rare Books, catalogues 31 (winter 1993) and
36 (January 1995).

65 ❧ *Bound by George Mullen, early 19th century*

James Thomson, *The Seasons*, London 1807. Size: 317 × 255 × 40 mm
Literature: O'Sullivan 1992, pp. 168–76; MacDonnell and Healy 1987, p. 69
THE NATIONAL LIBRARY OF IRELAND (LO 2,731)

Bound in contemporary straight-grained green goatskin and tooled in blind and gilt by George Mullen (with his white oblong ticket framed with a black border: *Bound by George Mullen Dublin*); white vellum *doublures* with a panel design in gilt enclosing a lozenge; facing leaf with pink watered silk and framed by a gilt roll; centre; flat spine tooled in gold and blind; green, red and white silk double endbands; pink marker with yellow stripes on each side of a green leaf pattern and ending with a gold fringe. Probably the finest Mullen binding in existence.

George Mullen was apprenticed to William McKenzie, Bookseller, Stationer and Bookbinder, on 4 November 1782.[1] He was binding for Trinity College Dublin by 1808, and continued to do so until his death in 1821. From 1813 to 1817 he was binder to the Lord Lieutenant. His son, also called George, continued to work for Trinity College until 1848. An idea of the scale and prestige of the Mullen establishment can be gleaned from a letter of George (jr) to Christopher Bellew of Galway in 1822: "… from my connections in London and Paris, I flatter myself I possess many advantages. I keep the business up precisely in the same extended scale as during my late father's lifetime, deal with the same manufactures in London for the best Leathers, boards and other articles in my business, employ the same excellent workmen, with the addition of some new and very excellent hands."[2]

1. National Library of Ireland MS 12,131, p. 153.
2. National Library of Ireland Bellew papers.

66 ❧ *Bound by George Mullen Junior, late 1830s or early 1840s*

Isaac Weld, *Illustrations of the Scenery of Killarney*, London 1812. Size: 304 × 245 × 26 mm

GEORGE MEALY AND SONS, CASTLECOMER

Dark-green crushed goatskin tooled in gold and blind, the covers decorated to an overall interlacing design in blind for the most part. *Doublures* lavishly decorated with onlays and gold tooling, and enclosing a depiction of a bird in coloured onlays, facing leaves of purple watered silk with floral designs onlaid. A *tour de force* of the finisher's art. A very similar binding on the same book is in the Victoria and Albert Museum, London. Those bindings probably date from the late 1830s or early 1840s. See previous entry for an account of the firm of George Mullen.

67 ❧ *Bound by Gerald Bellew, mid-19th century*

Illuminated MS of the *Stabat Mater*, 1859. Size: 258 × 200 × 6 mm

GEORGE MEALY AND SONS, CASTLECOMER

Black crushed goatskin with multi-coloured onlays and tooled in gold with a centre rectangle sunken panel. Signed *G. Bellew, Bookbinder Dublin* on the turn-in of the lower cover. Bellew was one of the most prolific boookbinders of nineteenth-century Dublin: most of his bindings are easily recognizable by their Celtic-revival motifs of high crosses and round towers.

68 ❧ *Bound by Galwey, ca. 1857*

Revd George Gilfillan, *Poetical Works of Edmund Waller and Sir John Denham*, Edinburgh 1857.
Size: 219 × 145 × 35 mm

Provenance: Armorial bookplate of George Fotterell; his signature also appears on the flyleaf, with the date November 1891

THE NATIONAL LIBRARY OF IRELAND (LO 2,486/BD)

Bound in vellum with coloured onlays and tooled in gold. The covers are decorated with a central lozenge with multi-coloured onlays, in each corner is a circular disc with onlays. Flat spine with onlays and gold-tooled; edges of the leaves stained dark-red and gaufered. An inscription on the endleaf reads: *This book was bound by Galwey as a specimen of Irish binding in the Dargan Exhibition in Dublin.* Galwey & Co. specialized in bindings with lavish onlays. Charles Ramsden describes a volume bound in vellum by Galwey in his collection as being as fascinating as the Albert Memorial.[1]

1. Ramsden 1954, p. 235.

69 ❧ MS *in Irish and English by Eugene O'Curry, 1846*

St Patrick's Hymn, transcribed and translated by Eugene O'Curry. Size: 283 × 133 × 40 mm

Text in Irish, with an interlinear translation into English

Colophon: *Eugene Curry, Royal Irish Academy October 16, 1846*

Provenance: Signature of the actress Helen Faucit; Sir Theodore Martin (later her husband)

Literature: O'Neill 1984

THE JESUIT LIBRARY, MILLTOWN PARK, DUBLIN

Bound in green goatskin and gold-tooled by George Mullen (jr). Eugene O'Curry (1796–1862) was the son of a small farmer from Dunaha in Co. Clare. He received no formal education but was greatly influenced by his father's keen interest in antiquities and the collecting of Irish manuscripts. As he later recalled: "It was not until my father's death that I fully awoke to the passion of gathering those old fragments of our history. I knew that he was a link between our day and a time when everything was broken, scattered, and hidden; and when I called to mind the knowledge he possessed of every old ruin, every old manuscript, every old legend and tradition in Thomond, I was suddenly filled with consternation to think that all was gone forever, and no record made of it."[1]

After working for a number of years in the Limerick Lunatic Asylum, he found employment in the topographical and historical department of the Ordnance Survey of Ireland. There he met and became friends with John O'Donovan, George Petrie and James Clarence Mangan. His work led him to research the Irish manuscripts in the libraries of Trinity College and the Royal Irish Academy, which he copied in his fine hand and also catalogued. Moving further afield he copied the Irish manuscripts in the Bodleian Library in Oxford and also made important discoveries among the Irish manuscripts in the British Museum. In 1854 O'Curry was appointed Professor of Irish History and Archaeology in the newly founded Catholic University of Ireland by John Henry Newman, who attended many of his lectures. Thomas D'Arcy McGee decribed him at his work: "There, as we often saw him in the flesh … behind that desk, equipped with ink-stands, acids, and microscope, and covered with half-legible vellum folios, [he] rose cheerfully and buoyantly to instruct the ignorant, to correct the prejudiced, or to bear the petulant visitor, the first of living Celtic scholars and palaeographers."[2] His publications include: *Lectures on the Manuscript Materials of Ancient Irish History*, Dublin 1861; *The Manners and customs of the Ancient Irish*, 3 vols., Dublin 1873.

1. Alfred Webb, *A Compendium of Irish Biography*, Dublin 1878.
2. *Ibid.*

THE TWENTIETH CENTURY

70 ☙ *Binding finished by Sir Edward Sullivan, before 1907*

Alberto da Castello OP, *Rosario*, Venice, 1579. Size: 153 × 110 × 30 mm

Provenance: Presented by Sir Edward Sullivan to the Jesuit Library, Milltown Park, 2 September 1907 (Sir Edward's brother, Fr John Sullivan, was a members of the Jesuit Order)

Literature: Sullivan 1914; Sullivan 1904, pp. 34–39.

THE JESUIT LIBRARY, MILLTOWN PARK, DUBLIN

Bound in blue goatskin and finished by Sir Edward Sullivan with his signature *E.S. Aurifex* tooled in gold. The cover has a red oval onlay and is tooled in gold with floral motifs; flat spine with red and citron onlays tooled in gold.

Sir Edward Sullivan, 2nd Bt. (1852–1928), was the eldest son of the Lord Chancellor of Ireland.[1] Inspired by the work of T.J. Cobden-Sanderson in England, Sullivan took up bookbinding, or more precisely "finishing", which is the art of decorating the covers with gold-tooling and inlaying or (more likely) onlaying different coloured leathers (or papers). He exhibited at the Arts and Crafts Society in London and became actively involved with the Earl of Mayo in setting up the Arts and Crafts Society of Ireland which held its first exhibition in Dublin in 1895. There he showed examples of his own work and also that of T.J. Cobden-Sanderson, which was much admired. However, he was not happy with the prospect of Irish binding being merely a pastiche of more fashionable English work. In an article he commented on the deplorable state of binding in England and Ireland, with the exception of Cobden-Sanderson, and remarked, "I see no reason why Ireland should not take the lead in changing all of this". As Sullivan saw it, the main lack was not of workmanship but of artistic spirit and sense of design. As it was the aim of the Society to improve artistic spirit and design, he thought few areas would be more open to the working of original design than that of book decoration.[2]

Sullivan's most important achievement, however, is his study and recording, by means of rubbings (and some photographs), of the bindings of the Irish eighteenth-century Parliamentary Journals, which were tragically destroyed in 1922 (see Introduction).[3]

1. For an account of the family, see Fr Fergal McGrath SJ, *Father John Sullivan S.J.*, London 1941.

2. See further Sir Edward Sullivan, 'Irish Bookbinding, and How it may be Improved', *Arts and Crafts Society of Ireland Journal and Proceedings*, I, no. 1, 1896, pp. 57–60; *id.*, 'The Queen's Album', *ibidem*, I, no. 2, 1896, pp. 167–69.

3. McDonnell and Healy 1987, pp. XIII–XVII.

71 ☙ *Bound by Eleanor Kelly, ca. 1913*

Rabindranath Tagore, *Gitanjali*, with an introduction by W.B. Yeats, London 1913, 8vo. Size: 194 × 134 × 20 mm

Provenance: Mrs T.H. Grattan-Bellew

Literature: Larmour 1992, pp. 89, 109, 134, 160, figs. 83, 134; Bowe 1987, pp. 22–27

GEORGE MEALY AND SONS, CASTLECOMER

Contemporary olive goatskin with centrepieces in blue and green, Indian motif surrounded by a *semis* of stars and other tools, front cover with jewel inset.[1] A circular ticket signed with a monogram is loosely inserted. The book is preserved in a wooden case covered with a Japanese-style textile.

Eleanor Kelly (*fl.* 1910–20), bookbinder, apparently first exhibited at the Fourth Exhibition of the Arts and Crafts Society of Ireland in 1910. She worked for a time with the Dun Emer Guild. Her major extant works in the Celtic-revival style are the bindings of the prayer books and Altar Missal (1916) in the Honan Chapel at University College Cork. Her work in the Fifth Exhibition of the Arts and Crafts Society of Ireland in 1917 was singled out for praise in an article by Oswald Reeves in *The Studio* (October 1917), who commented that it was "marked by a reserve in the enrichments and the tasteful use of inlaid coloured leather and jewels" (quoted by Larmour 1992, chapter 8). Larmour also reproduces a ticket which was used as an advertisement by Kelly from the Catalogue of the Fifth Exhibition: *Eleanor Kelly, Hand Bookbinder, 16 Kildare St. Dublin.*

1. *Exhibition of Irish Bindings from the Seventeenth to the Twentieth Centuries*, exhib. cat., London, Foyles Art Gallery, 29 Sept.–23 Oct. 1954, no. 57.

72 ✍ *Illuminated by Art O'Murnaghan*

MS *Leabhar na hAiseirghei* (The Book of the Resurrection). Size: 326 × 328 (unbound)

Literature: Larmour 1981

THE NATIONAL MUSEUM OF IRELAND

Illuminated by Art O'Murnaghan on twenty-six sheets of calf-vellum as a memorial book of the Rising of 1916. Art O'Murnaghan (1872–1954) joined the Dublin Gate Theatre in the 1930s as a stage manager, actor and designer. *The Book of the Resurrection* became his life's work, occupying him over three periods, 1924–27, 1937–38 and 1943–51. Although the book is manifestly in the Celtic-revival mode, it quickly evolved into a highly personal interpretation of it and drew on motifs from the Art Nouveau and the Art Deco styles.

73 ✍ *Illustrated by Jack B. Yeats, 1940*

A Lament for Art O'Leary, trans. from the Irish by Frank O'Connor, 6 coloured illustrations by Jack B. Yeats, Dublin, Cuala Press, 1940

130 copies printed. Size: 290 × 197 × 8 mm

Literature: Pyle 1994, no. 1472

THE YEATS MUSEUM, NATIONAL GALLERY OF IRELAND

Jack B. Yeats (1871–1957) was born in London and studied at various art schools. He began illustrating books in 1891 as well as writing boys' stories. His first one-man exhibition was held in London in 1897. By 1910 he had settled in Ireland where he exhibited his paintings. Over the years he continued to illustrate books and broadsides. The *Lament for Art O'Leary* appealed to Yeats' bohemian imagination, and the baroque rendition of the horse and rider is one of his most compelling graphic works.

74 ❧ *Written and illuminated by Timothy O'Neill, 1981*

The Roscrea Missal, written and illuminated by Tim O'Neill, completed on St Patrick's Day, 1981.
Size: 295 × 200 × 35 mm

Bound by Paddy Kavanagh and Colm Moore in oak boards from Roscrea; silver clasps by Michael Cunningham; leather satchel by Brendan Brennan

Literature: O'Neill 1982, pp. 41–44

MOUNT ST JOSEPH'S ABBEY, ROSCREA, CO. TIPPERARY

A manuscript volume of 142 pages. The leaves, measuring 275 × 175 mm, are of handmade paper; there are 23 lines to the page. It was designed for the Cistercian Abbey of Mount St Joseph, Roscrea, as an altar missal to be used on special feastdays. There are two main sections in the missal: the Order of Mass and the Proper of the Saints. The Order of Mass uses the texts of the Roman Missal, and includes various introductory and penitential rites, Liturgy of the Word, Liturgy of the Eucharist, six prefaces (some with music), the Roman Canon, Eucharistic Prayer III, the Communion and concluding rites. The Proper of the Saints begins with a calendar of the thirty-five special feasts of the Abbey and continues with the prayers of the Mass for each of these feasts. Most of the saints commemorated were members of the Benedictine or Cistercian orders but several Irish saints, St Malachy of Armagh, St Flannan of Killaloe, St Cronan of Roscrea and St Elair of Monaincha, are also included.

A book such as the Roscrea Missal is not written page after page with each one completed before moving on. The whole manuscript is planned at the beginning and a little model book is made up indicating what is going to be on each page. The main text, consisting of black writing, is written first of all, and then all the red or blue headings are done. Decorative panels and initial letters are generally left to the end. The basic style of script is loosely modelled on twelfth-century Irish bookhands, as are the illuminated initials. In the early stages a number of manuscripts from this period in Oxford, London and Dublin were examined. Because of the Roscrea connection, decorative elements were borrowed from the eighth-century Book of Dimma. Another local connection is in the cross embossed on the Missal's leather satchel.

Timothy O'Neill has written and illuminated several manuscripts and has written extensively on the subject, including his influential *The Irish Hand*, Dublin (Dolmen Press) 1984.

75 ❧ *Illustrated by Louis le Brocquy, 1969*

The Táin, trans. from the Irish by Thomas Kinsella, illustrated with brush drawings by Louis le Brocquy, Dublin, Dolmen Press, 1969. Size: 309 × 197 × 36 mm

ÉAMONN DE BÚRCA

The *Táin Bó Cuailnge* is the longest and most important of the Ulster cycle of heroic tales. The subject is the invasion of Ulster by the forces of Maedb and Ailill, queen and king of Connacht. The reason for the invasion is the great Brown Bull of Cuailnge, which Maedb covets. The hero of the tale is Cúchulainn, the Hound of Ulster, who resists the armies of Connacht singlehanded while all of Ulster lies low.

Louis le Brocquy, painter, designer and graphic artist, was born in Dublin in 1916. Like Francis

Bacon he was largely self-taught and travelled in his youth to France, Spain and Italy. This resulted in an eclecticism discernible in his work from the late 1930s to the mid-1950s. As well as painting he also designed tapestries. In the middle of the 1950s his style underwent a notable change, and henceforth began his 'white period' in which he concentrated on the single figures. The influence of Cubism and also, perhaps, Francis Bacon seems likely. The illustrations for the *Táin* show Le Brocquy's unrivalled ability as a graphic artist, especially in his almost oriental depictions of the great battle scenes.

76 ❦ *Illustrated by Wendy Walsh, 1996*

Dr Charles Nelson, *The Flowers of Mayo* (Patrick Browne's *Fasciculus Plantarum Hiberniae*, 1788), 15 illustrations by Wendy Walsh, Dublin 1996. Size: 370 × 275 × 40 mm

Edition of ten copies with an original watercolour by Wendy Walsh

ÉAMONN DE BÚRCA

Wendy Walsh is a self-taught artist who has established an international reputation for her botanical illustrations. She has received gold medals for her paintings from the Royal Horticultural Society of London and her works have been exhibited at the Royal Botanic Gardens, Kew, and in galleries in the United States, South Africa and Ireland.

For more twenty years Wendy Walsh has specialized in painting in watercolour the wild and garden flowers of Ireland. She was commissioned by An Post (the Irish Post Office) to design a series of stamps celebrating native plants and animals: the series contained flowers (1978), birds (1979), mammals (1980), horses (1981), marine animals (1982), dogs (1983) and trees (1984).

In 1979 Wendy Walsh began work on a series of flower paintings that led to her close association with the National Botanic Gardens, Glasnevin, and in particular to her joint publications with Charles Nelson. Their *An Irish Florilegium; the Wild and Garden Flowers of Ireland* was published in 1983 and was highly acclaimed. The volume won the bronze medal in the competition for 'The most beautiful book in the world' at the International Book Fair in Leipzig. This was followed by *An Irish Florilegium II*, which was published in 1988. *The Flowers of Mayo* came out in 1996 and was voted the Book of the Year by the Irish Publishers' Association.

77 ✣ The Great Book of Ireland/Leabhar Mór na hÉireann, *1989–91*

A volume containing work by 143 poets, 121 painters, 9 composers and a calligrapher on vellum.
Size: 510 × 360 × 110 mm
Calligrapher: Denis Brown; binding by Anthony Cains; display case by Eric Pearce; clasp, Brian Clarke; vellum, Joe Katz
Exhibited at the Irish Museum of Modern Art, Royal Hospital, Kilmainham, Dublin, 26 June–4 October 1991
POETRY IRELAND (ÉIGSE ÉIREANN) AND CLASHGANNA MILLS TRUST

The editors of *The Great Book of Ireland*, Theo Dorgan and Gene Lambert, who commissioned this work, have written of the genesis of the project:[1] "The original idea came from a meeting between Theo Dorgan, Gene Lambert and Eamonn Martin in March 1989, and was for a handmade book of poems, on vellum and written out and illustrated by a single artist …. The Book would eventually incorporate the direct contributions of 140 poets, 120 artists, 9 composers and a calligrapher …. Choosing the early contributors was deceptively easy: the big names, the exciting talents, almost seemed to declare themselves. But then, subtle shifts began to insinuate themselves: what about artists or poets who had fallen silent? What about artists or poets in exile, voluntary or involuntary? …

"The technical problems were daunting enough in themselves. A pigment had to be found which would be flexible enough to accommodate a range of working practices which swept from a delicate watercolour technique to something verging on impasto. Vellum had to be found in sufficient quantities …. Artists had to face the nightmare of working, one chance only, on an unfamiliar surface, a material which stretched and shrank as it was wet or dry, a subtly uneven surface containing minute amounts of natural oils ….

"The poets, scratching away with their dip-pens on a surface pitted with microscopic bumps and hollows, found themselves writing with unfamiliar implements on a material light years away from bleached, flat paper …. The whole skin was used in each case, resulting in a book half as big again as Kells. Indeed, the sense of time on the project often induced near-vertigo, as the evolving community of makers rediscovered age-old techniques as well as an unexpected sense of a long-buried continuity."

The contributors are as follows:

ARTISTS

Robert Ballagh, Patrick Graham, Patrick Collins, Alice Hanratty, Patricia Hurl, Anne Madden, Eithne Jordan, Patrick Pye, John Kelly, Markus Thonett, Lorcan Walsh, Mick O'Dea, Charles Brady, Martin Gale, Peter Knuttel, Gráinne Dowling, Barrie Cooke, Matilda Faulkner, Charles Cullen, Michael Ashur, Louis le Brocquy, Michael Kane, Charlie Whisker, Rita Duffy, T.P. Flanagan, David Crone, Chris Wilson, Carolyn Mulholland, Sophie Aghajanian, Martin Wedge, Gerry Devlin, Marie Barrett, Alfonso Monreal, Neil Shawcross, Graham Gingles, Basil Blackshaw, Diarmuid Delargy, Cecily Brennan, Danny Osborne, Sean McSweeney, Tony O'Malley, Brian Bourke, Michael Farell, Eilis O'Connell, Robert Armstrong, Mary Fitzgerald, Paki Smith, Felim Egan, Gerald Davis, Campbell Bruce, Jackie Stanley, Patrick Scott, Paul Funge, Imogen Stuart, Brian King, Nigel Rolfe, Patrick Hall, Patrick Hickey, Cóilín Murray, Charlie Harper, Alanna O'Kelly, Anita Groener, Charlie Tyrell, Gwen O'Dowd, Mary Farl Powers, Pauline Bewick, Gabby Dowling, Margaret McNamidhe,

Cliff Colley, Maria Simmonds Gooding, Derek Walcott, John Moore, Donald Teskey, Patricia McKenna, Carmel Benson, Marie Foley, Gene Lambert, Veronica Bolay, Dorothy Cross, Kathy Prendergast, Michael Coleman, Michael Cullen, Sean Fingleton, Vincent Browne, Una Sealy, George Potter, Rob Smith, Brian Maguire, Anna McCleod, Oliver Whelan, Michael Mulcahy, Mick O'Sullivan, Yehuda Bacon, Arthur Armstrong, Jo Hanly, John Behan, Eamonn O'Doherty, James McKenna, Trevor Scott, Nancy Wynne Jones, Jane O'Malley, Conor Fallon, Theo McNab, John Noel Smith, Peter Collis, Finbar Kelly, Mary Donnelly, Pat Murphy, Paul Mosse, Michael Farrel, Deirdre O'Connel, Daniel Day Lewis, Berni Markey, Theresa McKenna, Sonja Landweer, Andrew Folan, Tim Goulding, Antóin Ó Máille, Guggi.

POETS

Seamus Heaney, Richard Murphy, Eiléann Ní Chuilleanáin, Thomas McCarthy, Sebastian Barry, Deirdre Brennan, Pat Boran, Valentin Iremonger, Patrick Deeley, Aidan Murphy, Pádraig Ó Snodaigh, Seamus Deane, Bella Akhmadulina, Mary O'Donnell, Julie O'Callaghan, Nuala Ní Dhomhnaill, Biddy Jenkinson, John Montagu, Samuel Beckett, Heathcote Williams, Brendan Kennelly, Michael O'Loughlin, Michael Hartnett, Rory Brennan, Robert Greacen, Dennis O'Driscoll, Hugh Maxton, Tom McIntyre, Máire Mhac an tSaoi, Derek Mahon, Macdara Woods, Evan Boland, Paul Durcan, Grete Tartler, Theo Dorgan, John F. Deane, Michael O'Siadhail, Anthony Glavin, Padraig J. Daly, Anthony Cronin, Conleth O'Connor, Michael Davitt, Liam Ó Muirthile, Seán Ó Curraoin, James Simmons, Kevin Smith, Damian Smith, Damian Gorman, Padraic Fiacc, Patrick Ramsey, Maedbh McGuckian, Gail Walker, Gerry Greig, Ciaran Carson, Chris Agee, Patrick Galvin, Andrew Elliott, John Kelly, Sam Burnside, Carolyn Forché, Mario Luzi, E.A. Markham, Derek Walcott, Miroslav Holub, Ted Hughes, Pearse Hutchinson, Patrick Cotter, Gerry Murphy, Greg Delanty, Ciaran O'Driscoll, Heather Brett, Gearailt Mac Eoin, Tomás Mac Siomóin, Áine Ní Ghlinn, Ulick O'Connor, Gerard Smyth, Hugh McFadden, Desmond O'Grady, John Ennis, Sean Dunne, Clair O'Connor, Jo Slade, Rita Ann Higgins, Mary O'Malley, Michael Coady, Ciaran Cosgrove, Michael D. Higgins, Jessie Lendennie, Aodh Ó Domhnaill, Basil Payne, Gregory O'Donoghue, Leland Bardwell, Michael Smith, Gabriel Rosenstock, Eithne Strong, Christopher Nolan, Dermot Bolger, Matthew Sweeney, Paula Meehan, Paddy Bushe, Thomas Kinsella, Anne Hartigan, Mary Dorcey, Eva Bourke, Moya Cannon, Anne Kennedy, Francis Stuart, Seán Ó Tuama, Eamonn Grennan, Louis de Paor, Mark Hutcheson, Mael Coll Rua, Sean Lysagh, Kevin Byrne, James J. McAuley, Tony Barry, Jack Hanna, Davoren Hanna, Patrick Deeley, Seamus Hogan, Frank Ormsby, Gerald Dawe, Sean Clarkin, Brian Lynch, Michael Longley, John O'Leary, Sara Berkeley, Peter Fallon, Ciaran Cosgrove, John McNamee, Joan McBreen, Roy McFadden, Richard Ryan, Cathal Ó Searcaigh, Paul Muldoon, Michael Ó Ruairc, Gabriel Fitzmaurice, Aodh Ó Domhnaill, Frank Galligan, Allen Ginsberg, Francis Harvey, Bono.

COMPOSERS

Jane O'Leary, Brian Boydell, Roger Doyle, John Buckley, Seoirse Bodley, John Kinsella, Gerald Barry, Jim Lockhart, Eric Sweeney.

1. Exhibition brochure, 1991. Three more poets and an artist contributed subsequently.

78 ❧ *Illustrated by Felim Egan, 1991*

Seamus Heaney, *Squarings*, twelve poems with 4 illustrations by Felim Egan, published in an edition of 100 volumes, Dublin, Hieroglyph Editions. Size: 321 × 311 × 33 mm

THE GRAPHIC STUDIO WORKSHOP, DUBLIN

Seamus Heaney wrote in a leaflet inserted in the volume as follows: "In 1986, when Felim Egan and I worked together on a small exhibition entitled 'Towards a collaboration', we had no exact sense of how the collaboration would be fulfilled. Yet the paintings on the walls and the writing in the catalogue had this much in common: they were about natural landmarks that had become marked absences.

"Two years later, therefore, when I got going on these twelve-line poems (the whole sequence was published in *Seeing Things*), I realized it was time for our next move. What I saw doing seemed to have a real connection with Felim's approach, since the writing was usually an attempt to catch at something fleet and promising, and the lines I liked best had a quality which recalled my earlier characterization of certain Egan paintings as 'brightnesses airbrushed on the air'. This book is intended to provide a setting for some of those commonly intuited 'lightenings'."

The book was designed by Felim Egan. The text, composed in 14-point Futura Light, was printed on an Albion press at the Graphic Studio. The lithographs were printed from stone by James McCreary. The binding in natural calf and the solander box cover were executed by Museum Bookbindings, Dublin.

ACKNOWLEDGEMENTS

I AM DEEPLY GRATEFUL to Raymond Keaveney, the Director of the National Gallery of Ireland, for inviting me to curate this exhibition and to write the accompanying catalogue. I am also grateful to the staff of the National Gallery for their helpful assistance, especially Adrian Le Harivel for supervising the loans and liaising with the publisher; Fionnuala Croke (Exhibitions Curator), and her assistant, Susan O'Connor; Maighread McParland (Conservator) and her assistant Nìamh McGuinne; and also Maire Bourke (Education) and Marie Fitzgerald (Bookshop). I am also indebted to Paul Holberton and Rita Winter for editing the text. I am grateful to the Trustees and staff of the National Library of Ireland for their help and support, especially the Keeper, Dónall Ó Luanaigh, and Noel Kissane of the Manuscripts Department; Fr Fennessy OFM, of the Franciscan Library, Dún Mhuire, Killiney, Co. Dublin, for his help and assistance; at the Jesuit Library, Milltown Park, I received every assistance from the Librarian, Fr Fergus O'Donoghue SJ, and Fr Brendan Woods SJ; I should like to acknowledge my gratitude to Edward Murphy, Librarian of the National College of Art and Design for his support; I am grateful to Ms Siobhán O'Rafferty, acting Librarian at the Royal Irish Academy, for facilitating my requests. I should like to thank the Board of Trinity College, Dublin, the Trustees and the Director of the Chester Beatty Library, the Keeper of Marsh's Library, the Director and staff of the National Museum, the Trustees and Keeper of the Worth Library, the Graphic Studio Dublin, Poetry Ireland and Clashganna Mills Trust, the Muskerry family, the President and Trustees of the Irish Georgian Society, the Abbot of Mount St Joseph's Roscrea and the President of St Patrick's College, Thurles.

At the National Gallery of Scotland, I am indebted to Ms Katrina Thomson, temporary Curator of Prints and Drawings, for listing the contents of the Angelica Kauffman Album; I should like to thank Dr Rowan Watson, of the National Art Library, Victoria and Albert Museum; I am also grateful to the staff of the British Library, especially Dr Mirjam Foot, for facilitating my researches there; I should also like to thank the staff of the Bodleian Library, Oxford, the University Library Cambridge, Sheffield Archives, and the Witt Library, Courtauld Institute, London; I am indebted to Paul Getty, KBE, for kindly allowing me to examine the bindings in his library at Wormsley; I should like to thank the Marquess of Bath, and Dr Kate Harris the Librarian at Longleat, for their kind assistance. I am indebted to the staff of the Museum für Kunsthandwerk, Frankfurt-am-Main, especially Dr Stefan Soltek, who was most generous with his time. I would also like to thank the authorities of the Koninklijke Bibliotheek, The Hague, and the Walters Art Gallery Baltimore, Maryland, USA.

I am indebted to the following individuals for help in various ways: David Alexander, Toby Bernard, Éamonn de Búrca, Christine Casey, Joe Collins, Finian Corley, Mairead Dunlevy, Jane Fenlon, Neville Figgis, Desmond FitzGerald, Laura Gannon, Daniel Gilman, James Green, David Griffin, Desmond Guinness, Aidan Heavey, Anthony Hobson, Anne Hodge, Michael McCarthy, Cyril McKeon, Philip Maddock, Bryan D. Maggs, Fonsie Mealy, Paul Morgan, Vicki Moltke, David Nevitt, James O'Nolan, Nabil Saidi, Tony Sweeney, Anthony Symondson SJ, Jan Storm van Leeuwen, Wendy Walsh and Fr Pearse Walsh. I should like to express my gratitude to Anne Crookshank for her comments on an earlier draft of the text, and Maurice Craig for his constant support and for access to his collection of rubbings and photographs. Finally, I should like to thank my mother for her encouragement and support.

JOSEPH MCDONNELL

PHOTOGRAPHIC CREDITS

Bodleian Library, Oxford
Figs. 1–2

British Library
38

David Davidson
Fig. 8, Cat. 31

Glasgow University Library
45

The Green Studio Ltd.
5

Koninklijke Bibliotheek, The Hague
44

Library Company of Philadelphia
Fig. 9

Maggs Bros. Ltd, London
16, 34, 37

Museum für Kunsthandwerk, Frankfurt-am-Main
32

National Gallery of Ireland (Roy Hewson)
Figs. 3, 4, 10, Cat. 1, 3, 8, 9, 11, 13, 17, 19, 24, 25, 30, 35, 36, 39, 41,
47, 50, 51, 52, 54, 55a–55e, 56, 59, 60, 61, 62, 63, 64, 66, 67, 69, 70,
71, 73, 74, 75, 76, 78

National Gallery of Scotland, Edinburgh
43

National Library of Ireland (Eugene Hogan)
6, 7, 14, 15, 18, 22, 23, 26, 27, 29, 46, 48, 49, 53, 57, 58, 62, 65, 68

National Museum of Ireland
72

Sheffield Archives
10

Sinéad Ní Riain
12

Trinity College History of Art Department
4, 32, 40, 42

Walters Art Gallery, Baltimore
20

BIBLIOGRAPHY

T.K. Abbott and E.J. Gwynn, *Catalogue of Irish Manuscripts in the Library of Trinity College, Dublin*, London 1921

J.H. Andrews, *Plantation Acres*, Omagh 1985

Charles Benson, 'Printers and Booksellers in Dublin', in *Spreading the Word: The Distribution Networks of Print 1550–1850*, edd. Robin Myers and Michael Harris, Winchester 1990, pp. 47–59

Martin Blake, 'William De Burgh, Progenitor of the Burkes in Ireland', *Journal of the Galway Archaeological and Historical Society*, VII, no. 2, 1912, pp. 83–101

Nicola Gordon Bowe, 'Women and the Arts and Crafts Revival in Ireland', *Irish Women Artists*, exhib. cat., edd. W. Ryan-Smolin, E. Mayes, J. Rogers, Dublin, National Gallery and Hugh Lane Gallery, 1987, pp. 22–27

J.J. Buckley, 'Some Early Ornamented Leatherwork', *Journal of the Royal Society of Antiquities of Ireland*, XLV, pt. IV, December 1915, pp. 300–09

Sir Charles Cameron, *History of the Royal College of Surgeons in Ireland*, Dublin 1916

Desmond Clarke and P.J. Madden, 'Printing in Ireland', *An Leabharlann* (Journal of the Library Association of Ireland), XII, no. 4, December 1954, pp. 113–30

Maurice Craig, 'The Irish Parliamentary Bindings', *The Book Collector*, II, no. 1, 1953, pp. 24–36

Maurice Craig, *Irish Bookbinding 1600–1800*, London 1954

Maurice Craig, 'Irish Bookbinding', *Apollo*, October 1966, pp. 322–25

Maurice Craig, *Irish Bookbinding* (Irish Heritage Series 6), Dublin 1976

Anne Crookshank and the Knight of Glin, *The Watercolours of Ireland*, London 1994

Ed. Brian de Breffny, *Ireland: A Cultural Encyclopaedia*, London 1983

Myles Dillon, Canice Mooney OFM, Padraig Dé Brún, *Catalogue of Irish Manuscripts in the Franciscan Library, Killiney*, Dublin 1969

Revd J.P. Droz, *A Literary Journal*, 5 vols., Dublin 1744–48

Exhibition of Irish Bindings from the Seventeenth to the Twentieth Centuries, exhib. cat., London, Foyles Art Gallery, 29 Sept.–23 Oct. 1954

Peter Fox (ed.), *Treasures of the Library of Trinity College Dublin*, Dublin 1986

Das Gesicht der Bücher, Einbände von der Gotik bis zum Jugendstil, exhib. cat. by Eva-Maria Hanebutt-Benz, Frankfurt am Main, Museum für Kunsthandwerk, 1986

J.T. Gilbert, *A History of the City of Dublin*, 3 vols., Dublin 1854–59

J.T. Gilbert, *Facsimiles of the National Manuscripts of Ireland*, London 1874–84

Marquis de Girardin, 'L'Edition des Fables de la Fontaine dite d'Oudry', *Bulletin du Bibliophile*, 1913

E. Harwood, *A View of the Various Editions of the Greek and Roman Classics*, 2nd edn., London 1778

C. Helbok (compiler), *Angelica Kauffmann und ihre Zeit*, (C.G. Boerner) 1979

F. Henry and G. Marsh-Micheli, 'Manuscripts and Illuminations, 1169–1603', in *A New History of Ireland*, ed. Art Cosgrove, Oxford 1987, II, pp. 781–815

G.D. Hobson, *Thirty Bindings*, London 1926

G.D. Hobson, *Bindings in Cambridge Libraries*, Cambridge 1929

G.D. Hobson, *English Bindings 1490–1940 in the Library of J.R. Abbey*, London 1940

Anne Hodge, 'A Study of the Rococo Decorations on John Rocque's Maps and Plans, 1755–1760', BA thesis, Dublin, National College of Art and Design, 1994

Arnold Horner, 'Cartouches and Vignettes on the Estate Maps of John Rocque', *Bulletin of the Irish Georgian Society*, XIV, 1971 pp. 57–76

Vincent Kinane and Charles Benson, 'Some Late 18th- and Early 19th-century Dublin Printer's Account Books: the Graisberry Ledgers', in *Six Centuries of the Provincial Book Trade in Britain*, ed. Peter Isaac, Winchester 1990, pp. 139–50

Vincent Kinane, *A History of the Dublin University Press*, Dublin 1994

Ed. Noel Kissane, *Treasures from the National Library of Ireland*, Dublin 1994

Gene Lambert, 'The Great Book of Ireland', in *Irish Arts Review*, VIII, 1991–92, pp. 149–51

Paul Larmour, *Celtic Ornament* (The Irish Heritage Series XXXIII), Dublin 1981

Paul Larmour, *The Arts and Crafts Movement in Ireland*, Belfast 1992

W.S. Lewis, *The Yale Edition of Horace Walpole's Correspondence*, London 1941

Le Livre Anglais, Trésors des Collections Anglaises, exhib. cat., Paris, Bibliothèque Nationale, 1951

J.B. Lyons, 'Sylvester O'Halloran (1728–1807)', *Irish Journal of Medical Science*, May 1963, pp. 217–32

Wesley McCann, 'Patrick Neill and the Origins of Belfast Printing', in *Six Centuries of the Provincial Book Trade in Britain*, ed. Peter Isaac, Winchester 1990, pp. 125–38

Muriel McCarthy, *All Graduates and Gentlemen - Marsh's Library*, Dublin 1980

Muriel McCarthy, 'An Eighteenth Century Dublin Bibliophile', *Irish Arts Review*, III, no. 4, 1986, pp. 29–35

E.R. McClintock Dix, *Catalogue of Early Dublin-printed Books, 1601–1700*, Dublin 1898–1912

E.R. McClintock Dix, 'The Ornaments used by John Franckton Printer at Dublin', *Transactions of the Bibliographical Society*, VIII, 1904–06, offprint

E.R. McClintock Dix, *Printing in Dublin prior to 1601*, Dublin 1932

J. McDonnell, 'Parliamentary Binder B identified', *Bulletin of the Irish Georgian Society*, XXXV, 1992–93, pp. 52–56

J. McDonnell, 'The Influence of the French Rococo Print in Ireland in the Eighteenth Century', *Bulletin of the Irish Georgian Society*, XXXVI, 1994, pp. 63–73

J. McDonnell, 'Romanesque Bookbinding Fragments', in *Miscellanea*, ed P.F. Wallace (Medieval Dublin Excavations 1962–81, series B, II, 1988, façciculus 1–5), Dublin, pp. 27–31

J. McDonnell, 'The Coote Armorial Bindings', *Bulletin of the Irish Georgian Society*, XXXVII, 1995, pp. 4–12

Ed. J. McDonnell, *Ecclesiastical Art of the Penal Era*, Maynooth 1995

J. McDonnell and P. Healy, *Gold-tooled Bookbindings commissioned by Trinity College Dublin in the Eighteenth Century*, Leixlip 1987

A. MacLochlainn, 'Jesuit Printing and Binding in Kilkenny, 1646', *Long Room*, no. 40, 1995

Edward McParland, A. Rowan and Ann Martha Rowan, *The Architecture of Richard Morrison (1767–1849) and William Vitruvius Morrison (1794–1838)*, Dublin 1989

Bernard C. Middleton, *A History of the English Craft Bookbinding Technique*, New York and London 1963

James Mills and Michael J. McEnery, *Calendar of the Gormanston Register*, Dublin, 1916

A. Mitchell, 'Our Bookbinders had a World Reputation', *The Irish Independent*, 26 February 1968

Canice Mooney, 'Short Guide to the Franciscan Library', *Archivium Hibernicum*, XVIII, 1953

Thomas Morris, *Holy Cross Abbey*, Dublin 1986

Ed. Denis Murphy SJ, *Triumphalia Chronologica Monasterii Sanctis Crucis in Hibernia 1640*, Dublin 1891

H.M. Nixon, 'An Irish Bookbinding', *The Book Collector*, Autumn 1954, pp. 216–17

H.M. Nixon, *The Broxbourne Library*, London 1956

Timothy O'Neill FSC, 'The Roscrea Missal, the Writing of a Manuscript Book', *Éile* (Journal of the Roscrea Heritage Society), no. 1, 1982

Timothy O'Neill FSC, *The Irish Hand*, Dublin 1984

Tomás O'Reilly, 'Seanchus na mBúrcach (Historia et Genealogia Familiae De Burgo)', *Journal of the Galway Archaeological and Historical Society*, XIII, 1927

Tomás O'Reilly, 'Seanchus na mBúrcach (Historia et Genealogia Familiae De Burgo)', *Journal of the Galway Archaeological and Historical Society*, XIV, 1928–29

William O'Sullivan, 'Dublin Binding, 1639', *Friends of the Library of Trinity College Dublin, Annual Bulletin* 1955, p. 13

William O'Sullivan, 'Binding Memories of Trinity Library', in *Decantations*, ed. Agnes Bernelle, Dublin 1992, pp. 168–76

J.B. Oudry, exhib. cat. by Hal Opperman, Fort Worth, Texas, Kimball Art Museum, 1983

O. Pächt and J.J.G. Alexander, *Illuminated Manuscripts in the Bodleian Library*, Oxford 1973

M. Pollard, 'John Chambers, Printer and United Irishman', *Irish Book*, III, 1964, pp. 1–22

M. Pollard, *Dublin's Trade in Books, 1550–1800*, Oxford 1989

M. Pollard, 'Plain Calf for Plain People: Dublin Bookbinders' Price Lists of the Eighteenth Century', in *Decantations*, ed. Agnes Bernelle, Dublin 1992, pp. 177–86

Hilary Pyle, *The Different Worlds of Jack B. Yeats, his Cartoons and Illustrations*, Dublin 1994

Charles Ramsden, *Bookbinders of the United Kingdom (outside London) 1780–1840*, London 1954, pp. 224–50.

The Rothschild Library: A Catalogue of the Collection of Eighteenth-Century printed Books and Manuscripts formed by Lord Rothschild, 2 vols., Cambridge 1954

Royal Historical Manuscript Commission, 4th Report, 1874

C.E. Sayle (ed.), *A Catalogue of the Bradshaw Collection of Irish Books in the University Library Cambridge*, 3 vols., Cambridge 1913

Nessa Ní Shéaghdha, *Catalogue of Irish Manuscripts in the National Library of Ireland*, Dublin 1961, Fasciculus II

Nessa Ní Shéaghdha, *Catalogue of Irish Manuscripts in the National Library of Ireland*, Dublin 1976, Fasciculus III

Roger Stalley, *The Cistercian Monasteries of Ireland*, London and New Haven 1987

W.G. Strickland, *A Dictionary of Irish Artists*, Dublin 1913

Sir Edward Sullivan, 'Irish Bookbinding, and how it may be Improved', *Arts and Crafts Society of Ireland Journal and Proceedings*, I, no. 1, 1896, pp. 57–59

Sir Edward Sullivan, 'The Queen's Album', *Arts and Crafts Society of Ireland Journal and Proceedings*, I, no. 2, 1896, pp. 167–69

Sir Edward Sullivan, 'Design in Gold-Tooled Bookbinding', *The Studio*, XXXIII, 1904, pp. 34–39

Sir Edward Sullivan, 'Ornamental Bookbinding in Ireland in the Eighteenth Century', *The Studio*, XXXVI, October 1905, pp. 52–59

Sir Edward Sullivan, 'The Parliamentary Journals of Ireland 1613–1800', *Country Life*, 5th September 1908, pp. 313–16

Sir Edward Sullivan, *Decorative Bookbinding in Ireland* (Opuscula, no. LXVII, Ye Sette of Odd Volumes), London (privately printed) 1914

Jan Storm van Leeuwen, *De meest opmerkelijke boekbanden uit eigen bezit,* exhib. cat., The Hague, Koninklijke Bibliotheek, 1983

Thomas Wall, introduction to the 1970 Gregg reprint of *Hibernia Dominicana*

Paul Walsh, 'Two Irish Manuscripts', *Studies*, XVIII, 1929, pp. 292–306

W.F. Walsh and E.C. Nelson, *A Prospect of Irish Flowers*, Belfast 1990

Robert E. Ward, *Prince of Dublin Printers: The Letters of George Faulkner*, Kentucky 1972

John W. Waterer, 'Irish Book-Satchels or Budgets', *Medieval Archaeology*, XII, 1968, pp. 70–82

J.D.H. Widdis, *A Dublin School of Medicine and Surgery,… the Royal College of Surgeons Dublin 1784–1948*, Dublin 1949

Daniel Wildenstein, 'L'œuvre gravé des Coypel', *Gazette des Beaux-Arts*, LXIII, May–June 1964, pp. 267–74

LENDERS

Figures refer to catalogue numbers

Anonymous 17, 19, 28, 41, 50, 51, 54, 55a

Arranmore Collection of Early Irish Books 9

The Marquess of Bath, Longleat House, Wiltshire 21

British Library, London 38

Trustees of the Chester Beatty Library, Dublin 31

Éamonn de Búrca 75, 76

Franciscan House of Studies, Dún Mhuire, Killiney, Co.
 Dublin 1

Paul Getty, KBE (Wormsley Library) 16, 34, 37

Glasgow University Library, Special Collections
 Department 45

Glin Castle, Co. Limerick 52

Graphic Studio Workshop, Dublin 78

The Hon. Desmond Guinness 59

Irish Georgian Society 35, 36, 39

Jesuit Library, Milltown Park, Dublin 13, 30, 69, 70

Koninklijke Bibliotheek, The Hague 44

George Mealy and Sons, Castlecomer, Co. Kilkenny 24, 55d,
 55d, 56, 60, 63, 64, 66, 67, 71

Mount St Joseph's Abbey, Roscrea, Co. Tipperary 74

Museum für Kunsthandwerk, Frankfurt-am-Main 32

The Muskerry Family, through Bank of Ireland 47a, 47b

National Gallery of Ireland, Dublin (Yeats Museum) 73

National Gallery of Scotland, Edinburgh 43

National Library of Ireland, Dublin 2, 6 (on long-term loan
 from the Power O'Shee family), 7, 8, 11, 14, 15 (on long-
 term loan from the Ormonde Estate), 18, 22, 23, 26, 27, 29,
 46, 48, 49, 53, 55c, 55e, 57, 58, 61, 62, 65, 68

National Museum of Ireland, Dublin 72

Poetry Ireland (Éigse Éireann) and Clashganna Mills Trust 77

Royal Irish Academy, Dublin 3

St Patrick's College, Thurles, Co. Tipperary 12

Sheffield Archives, Sheffield Libraries and Information
 Services and Trustees of Olive, Countess Fitzwilliam
 Chattels Settlement 10

The Board of Trinity College, Dublin 4, 5, 33, 40, 42

The Walters Art Gallery, Baltimore, Maryland 20

The Worth Library, Dr Steevens's Hospital, Dublin 25